MOVIE MAKERS

50 ICONIC DIRECTORS FROM CHAPLIN TO THE COEN BROTHERS

IAN FREER

Quercus

Quercus
21 Bloomsbury Square
London
WC1A 2NS

First published in 2009

A catalogue record of this book is available from the British Library

Cloth case edition:
ISBN 978 1 84724 856 5

Printed case edition:
ISBN 978 1 84724 512 0

Paperback edition:
ISBN 978 1 84724 857 2

Printed and bound in China

10 9 8 7 6 5 4 3 2 1

Developed for Quercus by The Package

White-Thomson Publishing Ltd.
Director: Stephen White-Thomson
Editor: Simon Smith
Picture researcher: Amy Sparks

Balley Design Ltd.
Art Director: Simon Balley
Designers: Joanna Clinch, Andrew Li

Contents

Introduction

George Lucas, the writer-director of *Star Wars*, once said that directing a film was 'like putting out a fire with a sieve'. Louis Malle, the filmmaker behind *Lacombe, Lucien* and *Au revoir les enfants*, once quipped that filmmaking is akin to spermatozoa because 'only one in a million makes it'. Stanley Kubrick, the visionary who brought us *2001: A Space Odyssey*, likened the experience to 'trying to write *War and Peace* in a bumper car in an amusement park, [but] when you finally get it right, there are not many joys in life that can equal that feeling'. So to recap, directing a film is like making love on a bumper car in a raging inferno.

In attempting to put together a list of the 50 greatest moviemakers of all time it is hard not to feel a certain sense of kinship with Messrs Lucas, Malle and Kubrick. Sifting through the entire length and breadth of film history and attempting to distil its shining talents to just a single half-century is another task that borders on the impossible. For a start you need to land on a definition of what separates the very good from the truly great. Traditional notions of cinematic greatness usually cleave close to the *auteur* theory developed by the French film critics of *Cahiers du cinéma* magazine, that genius lies in a consistency of theme and visual style across a broad range of work. This is a persuasive argument, but it doesn't embrace the work of craftsmen such as Michael Curtiz or Ridley Scott, whose films are thematically disparate yet still undeniably 'great'. Also, seriousness and gravitas often factor into how some perceive greatness – witness the lack of comedies that have won Best Picture Oscars – which would rule out the likes of François Truffaut, Woody Allen and Pedro Almodóvar.

So perhaps it is more fruitful to perceive greatness not as one monolithic thing but as an umbrella term for a host of different definitions. It can relate to the ability to produce a run of brilliant work, to create a single defining work of genius, to be the figurehead of a movement or to influence and define those that follow. But if anything unites the 50 moviemakers collected here – 47 directors, two filmmaking partnerships and one animation legend, who exerted just as much control as any director – it is that they do two things: they fully express an idea of the world *and* an idea of cinema. That seems as good a benchmark for cinematic greatness as any.

Once you have the criteria established you then have to decide who makes the grade. Some names immediately announce themselves as cast-iron certainties. It is, for example, impossible – in fact, plain stupid – to create a list of the 50 greatest moviemakers and not include the likes of John Ford, Jean Renoir, Sergei Eisenstein, Alfred Hitchcock, David Lean, Akira Kurosawa, Orson Welles, Ingmar Bergman, Federico Fellini, Stanley Kubrick, Martin Scorsese and Steven Spielberg.

So far, so easy. But it is the next tier down from these masters that causes the real headache. So it is with a heavy heart that some truly fine directors have been excluded. There is no room for the magic of Georges Méliès, the playfulness of Dziga Vertov, the poetry of Jean Vigo, the comedic genius of Preston Sturges and Ernst Lubitsch, the magic

of Jean Cocteau, the animated invention of Chuck Jones and Tex Avery, the spirituality of Robert Bresson, the slapstick of Jacques Tati, the subtlety of Yasujiro Ozu, the dark hearts of Nicholas Ray, Sam Fuller, Douglas Sirk, the elegance of Max Ophuls, the ambiguity of Michelangelo Antonioni, the luxury of Luchino Visconti, the beauty of Andrei Tarkovsky, the rawness of John Cassavetes, the delicacy of Eric Rohmer and the flawless technique of Brian De Palma, Robert Zemeckis and James Cameron.

Also, as this list is restricted to fiction films, it means that the great documentary filmmakers and experimental artists will have to wait for a different book. It is also a completely male list. Women filmmakers, historically denied opportunities and creative power, have not been allowed to amass the kinds of bodies of work that create seismic shifts, although the careers of Jane Campion and Sofia Coppola suggest that will soon change.

The list is ordered by date of birth, so it is not a countdown – trying to decide whether Hitchcock should be higher or lower than, say, Bergman just doesn't bear thinking about. This format makes *Moviemakers* particularly suited to reading out of order – perhaps you would wish to start with your favourite directors before venturing to explore less familiar names and works. Yet, while each piece is designed to stand alone, every effort has been made to join the dots between the filmmakers, highlighting how the directors of the first half of the book have influenced those of the second, how various cinematic trends and movements have been usurped by others and how the image, perception and even dress codes of filmmakers have evolved from the silent era to the present – Martin Scorsese is no doubt thankful he doesn't have to wear a monocle and jodhpurs.

Films are referred to by their most commonly used title in the English-speaking world – so, for example, Jean-Luc Godard's classic debut is listed as *Breathless* rather than the original *À bout de souffle*, but his *Une Femme est une femme* is left in the French instead of being translated as *A Woman is a Woman*.

As well as providing at least some sense of the development of film history this book really hopes to provoke – please feel free to agree, disagree, cogitate or fulminate over the inclusions and exclusions. That's one of the joys of loving movies. But if *Moviemakers* has one overriding aim it is to instil within you a desire to discover or revisit some of the most exciting films ever to flicker on the silver screen – and if you can see them on a big screen, all the better. Every director has a Must-see Movies box, a pick of their essential works. If you see all of these you will not only have a solid grounding in the cream of film history, you will also enjoy the most rewarding, challenging, entertaining and moving 600 hours or so of movie-watching you could ever hope to have.

Ian **Freer**
London

D.W.
Griffith

'Griffith was the teacher of us all.'

Charlie **Chaplin**

1875–1948

D.W. Griffith was the founding father of American cinema. His reputation as a stern, imperious, reputedly humourless figure has nothing to do with these patriarchal qualities. It was Griffith who first understood and capitalized on the capabilities of the medium, almost single-handedly creating a syntax for cinema. Although Griffith probably didn't invent such techniques as the close-up, the fade and the manipulation of camera angles, as is often suggested, he was the first filmmaker to apply them thoughtfully and creatively, inventing a film language that is still its native tongue today.

But his influence goes even further. Griffith's aesthetic was charged with the absolute conviction that cinema was the ideal medium for telling ambitious, involving stories. Before Griffith films were essentially one-reel sketches; after Griffith audiences could lose themselves in his poetic and epic moving experiences. He also presided over a subtler, less theatrical form of acting that could withstand the intensifying gaze of the camera lens, a shift that, in turn, created a whole raft of important silent stars. With this newfound storytelling sophistication Griffith elevated movies from their status as simple diversions to an art form of social and financial

Must-see Movies

Birth of a Nation (1915)
Intolerance (1916)
Broken Blossoms (1919)
Orphans of the Storm (1921)
America (1924)

significance. When, in 1975, he was honoured on a 10-cent US postage stamp it seemed scant reward for a man who crystallized the DNA of narrative film.

FROM STAGE TO SCREEN

The son of Confederate US Civil War hero Jacob 'Roaring Jake' Griffith, David Llewellyn Wark Griffith was born on 22 January 1875 in La Grange, Kentucky. A failed career as an actor – stage name Lawrence Griffith – and playwright saw him turn his back on the theatre and turn to movies. Hawking around story ideas to studios in New York Griffith won the lead role as an actor in Edwin S. Porter's *Rescued from an Eagle's Nest* (1908) but fared better with Biograph Studios, which employed him as both an actor and screenwriter.

Griffith quickly became a leading light at Biograph. After directing his first film in 1908, *The Adventures of Dollie*, he supervised all of Biograph's output between 1909 and 1913, directing many of the features himself. In a white-hot creative spell unmatched in film history he churned out 485 shorts in a four-year period, growing increasingly ambitious and technically proficient. *Enoch Arden* (1911) was a drama that ran for two reels, a length that conventional wisdom dictated was beyond the attention span of film audiences. He also gained the trust of Biograph to attempt works that reflected his own passions and concerns: *A Man's Genesis* tackled Darwin's theory of evolution, *The New York Hat* satirized religious Puritanism and *The Musketeers of Pig Alley*, America's first gangster flick, all from 1912, highlighted his growing social consciousness.

Under the influence of the 1914 Italian feature *Cabiria* Griffith became increasingly convinced that feature-length films could be financially successful. In 1914 *Judith of Bethulia*, a biblical epic, ran to a mighty four reels, the equivalent of 61 minutes. Biograph put a block on the film's release, so Griffith left the studio, taking his stock company of actors and technicians with him. In his new production base at Reliance Majestic, where he was made Production Chief, Griffith set in motion his magnum opus: *Birth of a Nation*.

BIRTH OF A NATION

At 192 minutes long *Birth of a Nation*, initially known as *The Clansman* and based on Thomas Dixon's novels, became American cinema's first bona fide feature film. It was an epic portrait of the US Civil War that mixed astonishing breadth of vision, touching intimate moments and a newly found depth of character. The movie was a superlative showcase for Griffith's total command of the medium, and it became cinema's first big financial success, with long lines of cinemagoers paying an astronomical US$2 a ticket for the privilege of the experience. It was also the first movie to be shown at the White House, with President Woodrow Wilson declaring that it was like 'writing history with lightning'. Yet the film's ugly racist views – slavery was depicted as benign, the Ku Klux Klan as restoring order to a black-ruled South – caused enormous controversy, casting an uneasy pall over its masterpiece status. After it opened in March 1915 riots broke out in Boston and Philadelphia, and the film was denied release in Chicago, Ohio, Denver, Pittsburgh, St Louis and Minneapolis. In Lafayette, Indiana, a white man killed a black teenager after seeing the movie.

A CLOSE COLLABORATOR

While Griffith has rightly been dubbed a pioneer of film technique he did not do this alone. Key to the development of Griffith's art was his cinematographer G.W. Bitzer. Griffith may have had the vision, but innovations such as the fade (an optical effect that allows a scene to emerge in and out of darkness), the iris (a transition effect where an image emerges from or disappears into a circle in the middle of the frame) and the dolly shot (a moving camera shot) were all brought to life by Bitzer's technical know-how and audacity. After a 16-year partnership Bitzer parted ways with Griffith in 1934 and, like his director, found it difficult to survive in an ever-changing industry.

> 'Remember how small the world was before I came along? I brought it all to life.'
>
> D.W. **Griffith**

Griffith was stung by the controversy and accusations. In 1911 he had directed *The Rose of Kentucky*, which portrayed the Ku Klux Klan as villainous marauders, and he had made two films – *The Red Man's View* (1909) and *Ramona* (1910) – that criticized the oppression of Native Americans by white settlers. So, refusing to rest on his laurels, Griffith's next film was conceived as an ambitious riposte. *Intolerance*, released in the summer of 1916, combined four separate stories – 'The Modern Story', 'The Judean Story', 'The French Story' and 'The Babylonian Story' – set in different time frames but all linked by the theme of man's inhumanity to man. Costing an unprecedented US$2.5 million, including most of Griffith's profits from *Birth of a Nation*, the film disappointed at the box office but proved influential to a whole generation of filmmakers, in particular Russia's Sergei Eisenstein, and still stands today as a monumentally impressive achievement.

A SLOW DECLINE

After the failure of *Intolerance* Griffith's appetite for big-budget projects diminished. Instead, he directed a series of modest intimate dramas – *The Greatest Thing In Life* (1918), *A Romance of Happy Valley*, *The Girl Who Stayed Home* and *True Heart Susie* (all 1919). Following *Scarlet Days*, his only western, Griffith joined forces in 1919 with fellow filmmakers Charlie Chaplin, Mary Pickford and Douglas Fairbanks to form a new studio, United Artists. His first film for UA that same year, *Broken Blossoms*, became the best of his small-scale dramas, a poetic, atmospheric piece set in London and starring Lillian Gish.

From the 1920s onwards Griffith's work rate, not to mention his success rate, faltered. *Orphans of the Storm* (1921), a spectacular recreation of the French Revolution, went some way to recapturing former epic glories, and 1924's *America*, his final silent epic, was a touching, impressive panorama of the Revolutionary War, but, for the most part, films such as *One Exciting Night* (1922), *White Rose* (1923) and *Isn't Life Wonderful?* (1924) overdosed on sentiment, resulting in box-office failure that sent Griffith spiralling into debt. To regain financial security Griffith signed with Adolph Zukor at Paramount in 1924 and then returned to United Artists three years later but gave up creative control in the bargain, turning in cold, uninspired works that reflected his loss of confidence. After once declaring 'There will never be talking pictures', in 1930 he directed his first sound film, *Abraham Lincoln*, a bloated, disjointed biopic, and followed it with *The Struggle* a year later. Neither found a home with audiences, and *The Struggle* was Griffith's last film.

The last 15 years of Griffith's life were a miasma of stalled projects, a failed second marriage and a new career as a Broadway impresario. Despite owning a ranch in California Griffith lived out the last years of his life in a series of hotels. He was given an honorary Oscar in 1935, but he was a forgotten figure by the time he died of a cerebral haemorrhage on 23 July 1948. The Directors' Guild of America instituted the D.W. Griffith Award as its highest honour in 1953, but the award was renamed the DGA Lifetime Achievement Award in 1999 because *Birth of a Nation* had 'helped foster intolerable racist stereotypes'. If Griffith's legacy has been blighted by the spectre of bigotry, his influence is incalculable and undeniable. American cinema would have grown up differently without him.

INSIDE *INTOLERANCE*

The making of *Intolerance* is the stuff of Hollywood legend. The Babylonian orgy scene cost US$200,000 alone, twice the total budget of *Birth of a Nation*. To populate his huge sets Griffith hired hundreds of extras at the exorbitant rate of US$2 a day, which might have translated into danger money – 60 injuries were treated at the production hospital tent during just one day of filming of huge battle scenes. After shooting finished, the 100-foot- (30-metre)-high Great Wall of Babylon replica was left standing for years on the corner of Sunset Boulevard and Hollywood Boulevard, a fitting monument to an epic endeavour.

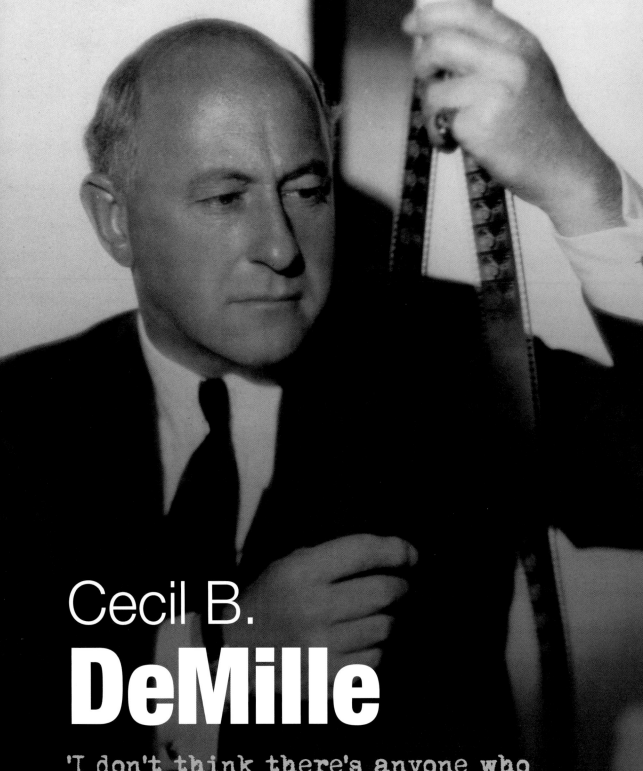

Cecil B.
DeMille

'I don't think there's anyone who
knows more about what the American
public wants than Cecil B. DeMille.'

John **Ford**

1881–1959

The Greatest Showman on Earth was a frequent and apt description of Cecil B. DeMille.

Long before Alfred Hitchcock or Steven Spielberg came to embody the public perception of the film director, DeMille *was* Hollywood, the first filmmaker to become a household name in an age where movie stars held sway. With his trademark directorial jackboots, megaphone and riding crop, DeMille became the symbol of the movies' golden age, and his flamboyant, forceful personality did much to make Hollywood the capital of world cinema. But the strong public persona has often masked DeMille's reputation as an inventive and influential filmmaker, and as such he has never really been treated with the seriousness he deserves.

He was often dismissed as crass and vulgar by the intelligentsia, but DeMille had a canny knack for anticipating public tastes. Although he is best known for biblical epics his films are potent mixtures of solid, organic storytelling, high production values and exotic locations. DeMille knew what worked and stuck with it: he remade four of his own films, making 70 films in all, ranging from small-scale dramas (*The Cheat*, 1915) to Oscar-winning epics (*The Greatest Show on Earth*, 1952) and everything in between.

MORAL TALES

Cecil Blount DeMille was born on 12 August 1881 in Ashfield, Massachusetts, the son of an Episcopalian lay preacher and a schoolmistress. He studied at New York's Academy of Dramatic Arts and started his creative life in the theatre, but in 1913 he joined forces with vaudeville musician Jesse Lasky and glove salesman Samuel Goldfish (soon to become Goldwyn) to form the Jesse L. Lasky Feature Play Company. The team moved to Arizona to start production but, hating the weather, switched to Hollywood to make their

Must-see Movies

King of Kings (1927)
Samson and Delilah (1949)
The Greatest Show on Earth (1952)
The Ten Commandments (1956)

first picture, *The Squaw Man* (1914) – the story of an English lord who marries a Native American – which DeMille co-directed with Oscar Apfel. The film was a commercial and critical hit, and its success consolidated the position of the fledgling company and established DeMille within the infant industry. Interestingly, DeMille would go on to make two further versions of the film, one in 1918 and another in 1931. Lasky eventually became Paramount, and DeMille became its creative force, writing and directing many of its early pictures while supervising the other productions.

DeMille honed his filmmaking ethos at Paramount, avoiding big-name stars by developing his own talent – Gloria Swanson, Gary Cooper, Charlton Heston – and spending the money he saved on spectacle. Long before he became known as the King of the Epic, DeMille was renowned for a series of sex comedies, usually romantic triangles involving straying partners who eventually return to the fold. With such titles as *Don't Change Your Husband*, *Why Change Your Wife?* and *Forbidden Fruit* these films were

sensationalist – DeMille was the first filmmaker to shoot scenes in bathrooms and bedrooms – but they also championed Victorian values. They were a canny mixture of 20th-century sex tempered by 19th-century morality.

THE BIBLICAL EPICS

DeMille started making the biblical epics for which he became famous in the 1920s. Yet he still cleaved close to his filmmaking formula, with the films espousing Christian values while all the time revelling in sin and showmanship. DeMille's first take on *The Ten Commandments* in 1923 combined the biblical story with a contemporary yarn of sin and redemption; 1927's *King of Kings* played the Passion straight but depicts Christ's resurrection using the primitive two-strip Technicolor process; and *The Sign of the Cross* (1932) livened up a tale of first-century Christianity with some provocative orgy scenes.

DeMille continued his penchant for such subjects into the years after the Second World War. *Samson and Delilah* (1949), starring Victor Mature and Hedy Lamarr, features a spectacular scene in which a pagan temple is toppled. However, DeMille's best-known religious epic remains his second attempt at *The Ten Commandments* in 1956. Starring Charlton Heston as Moses, and featuring Yul Brynner and Edward G. Robinson, DeMille conceived the film on a huge scale – 12,000 extras, 15,000 animals – and laced it with state-of-the-art Oscar-winning effects to present the burning bush and the parting of the Red Sea. The publicity campaign matched the scale of the film, with DeMille placing stone plaques of the Commandments at government buildings across the USA, many of which are still there today.

> ## 'Give me any two pages of the Bible and I'll give you a picture.'
>
> Cecil B. **DeMille**

DeMille was ruthless in his desire to create vivid spectacle, and he publicly humiliated actors who were afraid to take physical risks. When Victor Mature refused to wrestle a tame and toothless lion on the set of *Samson and Delilah* DeMille branded him '100 percent yellow', and Paulette Goddard fell out of favour when she refused to act near a fire in *Unconquered* (1947). Still, DeMille had the courage of his convictions. While directing *The Ten Commandments* on location in Egypt he climbed a 107-foot (33-metre) ladder to supervise the Exodus scene and suffered a near-fatal heart attack. He was back working within a week.

The Ten Commandments proved to be DeMille's last work. He was in negotiations to direct *Ben-Hur* and planning a biopic of the founder of the Scout movement, Robert Baden Powell, starring James Stewart, when he died of heart failure on 21 January 1959.

LUX RADIO THEATER

From 1936 to 1945 DeMille directed and hosted a popular radio show, *Lux Radio Theater*, which presented one-hour adaptations of famous films such as *Morocco* and *The Thin Man* on the wireless, often with the original Hollywood or Broadway stars reprising their roles. Lauren Bacall, Ingrid Bergman, Humphrey Bogart, Gary Cooper, Bing Crosby, James Stewart and John Wayne all appeared, being paid US$5,000 per performance. In June 1945 DeMille was forced to quit the show when he fell foul of the American Federation of Radio Artists over a political dispute. Nonetheless, the show did much to foster the perception of the director as the very image of Hollywood.

Michael
Curtiz

'Curtiz was not flesh and
bones. He was part of the
steel of the camera.'

Fay **Wray**

1886–1962

If for nothing else, Michael Curtiz's place in film history would be assured by *Casablanca*. Many people pick it as the Greatest American Film Ever Made, and the evergreen romantic drama, starring Humphrey Bogart and Ingrid Bergman, is the epitome of the golden age of Hollywood. Yet Curtiz's contribution has, remarkably, been lost in the shuffle. Film history has deemed that *Casablanca* is the perfect example of the studio system working at full tilt, a happy accident of stars, script, setting and song – 'As Time Goes By' – that could have been put together by anyone. But, as the contemporary reviews and awards suggest, *Casablanca* is very much its director's film, an adroitly judged mixture of action, drama, comedy, romance and exoticism beautifully conducted by an unheralded maestro who repeated the same trick with remarkable regularity.

Curtiz was one of cinema's most prodigious and prolific talents, turning out 160 films in a 50-year career. He had vision and versatility, depth and breadth, making a huge range of great films and anointing stars in the process. He guided Bette Davis to popularity in the 1930s, established Errol Flynn as a matinée action hero in 12 movies and directed Joan Crawford to an Oscar for *Mildred Pierce*. His *annus mirabilis* was 1942, when he steered James Cagney to the Best Actor Oscar for *Yankee Doodle Dandy* while picking up the Best Director award himself for *Casablanca*. He was one of the finest exponents of the classic Hollywood style, happy to work within the constraints of the studio system, always subordinating his own concerns and personality to the needs of the movie and the dream factory.

> ## 'Don't talk to me while I'm interrupting.'
> Michael **Curtiz**

FROM HUNGARY TO HOLLYWOOD

The actual facts of Curtiz's early years are fuzzy, mostly because of his tendency to tell tall tales to gullible interviewers, and at certain times the Curtiz biography has been embellished by blatant fabrications – that he had run away to join the circus and that he was a member of Hungary's 1912 Olympic hockey team, for example. The less colourful truth was that Curtiz, born Manó Kertész Kaminer on 24 December 1886, had a conventional middle-class, Jewish upbringing. He entered the Hungarian film industry as an actor in 1912 but quickly graduated to directing, honing his craft for six months at the Nordisk studio in Copenhagen. When the Hungarian film industry was nationalized in 1919 he sought sanctuary in Austria and Germany, making significant films such as the sumptuous epic *Sodom and Gomorrah* (1922) and *Moon of Israel* (1924).

It was the latter that caught the eye of Jack Warner, who brought the 38-year-old Curtiz to Hollywood in the mid 1920s to direct the similarly themed *Noah's Ark*. Over the next 25 years at Warner Bros he averaged four films a year and was renowned for his versatility – after the darkness of social drama *Mildred Pierce* (1945) Curtiz followed up with the Cole Porter biopic *Night and Day* (1946) and the nostalgic romance *Life With Father* (1947), all of which earned good reviews and did well at the box office.

Must-see Movies

Captain Blood (1935)

The Adventures of Robin Hood (1938)

Casablanca (1942)

Yankee Doodle Dandy (1942)

Mildred Pierce (1945)

In the 1930s and 1940s he made a run of adventure films with Errol Flynn, including *Captain Blood* (1935), *Dodge City* (1939) and *The Sea Hawk* (1940), but of all of them *The Adventures of Robin Hood* (1938) remains an everlasting classic. Curtiz took over direction from William Keighley and delivered cinema's best take on Sherwood Forest's dashing outlaw with Flynn shining in a role originally intended for James Cagney. The Technicolor visuals still dazzle, Erich Wolfgang Korngold's score still soars and the swordplay is still thrilling.

While as a filmmaker he didn't originate or challenge – rather he was a conservative director who eloquently spoke the language created by others – by the early 1940s his reputation was such that he demanded a salary of US$3,600 per week. But with the trappings came the tantrums, and Curtiz earned a reputation as a despot, brandishing a flywhisk at the slightest irritation. He was a stickler for realism, thinking little of nearly drowning thousands of extras on *Noah's Ark* or firing real spears at Errol Flynn, who subsequently wrote, 'Nothing delighted Curtiz more than real bloodshed.' Legend has it that he also pinched a baby to make it cry on cue for the camera.

Curtiz's faltering command of the English language probably contributed to the distance between director and crew. On the set of *Casablanca* he once demanded the crew supply a poodle instead of a puddle. While filming *The Charge of the Light Brigade* (1936) he commanded the crew to 'Bring on the empty horses!' as opposed to the riderless horses – a phrase that David Niven purloined for the title of his memoirs.

LEAVING WARNER BROS

Curtiz finally left Warner Bros in the early 1950s and, away from his spiritual home, his grip and consistency faltered. In 1954 he turned in the disappointing CinemaScope spectacle *The Egyptian* for 20th Century Fox and, moving to Paramount, his career declined with a row of second-string musicals, including *White Christmas* (1954) with Bing Crosby and *King Creole* (1958) with Elvis Presley. His final film, in 1961, was *The Comancheros*, starring John Wayne. He died the following year of cancer, aged 76. His inferior later work and the rise of the *auteur* theory, which champions directors with personal visions and styles in favour of talented craftsmen, tarnished Curtiz's reputation. But he remains one of the great journeyman filmmakers, able to transform the most formulaic material into something memorable and magical. It is a brand of alchemy that Hollywood could do with a lot more of today.

CASTING *CASABLANCA*

It is one of the great urban legends of Hollywood that Ronald Reagan was originally slated to play the role of Rick Blaine in *Casablanca*. The truth is that this story was planted by a studio publicist to keep the movie and Reagan in the papers. George Raft was also angling for the role, but producer Hal B. Wallis only ever seriously considered Bogart for the lead. Wallis did approach Hedy Lamarr and Michele Morgan but eventually chose Ingrid Bergman, partly because she was US$30,000 cheaper than Morgan.

Charlie
Chaplin

'The only genius developed
in motion pictures.'

George Bernard **Shaw**

1889–1977

Film folklore has it that Charlie Chaplin

once came third in a Charlie Chaplin lookalike contest. The anecdote, while probably apocryphal, speaks volumes about how sharply defined the Chaplin image was and that the persona belonged to the public as much as it belonged to the filmmaker. At the start of the 20th century, when cinema was in its infancy, Chaplin became its first globally recognized brand, popularizing and legitimizing the burgeoning medium. By 1916 his salary of US$10,000 a week made him the highest-paid actor in the world. The industry surrounding him – Chaplin dolls, dance crazes, songs and cocktails – was mind-boggling, and he counted such luminaries as George Bernard Shaw, Marcel Proust and Sigmund Freud among his admirers. No one did more to establish cinema on the cultural landscape than Charlie Chaplin.

However, Chaplin's skill as a filmmaker is debatable. He never really exploited the possibilities of the form to the full, using the camera simply to document the pantomime in his silent films and subsequently floundering in the talkie era. He is also often criticized for introducing a strain of sentimentality into American cinema from which, some argue, it has never recovered. But the fact remains: he elevated silent comedy from knockabout farce into something more engaging and emotional. He was also the first, and possibly last, person to control every aspect of the filmmaking process – starring in, writing, directing, producing, editing and scoring his own pictures – and so blazing a trail for every actor-writer-director that followed.

STREET LIFE

The depiction of street life that populates much of Chaplin's work has its roots in his impoverished childhood. He was born on 18 April 1889 in London, growing up in state-sponsored poorhouses, orphanages and on the streets after his father deserted the family when he was two years old. Both Chaplin's parents were entertainers, and as a child he began to work regularly in music hall, the British equivalent of vaudeville, touring with dance troupe the Flying Lancaster Lads and playing small roles in London's West End.

Must-see Movies

The Kid (1921)
The Gold Rush (1925)
City Lights (1931)
Modern Times (1936)
The Great Dictator (1940)

His big break came when, aged 17, he joined the successful Fred Karno Company, which toured both Britain and abroad. During his seven-year stint with Karno, Chaplin honed the athletic prowess, impeccable timing and endless invention that became his stock-in-trade, but, perhaps more importantly, Karno took Chaplin to America, where he was spotted by comedy impresario Mack Sennett. In 1913 he joined Sennett's Keystone Company. Following his inconsequential debut, *Making a Living*, Chaplin's second film,

Kid Auto Races in Venice (1914), introduced many key elements of his future success. Wearing baggy pants – borrowed from silent star Roscoe Fatty Arbuckle – oversized shoes, an ill-fitting jacket, a bowler hat, a cane and Sennett's fake moustache trimmed to toothbrush size, Chaplin established the iconic tramp figure that captured the world's imagination: a gentleman reimagined as the salt of the earth.

After 12 films lending support to established comics Chaplin took the reins of *Caught in the Rain* in 1914 and began writing, directing and starring in a run of movies, applying and refining the stagecraft he learned with Karno for film. After joining the Essanay Company in 1915 Chaplin began a meteoric rise in popularity, defining his persona – the small man with a big heart who ridicules and triumphs over pompous authority figures – in films such as *The Tramp* (1915). By now Chaplin could afford to be more discerning, making fewer films but with an increasing attention to detail and quality.

> 'All I need to make a comedy is a park, a policeman and a pretty girl.'
>
> Charlie **Chaplin**

The Rink (1916), *Easy Street*, *The Cure*, *The Immigrant* and *The Adventurer* (all from 1917) were brilliant exercises in physical comedy, but they also showcased Chaplin's desire to shift between pratfalls and pathos, humour and heartbreak. This approach reached its zenith with *The Kid*, his first full-length feature, in 1921. The story of Charlie raising an abandoned child pulled firmly on the public's heartstrings, and the result was a huge box-office success.

THE GOLD RUSH

He signed with the Mutual Film Corporation (1916–18) and First National (1918–23), but in 1919 Chaplin co-founded his own creative haven, United Artists, with director D.W. Griffith and actors Douglas Fairbanks and Mary Pickford. After directing *A Woman of Paris*, the only silent film of his in which he did not appear, Chaplin hit pay dirt in 1925 with *The Gold Rush*, in which he turns prospector looking for riches in Alaska. *The Gold Rush* is the perfect synthesis of comedy and emotion, and it features many of Chaplin's greatest routines, including the bread-roll dance, and a rare strand of darkness – a starving accomplice imagines Chaplin as a succulent chicken – all told with a tender poetry.

The Gold Rush was followed by *The Circus* (1928), for which he won an honorary Academy Award in 1927 – Chaplin never won a regular Oscar – then *City Lights* (1931), a charming picture in which Chaplin falls for a blind flower girl. Although it was made after the advent of sound Chaplin insisted that *City Lights* be made without dialogue, with sound effects and his own

THE LADIES AND THE TRAMP

As well as for political controversy Chaplin also courted attention for his personal life, in particular his penchant for younger brides. His first two wives – film extra Mildred Harris and aspiring actress Lita Grey – were both 16 when Chaplin married them in 1918 and 1924 respectively. Following a bitter divorce from Grey, Chaplin married his then co-star Paulette Goddard secretly at sea in 1933, although the marriage was not revealed until 1936 following the release of *Modern Times*. Chaplin finally settled down with his fourth marriage, to Oona O'Neill, daughter of playwright Eugene O'Neill, in 1943. Despite her father's disapproval – she was 18, and Chaplin was 54 – the pair remained together until his death in 1977.

THE CHAPLIN LEGACY

Chaplin is an enduring icon, and he has entered popular culture in countless ways. In 1992 Richard Attenborough made the heartfelt biopic *Chaplin* with Robert Downey Jr in the title role. Films as diverse as *La Strada, The Good, the Bad and the Ugly* and *Benny and Joon* – Johnny Depp replicating *The Gold Rush*'s bread-roll ballet – have all paid homage. Chaplin also made his mark outside film. During the 1950s he was a touchstone for the Beats, Jack Kerouac proclaiming that he went on the road because he wanted to be like Chaplin's hobo. From 1981 to 1987 IBM used the tramp figure to advertise and humanize its foray into personal computers. However, perhaps the most bizarre tribute comes from Spain, where a comedic form of bullfighting is known as *charlotada*, derived from the Spanish Charlot, or Charlie.

score, including the song 'Smile', his only concessions to the new innovation. *City Lights*, against all industry expectations, was a huge hit, and five years later Chaplin once again eschewed dialogue in *Modern Times*, a warning against the advances of mechanization that included some of Chaplin's most visually interesting and sustained comedy.

DARK TIMES

Chaplin resisted the technological advances of sound for 13 years, and when he finally embraced it the results lacked the consistency of his silent output. In *The Great Dictator* (1940) Chaplin played the dual role of a Jewish barber and fascist dictator Adenoid Hynkel in a pointed satire on Nazism. Five years later, in *Monsieur Verdoux*, based on an idea by Orson Welles, Chaplin assayed a sardonic mass murderer in a brilliant, if bitter, black comedy. *Limelight* (1952) was a kind of summation of Chaplin's work, with him playing a has-been entertainer nursing a starlet (Claire Bloom) to success. It is doused in self-pity but does feature Chaplin sharing the screen with his great rival Buster Keaton.

This shift in tone may well have been down to the tumult in Chaplin's personal life. Even though he had lived in the USA for 42 years Chaplin had never become an American citizen. This fact, coupled with the increasingly politicized and pacifist messages in his movies, meant that he had come under increasing scrutiny and pressure from the political right. In 1952 the FBI put together a 2,000-page dossier on him and subpoenaed him to appear in front of the House Un-American Activities Committee to discuss alleged communist affiliations. Chaplin refused to appear, and, after he had set sail for the London premiere of *Limelight*, Attorney-General James McGranery revoked his re-entry visa until he agreed to submit himself to a full inquiry.

Chaplin feared he had lost the adoration of the American public, and he refused to return, settling instead in Switzerland. He made two final films, *A King in New York* (1957) and *The Countess from Hong Kong* (1966), both unsuccessful. Aged 83, Chaplin finally set foot back on American soil in 1972 to accept his second honorary Oscar, receiving one of the loudest and longest standing ovations in Academy Awards history. He was knighted by Queen Elizabeth II in 1975, and he died from natural causes on Christmas Day 1977. Tributes poured in, perhaps the most touching being from Bob Hope: 'We were fortunate to live in his lifetime.'

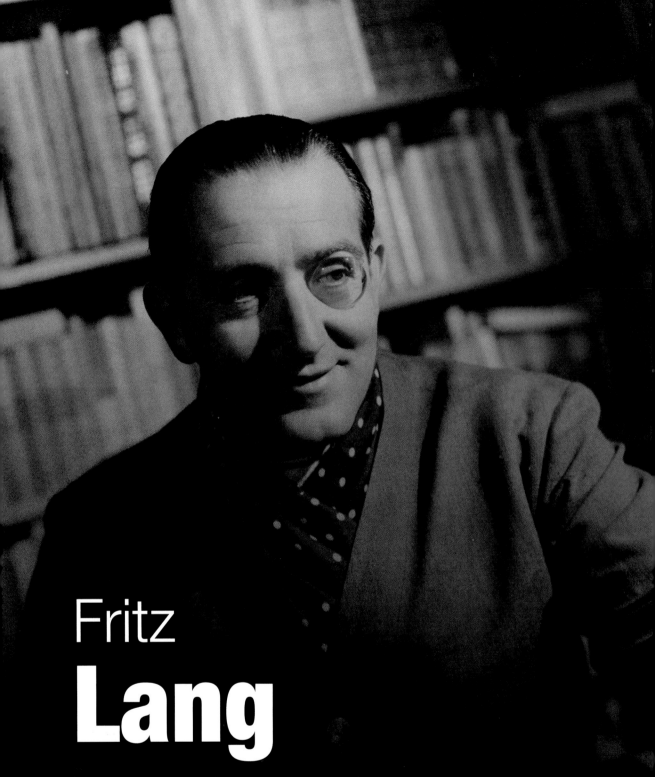

Fritz
Lang

'As a creator of nightmares,
Lang has few peers.'

Peter **Bogdanovich**

1890–1976

Fritz Lang created art out of darkness. He
was a colourful character, wearing a monocle purely for dramatic effect, and he once threw an actor down the stairs to help him look battered and bruised. But Lang's penchant for flamboyance didn't extend to his films. Whereas Hollywood was mostly concerned with creating soothing opiates, Lang dealt in the opposite. A leading light in the German expressionist movement, Lang specialized in grim allegories of crime, his world populated by criminals, psychopaths, prostitutes and maladjusted personalities. Whether he was working in Germany or the USA his obsessions remained constant – the allure of revenge, the fickle hand of fate, the destructive nature of passion. His characters live and breathe in the grey areas of morality, and Lang was never quick to make easy judgements.

Yet what set Lang apart was the astonishingly imaginative visual means he used to express and expose these damaged psyches. His work is dominated by arresting composition, breathtaking production design and, later, an innovative use of sound effects that raised the level to which cinema was able to lay bare a character's tortured soul. Unlike much pre-1960s cinema Lang's work does not date; his filmmaking techniques and character psychology remain sophisticated and fresh. Seven decades on, his cinema of unease can still creep under your skin – and stay there.

THE GERMAN YEARS

Lang's advanced sense of design was instilled in him at an early age. He was born on 5 December 1890 in Vienna. Lang's father was an architect, and the young Lang followed suit, attending Vienna's College of Technical Science from 1908 to 1911. After travelling the world as an artist and, during the First World War, fighting against both Russia and Romania, Lang turned to writing short stories and screenplays during extended periods of convalescence from war wounds. He was subsequently hired as writer in residence at Erich Pommler's Berlin-based production company Decla, but he soon found the written word was not enough to sate his storytelling impulses. In 1919 he made his directorial debut with *The Half Breed*, which concerns a man destroyed by his love for a woman. It was a theme that would captivate Lang for the rest of his career.

Following this Lang alternated between populist crime dramas – *The Spiders, Parts I and II* (1919 and 1920), *Dr Mabuse the Gambler* (1922) and *Spies* (1928) – and more personal efforts such as *Destiny* (1921), which represented his

Must-see Movies

Die Nibelungen (1924)

Metropolis (1927)

M (1931)

Fury (1936)

The Big Heat (1953)

twin desire to be both entertainer and artist. During this early phase of his career Lang began collaborating with Thea von Harbou, a writer and actress who became his wife in 1924 and worked on all their collaborations until their separation in 1934. She was a forceful figure, and her constant campaigning for her husband's career became notorious, leading Dorothy Parker to quip, 'There's a man who got where he is by the sweat of his frau.'

In 1924 Lang tackled *Die Nibelungen*, dividing the 13th-century saga into two parts. The first (*Siegfried*) included a fantastically realized dragon, and the second (*Kriemhild's Revenge*) concluded with a massive battle. These represented new highs in production design and special effects, and

GERMAN EXPRESSIONISM

Lang's emergence as a moviemaker coincided with the rise of expressionism as the dominant cinematic movement in Germany after the First World War. It was influenced by Dadaism, and it sought to reveal the inner experiences of – frequently insane – characters through use of overt stylization and metaphor. Often dealing with stories of crime, expressionist films are marked by the employment of obviously artificial lighting with deep shadows, distorted sets and disorientating camera angles. While the movement influenced Lang throughout his career *Destiny* (1921), in which Death grants a girl three chances to save her lover, is his most obvious full-blown entry in the expressionist style.

it seemed unlikely that Lang could top them. But he did. On a visit to the USA in 1924 to observe production techniques Lang, gazing at the Manhattan skyline, conceived what became *Metropolis* (1927), a visually stunning depiction of the future, in which the workers of a super-city rise up against the evil Master of Metropolis. Featuring gargantuan sets, a cast of thousands and spectacular fires and floods, the film took two years to make and was the most expensive German film to date, nearly bankrupting studio UFA. It remains an essential, influential work of science fiction, its imagery – the futuristic cityscape, the metal-handed mad scientist, the now-iconic sexy female robot played by Brigitte Helm – reappearing in practically every subsequent science-fiction film.

Initially he resisted the advent of sound, but Lang's first talkie in 1931 is his definitive masterpiece. Based on the real-life manhunt for a serial killer in Düsseldorf, *M* is the seminal chase-the-serial-killer movie, a brilliant mixture of realism and expressionism that creates a creepy character study of evil – it launched star Peter Lorre on to the world stage – and a portrait of a city doused in fear, torn between the need for order and the fear of mob rule.

'My private life has nothing to do with my films.'

Fritz **Lang**

In 1933 Lang followed *M* with *The Testament of Dr Mabuse*, a politically charged thriller depicting villainous characters espousing Nazi doctrine. Early that year the Nazis prohibited the film, and Lang was summoned to see propaganda minister Joseph Goebbels, who apologized for the ban and offered Lang the chance to direct and supervise Nazi film production. Nervous about his mother's half-Jewish ancestry and fearing a trap, he left behind his wealth, possessions and wife and caught the first train to Paris. Doubt has been cast over this – Lang's – version of events, as some sources suggest Lang departed with most of his money and returned to pick up his belongings. What is known for sure is that Lang divorced von Harbou that year, the latter going on to make films for the Third Reich.

THE HOLLYWOOD YEARS

After one picture in Paris, *Liliom* in 1934, Hollywood producer David O. Selznick brought Lang to Hollywood, signing him up with MGM for one movie only. His first American film, *Fury* (1936), starring Spencer Tracy as a man unjustly accused, was pure Lang, a vivid, relentless picture about lynch law. On the basis of *Fury*'s positive reception Selznick extended the émigré's contract.

Lang never felt comfortable within the dream factory, however, as he was often at odds with studio executives and felt friction from his crews. The result was that his American work never really attained the heights of his European period. He broadened his range from crime thrillers such as 1937's *You Only Live Once* to westerns – *The Return of Jesse James* (1940), *Western Union* (1941) and the bizarrely poetic *Rancho Notorious* (1952) – to noir melodramas – *The Woman in the Window* (1944) and *Scarlet Street* (1945) – and espionage thrillers including *Man Hunt* (1941) and *Ministry of Fear* (1944).

Lang's touchstones – the inexorability of fate and the corrosive nature of lust – ran though 1954's *Human Desire*, a remake of Jean Renoir's *La Bête humaine*. A year earlier, in 1953, Lang transposed his favourite storyline of an innocent man wrecked by revenge into an urban landscape with *The Big Heat*, starring Glenn Ford as a cop out to avenge the murder of his wife. It is brutal – its most famous scene has Lee Marvin throwing scalding-hot coffee into the face of Gloria Grahame – and uncomfortably stark, but Lang gave the viciousness a rainswept gloss and sheen. It is an astonishingly influential film, and it was the high point of his American work.

RETIREMENT AND RESURRECTION

Lang's Hollywood career continued to be inconsistent right to the end. In 1955 he tackled CinemaScope with seafaring adventure *Moonfleet*, but he dismissed the widescreen format pointing out it was 'only good for snakes and funerals'. Yet he followed this in 1956 with *While the City Sleeps*, a crime melodrama that proved to be among his own favourites. Following *Beyond Reasonable Doubt* that same year Lang lost the will to fight the studio system, and the movie proved to be his last American effort. A project set up in India stalled, and he returned to Germany, only managing two more projects: *Journey to the Lost City* in 1959 and *The 1,000 Eyes of Dr Mabuse*, made swiftly and on the cheap in 1960. Lang started to go blind during the production, and the film, brilliant and baffling in equal measures, was his last.

In retirement Lang returned to the USA, living out his final years planning projects that never came to fruition, buying primitive African art and becoming an icon for a younger generation of filmmakers: in 1963 Jean-Luc Godard cast the 73-year-old director as himself in *Contempt*, and critic-turned-filmmaker Peter Bogdanovich wrote the book *Fritz Lang in America* as an act of hero worship. Lang passed away with little fanfare on 2 August 1976, but his impact and influence can still be detected in the darker recesses of Scorsese or *The Sopranos* – if you have the nerve to look.

THE FATHER OF ROCKET SCIENCE

In 1929 Fritz Lang directed *Woman in the Moon* (*Die Frau im Mond*), the story of man's first rocket expedition to the moon. It proved to be remarkably prescient. Lang not only predicted the multistaged upright rocket, the correct trajectory around the moon and passenger weightlessness but also the backwards countdown that is still used by NASA today. In 1968 a US government space-science seminar welcomed Lang as an honoured guest, dubbing him the Father of Rocket Science.

John
Ford

'I love and respect the old
masters. By which I mean John Ford,
John Ford and John Ford.'
Orson **Welles**

1894–1973

John Ford grew up with American cinema and American cinema grew up with John Ford. Ford shaped America's view of itself, celebrating and examining the history that forged its identity, be it the Wild West – he transformed the low-regarded genre of the western into a truly American art form – the Irish-American experience or the Second World War. His concerns were coherent, his filmmaking elegant, lucid and strikingly beautiful but never calling attention to itself. As a man he was belligerent, bombastic and arrogant but none of these qualities infected his films.

Must-see Movies

Stagecoach (1939)
My Darling Clementine (1946)
She Wore a Yellow Ribbon (1949)
The Searchers (1956)
The Man Who Shot
 Liberty Valance (1962)

Ford made 112 movies in a 60-year career and was the first director to win back-to-back Best Director Oscars – in 1941 and 1942 – and he still holds the record for the most directorial Academy Award wins with four. He can also lay claim to being the most influential director, becoming a touchstone for each successive generation of moviemakers. Yet while he has many admirers – Orson Welles, Akira Kurosawa, Sergio Leone, Martin Scorsese and Steven Spielberg have all acknowledged their debt to him – he had few peers, creating a body of work that is beyond comparison.

FROM DANGER MAN TO DIRECTOR

John Martin Jack Feeney, the thirteenth and youngest child of Irish immigrant parents, was born in Cape Elizabeth, Maine, on 1 February 1894. He was encouraged by his brother Francis, a writer-director-actor at Universal, to enter the film business in 1913 as a set builder and prop man, occasionally acting as a stunt double for his brother, with whom he shared a remarkable resemblance, and infamously playing the Ku Klux Klan member in D.W. Griffith's *Birth of a Nation* who lifts up his hood.

He made his directorial debut in 1917 with the western *Straight Shooting* and went on to make 30 films for Universal – typically westerns starring Harry Carey – before moving to 20th Century Fox in 1920. He stayed at Fox for 20 years, winning his first Best Director Oscar in 1939 for *The Informer*, a drama about the betrayal of an IRA leader, which tapped into his Irish heritage. As the 1930s drew to a close Ford was such a power player in Hollywood that he had the clout to eject studio chief Sam Goldwyn from the sound stage after the mogul dared to offer him advice. In 1939 he returned to the western for the first time since *The Iron Horse* (1924) and made his first masterpiece. *Stagecoach*, based on a short story by French writer Guy de Maupassant, mixed action and adventure spills – Yakima Canutt's stunt work is still without parallel – with real literary merit, complex characterization and unforgettable images. It was Ford's first step on a trail that would lead him to define an entire genre.

THE WESTERNS

Although only a third of his movies are actually westerns, John Ford will forever be associated with the genre. At the time he was born the Wild West was still a reality for many – he actually met Doc Holliday – although it was fading as a way of life, but this afforded his frontier yarns depth, sensitivity and a sense of kinship. He commits to the values of his characters – the importance of church, the sanctity of family and a respect for the land – giving the films a unique aura of being both romantic and authentic.

> 'Directing is not a mystery; it's not an art. The main thing is: photograph the people's eyes.'
>
> John **Ford**

Stagecoach and *My Darling Clementine* (1946), Ford's classic retelling of the gunfight at the OK Corral, are object lessons in mythmaking, while later westerns such as *The Searchers* (1956), *Two Rode Together* (1961) and *The Man Who Shot Liberty Valance* (1962) expose the darker underbelly of those myths, the contradictions of trying to settle in the old west. The films are marked by the dynamic between the rugged individualism of his frontiersman heroes contrasting with the encroaching, containing effects of civilization – *My Darling Clementine*'s dance sequence in an unfinished church is redolent of the garden versus wilderness dichotomy that runs through his work.

As much as the films are about the allure of the community and the force of the group, so Ford surrounded himself with his own fraternity of collaborators, notably screenwriters Dudley Nichols and Frank S. Nugent and cinematographer Winston Hoch. He also regularly worked the same actors – John Wayne, Henry Fonda, Harry Carey, John Carradine, Ward Bond, Jane Darwell, Ben Johnson, Victor McLaglen, Mae Marsh, Woody Strode – to such an extent that the group was informally called the John Ford Stock Company.

His sense of composition, inspired by the western paintings of Frederic Remington, has a classic pictorial strength, often juxtaposing masses of people dwarfed by their natural surroundings and no other filmmaker has made the movement and sweep of riders on horseback look so spectacular. He pioneered the use of on-location photography, and his favourite backdrop was the breathtaking Monument Valley on the Arizona–Utah line. Ford made eight movies there, and it is now affectionately known in Hollywood as Ford's Country.

A PERFECT PARTNERSHIP

The collaboration between John Ford and John Wayne spanned 24 films in 36 years and is one of cinema's great actor–director partnerships. The pair first met in 1928 when Wayne, then a bit-part actor going under the pseudonym Duke Morrison, started working for Ford in small roles. Wayne had played the hero in 80 B-grade westerns but had been unable to get out of this rut until Ford cast him as the Ringo Kid in *Stagecoach*, which became a turning point in both their careers. After seeing Wayne in Howard Hawks's *Red River* (1948), Ford declared, 'I never knew the big son of a bitch could act', and proceeded to cast Wayne in more complex roles. Still, the pair had a prickly relationship on set, Ford regularly calling Wayne a 'big idiot'; actor Henry Brandon once said that Ford was the 'only man who could make John Wayne cry'.

THE SEARCHERS

For many critics *The Searchers* is the greatest western ever made. An astonishing John Wayne stars as Ethan Edwards, a man obsessed with finding the Comanche who killed his brother and abducted his niece Debbie (Natalie Wood) who has, in Ethan's eyes, gone native. In *The Searchers* Ford delivers fantastic vistas, great action sequences and poetic dialogue – Ethan's catchphrase 'That'll be the day' became a Buddy Holly song title. The movie is also a riveting, emotional meditation on revenge and racism. Ethan's five-year quest is as much an interior journey as it is an outward adventure. The final shot of Ethan, framed by a doorway, walking away from the homestead, is truly iconic.

THE OTHER MASTERPIECES

To take Ford's infamous maxim 'My name's John Ford, I make westerns' at face value is to leave much great work unacknowledged. Over the years he ploughed numerous furrows, making comedies – with top comedy star Will Rogers – historical dramas, including *Mary of Scotland* (1936) and *Young Mr Lincoln* (1939), and war films such as *They Were Expendable* (1945).

Astonishingly, none of Ford's four Best Director Oscars was for a western. After his win for *The Informer* Ford next triumphed in 1941 with his adaptation of John Steinbeck's *The Grapes of Wrath*, starring Henry Fonda and beautifully photographed by legendary cinematographer Gregg Toland. This tale of the flight of the Joad family from the dustbowls of Oklahoma to the promised land of California during the depths of the Depression is at once a telling indictment of capitalism and a moving tribute to human fortitude.

Ford won his third Academy Award the following year with *How Green Was My Valley*, a domestic drama set in a Welsh mining community played, bizarrely, by an Irish-American cast. In 1951 he picked up his final award for *The Quiet Man*, the story of an American (John Wayne) who starts a new life in rural Ireland, and which features the biggest barroom brawl in movie history. Ford didn't attend the ceremony, quipping that he was 'suddenly taken drunk'.

But these were not Ford's only Oscar triumphs. In 1940 he was appointed Chief of the Field Photographic Branch of the Office of Strategic Service, and his remit included making propaganda documentaries. Consequently he was present at the D-Day landings on Omaha Beach and won Oscars in 1942 for *The Battle of Midway*, where he was injured, and again the following year for *December 7th*. After the war Ford was promoted to rear-admiral in the US Navy Reserve. He was a proud military man and had been annoyed by John Wayne's refusal to enlist, so when it came to adding the credits for his wartime drama *They Were Expendable* Ford listed every actor's military rank and branch of service, but with no such credentials to go beside Wayne's name it was the most public of humiliations.

This was just the tip of Ford's prickly personality, an image enhanced by his eye patch, which was necessary because he pulled the bandages off too soon after a cataract operation. He once punched Henry Fonda during the filming of *Mister Roberts* (1955), a film that saw him replaced by Mervyn LeRoy after Ford ruptured his gall bladder. He also hated explaining his work and wasn't above embarrassing interviewers. When a young Jean-Luc Godard, then a journalist for French film magazine *Cahiers du cinéma*, asked him what brought him to Hollywood, he caustically replied, 'A train.'

He was plagued in later life by failing health and a broken hip, dying of cancer on 31 August 1973. His tombstone reads: 'Admiral John Ford'. His last film was the flop *7 Women* in 1966 about female missionaries held hostage in China, but his penultimate film, *Cheyenne Autumn* (1964), shot in his beloved Monument Valley, feels a more fitting finale to an epic career.

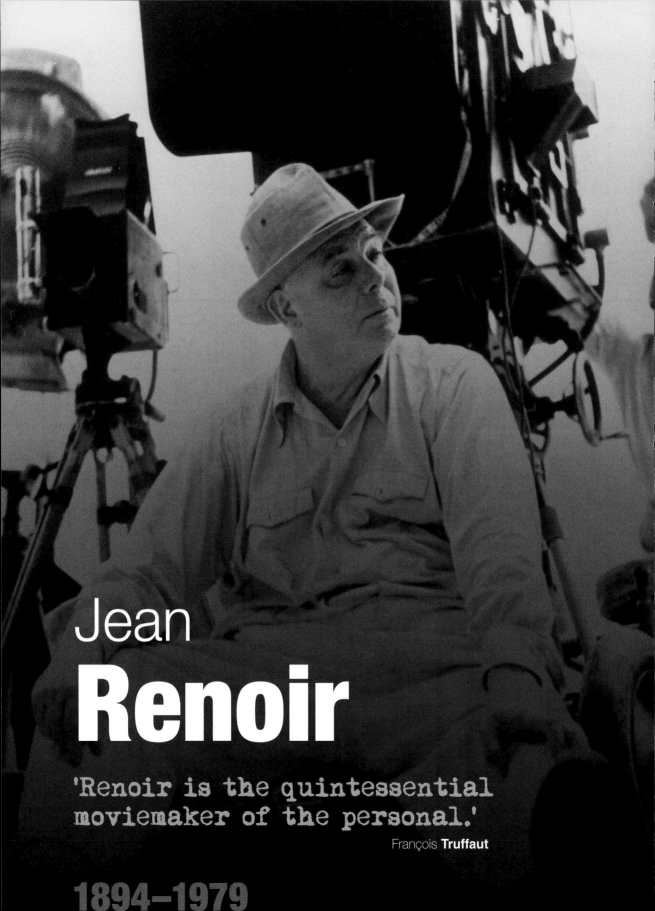

Jean
Renoir

'Renoir is the quintessential
moviemaker of the personal.'

François **Truffaut**

1894–1979

'Jean Renoir: the greatest of all directors,'

wrote fellow filmmaker Orson Welles in an article for the *Los Angeles Times* marking Renoir's death on 12 February 1979. He was a giant of world cinema, debatably Europe's most influential director, and Renoir had it all: cinematic widths, intellectual heights and, most of all, depths of generous, all-encompassing humanism.

Renoir often said that he spent his whole life making one film. The prosaic truth is he made 21 films on three different continents – Europe, America, India – over a period of 60 years. His directorial style is artful, organic and full of flair, marked by fluid and complicated staging captured in long takes and deep planes of focus. His camera explores sensual worlds often confounded and constrained by societal mores and conventions. His best work is consumed by ideas of social conscience and injustice, but his films never feel like polemics. He was blessed with a real feel for his people and their predicaments. During his masterpiece *La Règle du jeu* (*The Rules of the Game*, 1939) one of the characters, played by Renoir himself, says, 'Everybody has their reasons.' There is an enticing openness and wisdom about the statement, a compassion that is entirely, uniquely Renoir.

Must-see Movies

Boudu Saved from Drowning (1932)
The Crime of Monsieur Lange (1936)
La Grande illusion (1937)
La Bête humaine (1938)
La Règle du jeu (1939)

SOCIAL CONSCIENCE FILMMAKING

He was the second son of legendary impressionist painter Pierre-Auguste Renoir, and the young Jean was raised in a robust artistic atmosphere peopled by a constant flow of painters and writers. Initially he had planned to work in ceramics, but a prolonged period of convalescence from injuries sustained during the First World War saw Renoir fall under the spell of cinema, particularly the work of Charlie Chaplin and Erich von Stroheim. After his father died in August 1919 Renoir fell for and married Pierre-Auguste's model Andrée Heuchling, and, using money from his father's inheritance, he formed a film production company to launch her acting career under the pseudonym Catherine Hessling.

Renoir's erratic silent career ran to eight films and is perhaps most generously described as a test bed for the masterpieces that followed in the 1930s. The first of these, *La Chienne* (1932), painted a vivid, realistic portrait of Montmartre life. *Boudu Saved from Drowning*, from the same year, began a series of films marked by their social conscience. It is the story of a smelly, loutish tramp (Michel Simon), who, after being rescued from the Seine by a middle-class man, repays the kindness by forcing himself on his saviour's family. *Boudu* remains a masterclass in fast farce and smart satire.

Renoir continued to display his growing social awareness in *Toni* (1935) and *The Crime of Monsieur Lange* (1936), an ironic black comedy extolling the virtues of working-class solidarity as exploited workers take over a publishing house and murder the crooked boss (René

Lefèvre). The film is beautifully acted and is also renowned for a famous 360-degree pan covering Lefèvre's death scene. Renoir, looking for a change of pace, completed the glowing pastoral comedy *Partie de campagne* (*A Day in the Country*) and the atmospheric Gorky adaptation *The Lower Depths* (both 1936), which built on two great performances by Jean Gabin and Louis Jouvet. But the best was still to come.

MASTERPIECES

In 1937 Renoir made *La Grande illusion* (*Grand Illusion*), the film that announced his arrival on the world cinema stage, and it was the first foreign-language film to be nominated for a Best Picture Oscar. It stars Jean Gabin and Renoir's hero Erich von Stroheim and is a perfectly poised, artfully restrained meditation on patriotism and class as two French officers, one an aristocrat, the other a mechanic, move in and out of various prisoner-of-war camps during the First World War. It is a persuasive anti-war movie, although it does not contain a single scene of battle. Launched on the eve of the Second World War, it was dubbed 'Cinematographic Enemy Number 1' by Nazi propaganda chief Joseph Goebbels.

Renoir followed this in 1938 with *La Marseille*, a lacklustre chronicle of the French Revolution, but regained his stride with *La Bête humaine* (*Human Beast*) later that same year, an adaptation of French writer Emile Zola's thriller. Jean Gabin stars as a train driver who gets involved with a young woman (Simone Signoret) and plots the murder of her husband. Renoir imbues the potentially trashy material with psychological depth, tangible atmosphere – belching smoke, glistening rail tracks – and a sense of tragic poetry amid the pulp. Fritz Lang remade it later as *Human Desire* with Glenn Ford and Gloria Grahame.

'I am a citizen of the world of film.'

Jean **Renoir**

Renoir's next project proved to be his magnum opus. *La Règle du jeu (1931)* is a passionate examination of the French class system, in particular the hypocrisy and fragilities of the bourgeoisie, and it is the filmmaker's undisputed masterpiece. The Count and Countess la Chesnaye, played by Marcel Dallo and Nora Gregor, throw a lavish weekend party, and Renoir knits together numerous stories and telling moments involving upper-class guests and working-class servants into a rich multilevelled whole. *La Règle du jeu* is brilliant both in its individual scenes – the aristocrats on a rabbit hunt, the after-dinner entertainment – and its broad, breathless ability to weave farce, melodrama, satire and tragedy seamlessly together. For all the commentary on class, however, Renoir's focus is human – the title refers as much to love as it does to society – and this makes it as affecting as it is profound.

GLOBETROTTING

After a brief foray to Rome and a spell in the French army's film service Renoir decamped to America, his safe passage provided by documentary filmmaker Robert Flaherty. In 1944

he married *La Règle du jeu* script girl Dido Freire – although his divorce in 1930 from Andrée Heuchling was never officially recognized in Europe, technically making him a bigamist – and became a US citizen.

Renoir's American period lasted six years, but the director never settled in his new homeland, finding himself at odds with the demands of the system and lost without his core collaborators. He made the minor works *Swamp Water* (1941) and *This Land Is Mine* (1943), before his best American film, *The Southerner* (1945) – a thoughtful, sincere drama about a sharecropper's fight against nature – that earned him his only Best Director nomination. Wrapping up his Hollywood career with *The Diary of a Chambermaid* (1946), for which he recreated Paris in a Los Angeles studio, and *The Woman on the Beach* (1947), an intense, melodramatic film noir, the dejected Renoir left America, describing his time there as 'seven years of unrealized works and unrealized hopes and seven years of deceptions'.

Yet, rather than return to Europe immediately, Renoir went to India, and in 1951 made *The River*, his first colour film, beautifully shot by his nephew Claude. It was based on English writer Rumer Godden's autobiographical novel about three women hankering after an embittered American pilot who felt nature was a life force and source of eternal beauty. It is teeming with local colour and customs, and it has the feel of a particularly poetic travelogue. *The River* remains incredibly influential, and Wes Anderson's 2007 movie *The Darjeeling Limited* owes it a huge debt.

Renoir returned to France in the 1950s but never really regained the free-flowing flair of his previous French outings. *The Golden Coach* (*La Carrosse d'or*) in 1954 and *French Can-Can* in 1955 told colourful stories about French theatrical life but lacked the cinematic brio of his 1930s work. Over the next 25 years he only completed five more films, ranging from such conventional efforts as *Elena and Her Men* (1956), starring Ingrid Bergman, to the frankly bizarre, including *The Testament of Dr Cordelier* (1959) which revisited the Jekyll and Hyde story. For *Cordelier* he used uninterrupted takes with multiple cameras that allowed the actors to inhabit a scene rather than play to the camera.

The gaps between Renoir's films grew longer. He wrote a loving tribute to his father, *Renoir, My Father*, published in 1962, and a 1966 novel, *The Notebooks of Captain Georges*. In 1968 he made his final film, *Le Petit théâtre de Jean Renoir*, a witty portmanteau film originally made for television that told four different stories in four different styles. In time he found it increasingly difficult to secure financing for new projects and his health began to deteriorate. He spent his final years writing his memoirs and receiving friends and well-wishers in his Beverly Hills home.

THE REBIRTH OF *LA RÈGLE DU JEU*

La Règle du jeu, perhaps because it was too close to the bone, was a huge failure on its 1939 release, being booed at its Paris premiere and eventually withdrawn from its initial run after such a disastrous opening. Renoir drastically recut the film – most of the sequences featuring his own character Octavia were lost – but the film still remained unpopular when re-released after the Second World War. It was not restored to its original 110-minute running time until 1959 when it was premiered to huge acclaim at the Venice Film Festival. It has been a regular feature in most critics' greatest-films-ever-made lists since.

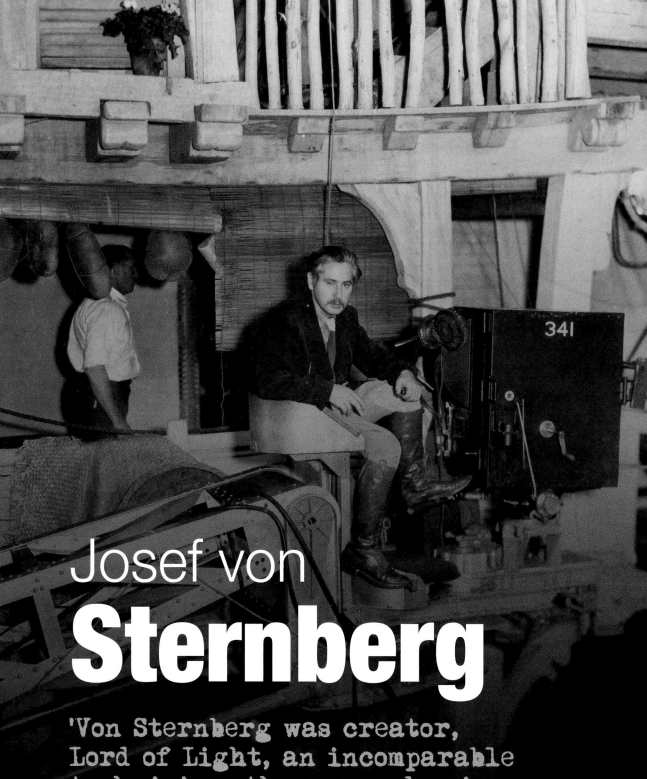

Josef von
Sternberg

'Von Sternberg was creator,
Lord of Light, an incomparable
technician, the commander-in-
chief of the film world.'

Marlene **Dietrich**

1894–1969

Truculent, enigmatic, unorthodox, visionary

– Josef von Sternberg represents everything that's great about the Hollywood maverick director. Although he is best known for discovering Marlene Dietrich in a series of memorable masterpieces, Sternberg's real contribution to cinema is as the consummate film artist. By using the camera like a painter uses a brush he was the first Hollywood filmmaker to emphasize atmosphere and lighting over plot, the meaning and drama often carried by the visuals rather than the flimsy stories he frequently spun. As cinema became obsessed with narrative he remained the high priest of cinematic style.

Josef von Sternberg was born Jonas Stern into a poor, Orthodox Jewish family in Vienna on 29 May 1894, the *faux* aristocratic 'von' added later by an unknown Hollywood producer to make him sound more impressive on the cinema marquee. He was educated variously in Vienna and New York and entered the movie business in 1911, working in menial jobs for the World Film Company in New Jersey before settling in Hollywood in 1924.

THE MASTER OF MOOD

After *The Salvation Hunters* (1925), his visually impressive debut shot on the docks of San Pedro Bay with semi-professional actors and a limited budget, Sternberg joined Paramount in 1926 as an assistant director. Having impressed the studio by salvaging films unfinished by other directors he was assigned to direct *Underworld* (1927), one of Hollywood's first gangster flicks.

Films such as *The Last Command*, which was his first collaboration with favoured actor Emil Jannings, and *The Docks of New York* (both 1928) as well as *The Case of Lena Smith* the following year accelerated his reputation as a skilled creator of mood pieces. Sternberg returned to the crime milieu of *Underworld* with his first talkie, *Thunderbolt*, in 1929, which starred George Bancroft as an imprisoned gangster plotting to kill his moll's lover, who is incarcerated in the same jail. Sternberg embraced the new medium, proving as inventive with sound as he was with his camera.

> 'I care nothing about the story, only how it is photographed and presented.'
>
> Josef von **Sternberg**

FINDING A MUSE

In 1930 Sternberg travelled to Germany to direct Emil Jannings in *The Blue Angel* (*Der Blaue Engel*), a co-production between Paramount and German studio UFA. The plot concerns an ageing professor (Jannings) who is destroyed by his infatuation with Lola Lola, headline act at a local strip club. In his hunt for an actress who could inhabit the role of the mysterious vamp Sternberg spotted a German singer and actress, Marlene Dietrich, on the Berlin stage. Dietrich, a veteran of 20 minor German films, sporting a top hat and stockings, perched on a bar stool, singing 'Falling in Love Again', created an everlasting movie icon. The film became an instant classic of screen erotica, Germany's first important sound film and a huge international success.

After the success of *The Blue Angel*, Dietrich left her husband and child to join Sternberg in Hollywood and what followed is one of cinema's greatest actress–director partnerships. Paramount sought to market her as the German equivalent to MGM's Swedish star Greta Garbo, and Sternberg directed her in six more films between 1930 and 1935: *Morocco, Dishonored, Shanghai Express* (which earned him a Best Director Oscar nomination), *Blonde Venus, The Scarlet Empress* and *The Devil Is a Woman*.

Over the course of these films, filled with a fascination with sensuality and a schoolboy sense of adventure, Sternberg controlled and shaped Dietrich's personality on and off screen, demanding the neophyte actress lose weight and undergo intensive coaching on how to use her body language. He dressed her in feathers and sequins, a tuxedo, a gorilla suit (*Blonde Venus*) and stunning gowns, but however he styled her he instinctively knew how to light her best.

Must-see Movies

The Blue Angel (1930)
Morocco (1930)
The Shanghai Express (1932)
The Scarlet Empress (1934)
The Devil Is a Woman (1935)

LIFE AFTER DIETRICH

For all the praise and plaudits heaped upon the Sternberg–Dietrich partnership their films failed to find an audience, and when Paramount dissolved its relationship with the director the partnership collapsed. What followed was a run of uninspired work: an adaptation of *Crime and Punishment* (1935), the operetta *The King Steps Out* (1936) and mediocre crime drama in 1939, *Sergeant Madden*. Only *The Shanghai Gesture* (1941) comes close to the creativity he reached during his Dietrich period. The story is told with rich detail, big close-ups and stylized dialogue and stars a stunning Gene Tierney as a spoiled rich girl who is seduced by the dangers of a Shanghai casino.

During the 1950s he made two films for producer Howard Hughes, *Macao* (1952) and *Jet Pilot* (1957), but only *The Saga of Anatahan* (1953), the last film he worked on, and which he shot in Japan at his own expense, is of lasting note. *Anatahan* was a recreation of an actual incident involving a group of Japanese soldiers who continued to fight the war seven years after it had ended. The film recouped its costs in Japan but was a disaster in America, despite Sternberg shooting nude scenes to be spliced into the prints.

In the mid 1950s Sternberg retired from directing, instead spending his time visiting film festivals and lecturing around the world. His death of a heart attack in 1969, aged 75, marked the end of an era. He was the last of the great volatile, tyrannical directors who often sported jackboots and a turban: actor William Powell had a clause inserted into his contract stating he would never have to work with Sternberg. He reinforced his supreme talent with stubbornness and arrogance: 'The only way to succeed,' he once claimed, 'is to make people hate you.'

THE STYLE OF STERNBERG

Sternberg was a highly skilled technician – and the only director of his day to belong to the American Society of Cinematographers – and he used this knowledge to create a personal signature. Some of his trademark techniques included using fog or smoke between the camera and the subject to diffuse the lighting, placing nets or veils over the lens to soften the image and scrims (translucent screens) over the lights to create delicate interplays between light and dark.

Howard
Hawks

'If one does not love the films
of Howard Hawks, one cannot
love cinema.'

Eric **Rohmer**

1896–1977

Howard Hawks was a consummate craftsman,

hopping from genre to genre but mastering each discipline, turning out great movies of all hues, including screwball comedies (*Bringing Up Baby*, *His Girl Friday*), musicals (*Gentlemen Prefer Blondes*), gangster films (*Scarface*), private-eye thrillers (*The Big Sleep*), westerns (*Red River*, *Rio Bravo*), action adventures (*Only Angels Have Wings*) and war films (*The Dawn Patrol*). No other filmmaker in Hollywood history can match him for consistency in diversity.

For a long time Hawks was ignored by the film industry, never winning an Oscar during his career and only picking up an honorary award in 1974, four years after his last film. He was not an originator like Griffith, a titan like DeMille, a personality like Chaplin or a poet like John Ford, and contemporary critics judged his career as too haphazard, too unshowy and perhaps too blissfully entertaining to be worthy of serious evaluation. But, inspired by interest from the French *Cahiers du cinéma* critics, the director's work was re-evaluated in the 1970s, and the critical consensus shifted from Hawks as a workmanlike Hollywood hack to a major artist whose approach and worldview was coherent enough to earn the adjective Hawksian.

> **'A good movie is three good scenes and no bad ones.'**
>
> Howard **Hawks**

Such is the intellectual apparatus that surrounds Hawks's work that it is easy to forget that his films are among the most enjoyable experiences that over a century of cinema has produced, filled as they are with classic moments such as Marilyn Monroe's rendition of 'Diamonds Are a Girl's Best Friend' in *Gentleman Prefer Blondes* and memorable dialogue – Lauren Bacall's classic 'You know how to whistle, don't you, Steve? Just put your lips together and blow' from *To Have and Have Not* is a choice example. Hawks's films crackle with an immediacy and vitality that is still evident today, and, given his storytelling sophistication, his grown-up view of sexual politics and his forward-thinking working methods, he could easily be described as cinema's first modern director.

AN INDEPENDENT TALENT

Howard Winchester Hawks was born in Goshen, Indiana, on 30 May 1896, and he studied mechanical engineering at Cornell University before serving in the US Air Corps during the First World War. Throughout these years Hawks was a risk-taker, flying planes and racing cars professionally and designing a car that went on to win the Indianapolis 500. He entered the movie industry in 1918, working as a prop master at the Jesse L. Lasky Feature Play Company studios (soon to become Paramount) in Hollywood. Hawks subsequently worked as a cutter, assistant director, story editor and casting director, serving an apprenticeship that would inform his later command of the medium.

In 1922 he wrote and directed two self-financed shorts while writing screenplays and stories for Paramount. After Paramount refused to allow him to direct, Hawks pitched *The Road to Glory* to 20th Century Fox with the proviso that he be allowed to direct. The studio accepted, and Hawks started on a path that he followed throughout his whole career, never working for a single studio

Must-see Movies

Scarface (1932)
Bringing Up Baby (1938)
Only Angels Have Wings (1939)
His Girl Friday (1940)
The Big Sleep (1946)
Rio Bravo (1959)

on a long-term contract, instead remaining independent and selling his projects to every studio, which became a model for the way future writer-director-producers would operate.

During the 1920s Hawks directed eight silent movies, going on to establish himself in talkies with 1930's *The Dawn Patrol*, a First World War aviation drama which was the first of many movies that reflected his passion for flying and danger. He followed this up with *Scarface* (1932), which was bankrolled by Howard Hughes and was the movie that transformed him into a major director. Starring Paul Muni as Tony Camonte – a thinly veiled Al Capone – *Scarface* didn't imbue its central figure with motivations for his criminality, it just presented Camonte as a full-blown monster. It was astonishingly violent for its day, and it rattles by with terrific shootouts, psychotic mobsters and a shocking amorality that said crime is fun some 60 years before *Goodfellas* – no surprise then that the censors added the subtitle *Shame of the Nation* to soften its cackle and glee. It remained Hawks's favourite of his own films – and it was also a favourite of Capone's.

HAWKSIAN TRAITS

Everything Hawks did was in service of the story. Surrounding himself with great screenwriters – Ben Hecht, William Faulkner and Jules Furthman – his storytelling style was elegant, economical and compact, his framing, camera moves and cutting purely functional, never indulging in any showmanship that would hinder the narrative.

Hawks's heroes and heroines talk tersely and without sentiment, and along with Frank Capra he practically invented fast-paced overlapping dialogue. To mirror the urgency of the news world Hawks had the cast of *His Girl Friday* deliver the dialogue at 240 words per minute, some 130 words above average speech delivery. He encouraged his actors to improvise, which added to the energetic spontaneity of his films. He also created movie archetypes – by directing Humphrey Bogart in tough thrillers, John Wayne in westerns and Cary Grant in comedies Hawks defined and refined the onscreen personas of some of Hollywood's greats – as well as discovering a number of talents: Paul Muni, Lauren Bacall (whom Hawks spotted on the cover of *Harper's Bazaar*), Montgomery Clift, Carole Lombard and James Caan all got their breaks under Hawks's direction.

HAWKSIAN MOTIFS

Hawks liked to lace his stories with recurring character types and motifs. He would always introduce a spirited, independent woman into the hothouse macho environment of his action adventure movies, and she would have to undergo elaborate courtship rituals in order to prove herself as tough as the men. Classic Hawksian heroines include Jean Arthur in *Only Angels Have Wings*, Lauren Bacall in *To Have and Have Not* and Angie Dickinson in *Rio Bravo*. The lighting of cigarettes was a regular storytelling aid, the act often denoting the relationship between characters. Another visual trait was to motivate dramatic lighting by hanging kerosene or electric lamps in the frame.

MAN OF ACTION

Hawks's career split neatly down the middle between action adventures and madcap comedies, and critics often argue whether they represent two sides of the same coin. His adventure pictures – whether featuring the flying aces of *Only Angels Have Wings* (1939), the cattle drivers of *Red River* (1948) or the misfit cowboys of *Rio Bravo* (1959) – were all underpinned by a remarkable similarity of theme. His heroes are often a tight-knit group of professionals, often isolated from conventional society and governed by a strict personal code, who must accomplish an insurmountable task that would make ordinary men baulk. It is typical of Hawks's dramas that the groups are comprised of different physical types who bond spiritually. This could mean an older, tougher, hardened male and a softer, younger, prettier sidekick – John Wayne and Montgomery Clift in *Red River* – or the more disparate trios of *To Have and Have Not* and *Rio Bravo*, in both of which the groups are saddled with an alcoholic. For Hawks, those who can overcome the odds are often those who appear least likely to save the day.

HAWKS'S LEGACY

Hawks's influence casts a long shadow over the filmmakers who followed him. Director Peter Bogdanovich, who wrote a book about Hawks, essentially remade *Bringing Up Baby* with *What's Up, Doc?*, starring Ryan O'Neill and Barbra Streisand as Grant and Hepburn updated. John Carpenter revisited *Rio Bravo*'s siege scenario in an urban environment with *Assault on Precinct 13*, even editing the film under the pseudonym John T. Chance, John Wayne's character's name in Hawks's film. More recently Quentin Tarantino paid homage in *Pulp Fiction* – the diner where John Travolta and Uma Thurman do the twist is a carbon copy of the racing drivers' hang-out in *Red Line 7000*.

KING OF COMEDY

Hawks's comedies, however, are the complete inverse of his action dramas. In *Bringing Up Baby* (1938), *I Was a Male War Bride* (1949) and *Monkey Business* (1952) ineffectual men become the victims of women – Katharine Hepburn, Ann Sheridan and Ginger Rogers respectively in the three films here – who are dominant forces of nature. It is common for the Hawksian comedy hero, usually Cary Grant, to undergo humiliation after humiliation often in the form of role reversal: Grant in *Bringing Up Baby* is forced into a négligé for parts of the movie and cross-dresses completely in *I Was a Male War Bride*. Moreover, the comedies are located in a much more conventional milieu, governed by recognizable societal norms and rules rather than individualized personal codes.

As his career moved into the 1960s and 1970s Hawks never abandoned these career concerns. *Hatari* (1962), a jungle adventure movie, and *Red Line 7000* (1965), a motor racing drama, continued his obsession with professionals in hermetically sealed worlds. *El Dorado* (1966) essentially replayed *Rio Bravo* whereas *Man's Favourite Sport* (1964) revisited the skewed universe of Hawks's comedies. These movies are slower, more bloated, less brilliant versions of his earlier work, but they are still resolutely, indefatigably Hawks. He died on 26 December 1977, the day after Charlie Chaplin passed away.

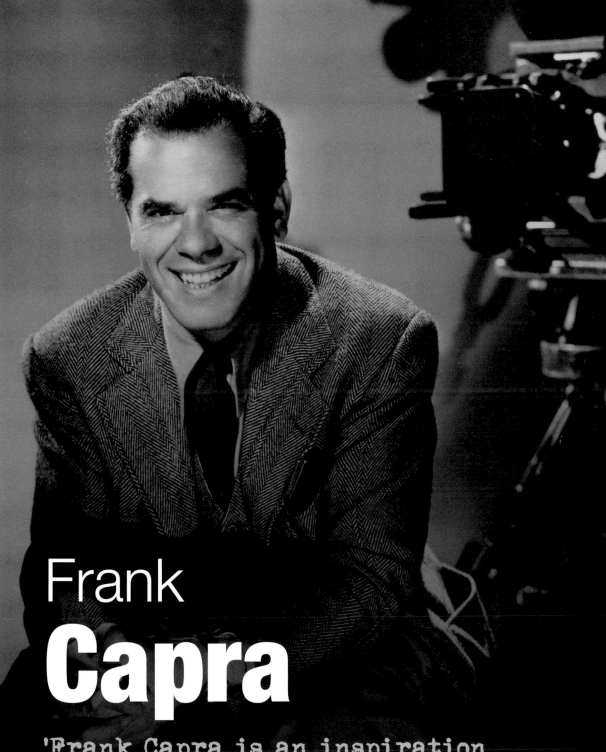

Frank
Capra

'Frank Capra is an inspiration
to those who believe in the
American Dream.'

John **Ford**

1897–1991

Frank Capra was the American Dream

personified. He was a Sicilian immigrant who played banjo in jazz honky-tonks, cheated at poker to make ends meet and rose to become America's most powerful director, and his films are informed by every step of that journey. His critical stock fluctuated wildly. During the 1930s he was Hollywood's golden boy, the first studio director to have his name above the title and winning three Oscars in five years. After the Second World War his sunny disposition seemed out of key with the prevailing audience mood, his naïvety, love of easy sentiment and cockeyed optimism derided as 'Capra-corn'. But his best-known works are timeless fables, every frame filled with love and respect for the struggles and aspirations of the common man.

Francesco Rosario Capra first entered the America he mythologized in 1903, aged six, when his family arrived from Sicily, eventually settling in California. After numerous odd jobs he double-talked his way into directing a one-reel adaptation of the Rudyard Kipling ballad *Fultah Fisher's Boarding House* (1922) for a small San Francisco film company, earning the grand total of US$75. He realized he needed a proper grounding in film, so he took a job in a film laboratory, processing and splicing rushes for Hollywood comedy producer Bob Eddy, who subsequently hired Capra as a prop man and editor.

Must-see Movies

It Happened One Night (1934)
Mr Deeds Goes to Town (1936)
Mr Smith Goes to Washington (1939)
It's a Wonderful Life (1946)

COMING TO COLUMBIA

After spells writing jokes for producers Hal Roach and Mack Sennett, Capra made his directorial debut, *For the Love of Mike* (1927), starring Claudette Colbert. His real breakthrough came in September of that year when he signed for Columbia Pictures under the aegis of studio boss Harry Cohn. Capra's early works for Columbia were unremarkable, but the signs of a style were emerging. *American Madness* (1932), a topical comedy about a failing bank, saw Capra eschew character entrances and exits, starting the action *media res* and having the actors overlap their dialogue. The result gave the movie a fresh urgency and set the scene for a series of comedies that made Capra the number-one director in America.

CAPRA-CORN

Capra's golden run started in 1934 with *It Happened One Night*, the story of an heiress (Colbert again) who, fleeing her father, falls in with an errant reporter (Clark Gable). Capra delivered brilliant romantic and comedic set pieces. It became the first film to win all five major Oscars, and although Capra may have made more so-called 'important' films few are so thoroughly entertaining.

Taking advantage of the creative autonomy this success gave him, Capra's next classic, *Mr Deeds Goes to Town* (1936), is perhaps the first true statement of his ideals. He took notions of

'There are no rules in filmmaking. Only sins. And the cardinal sin is dullness.'

Frank **Capra**

honesty, kindness, patriotism and populism and embedded them in stories of the common man battling against corruption. Gary Cooper plays Longfellow Deeds, the incorruptible small-town guy who inherits his uncle's business and travels to the big city to take over the family fortune. Cooper is terrific, embodying the uniquely Capraesque hero who is at once the common man yet also an individual. He also shines in Capra's next film, *Meet John Doe* (1941).

Another terrific interpreter of Capra, James Stewart, shines in the title role of *Mr Smith Goes to Washington* (1939), the artfully constructed tale of country hick Jefferson Smith who is ushered in to replace a dead senator by cynical politicians who believe that Smith will be easy to manipulate. The movie ends with Stewart's classic filibustering speech and is the greatest example of Capra's belief in the power of passionate discourse.

The summation of all these concerns is *It's a Wonderful Life* (1945), which was based on 'The Christmas Gift', a short story that the author and US Civil War historian Philip Van Doren Stern had sent to his friends as a Christmas card. Capra fashioned a tender, touching and uplifting fantasy about small-town do-gooder George Bailey (Stewart at his most heart-rending) who loses the will to live. However, it was a critical and commercial failure on its initial release, only becoming a perennial Christmas favourite after a lapse in copyright in the 1970s made it available for television companies to show cheaply. It remained Capra's favourite of all his work, and he showed it to his family every Christmas, without fail, until his death.

A MAN OUT OF TIME

Following the Second World War Capra was far less prolific, releasing just seven films after *It's a Wonderful Life*. The upbeat formula that succeeded in the gloom of the Depression didn't work for an audience jaded by conflict and more attuned to moral ambiguities, and his career went into serious decline. During the 1950s he busied himself making science documentaries for television. The last years of his career were spent revisiting former glories – two out of his last five films were remakes of previous movies, his final effort in 1961, *Pocketful of Miracles*, rehashing 1933's *Lady for a Day* to terrible reviews.

When he died of a heart attack in his sleep on 3 September 1991 his legacy remained intact. He had created feelgood entertainments before the phrase was invented, and his influence on culture – from Steven Spielberg to David Lynch, and from television soap operas to greeting-card sentiments – is simply too huge to calculate.

BREAKING THE MOULD

Despite Capra's image as a sultan of saccharine, the director did have different colours to his palette. In 1934 he directed *The Bitter Tea of General Yen*, a genuinely exotic oddity that delivered a sensual and disturbing view of clashing cultures. In 1937 he spent two years and US$3 million making *The Lost Horizon*, a literate, inventive fantasy adventure in which Robert Colman discovers Shangri-La in the Himalayas. *Arsenic and Old Lace* (1944) is the darkly hilarious flipside to Capra's frantic family comedies, with Cary Grant discovering that his two aunts poison aged gentleman callers with their homemade elderberry wine.

Sergei
Eisenstein

'Eisenstein was the great legitimizer, attaching cinema for the first time to the long line of Western cultural history.'

Peter **Greenaway**

1898–1948

Sergei Eisenstein was a Russian revolutionary.

To many he is the most important figure in the history of cinema. He was a filmmaker, theatre and opera director, graphic designer, teacher and theorist, but what is even more astonishing is that this lofty reputation is built on just seven features.

His innovations, particularly in the arena of editing, changed the way movies were made, and the ripples of his art are still being felt today. But, more important, Eisenstein's blistering work represented a conceptual shift, promoting cinema as a vehicle for ideas and change as well as emotion and storytelling, and he was one of the very few artists who accelerated and deepened the growth of the medium. Genius is an overused word in film, but in the case of Sergei Eisenstein it is entirely justified.

ART AND AGITPROP

Eisenstein came to movies via a circuitous route. Sergei Mikhailovich Eisenstein was born in Riga (now in Latvia) on 23 January 1898, and the child prodigy – he spoke four languages fluently aged ten – was raised in a bourgeois home. After fighting for the Red Army during the civil war that followed the Russian Revolution he gravitated to theatre, working as a set designer then director for the agitprop theatre company Prolekult.

Must-see Movies

Strike (1925)
The Battleship Potemkin (1925)
October (1927)
Alexander Nevsky (1938)
Ivan the Terrible, Part II (1946)

Eisenstein had been an avid cinemagoer since his teenage years, and he was a huge admirer of D.W. Griffith. He started to attend film workshops given by Soviet film pioneer Lev Kuleshov and experimented with editing, recutting Fritz Lang's *Dr Mabuse* and juxtaposing leftover fragments of film in attempts to create meaning. With this minimal experience Eisenstein embarked on his first feature, *Strike*, in 1924. It was intended to be the fifth episode of an eight-part epic – *Towards Dictatorship* – that would dramatize various incidents in the revolutionary struggle before 1917, but the full series failed to materialize, leaving *Strike* as an impressive standalone work.

Strike – which was conceived with the meticulous planning that would continue throughout his career – vividly documents the slaughter of striking workers by soldiers following the suicide of a sacked colleague. Time and again Eisenstein comes up with bold editing strategies and powerful visual metaphors – a factory boss uses a lemon squeezer just as the troops move in to quell the uprising; shots of the tsarist police massacre are compared with graphic images of a bull being slaughtered in an abattoir. These may seem like crass, clichéd comparisons now, but in 1925 no one had made such conceptual editing choices before. *Strike* also introduced another key tenet in Eisenstein's filmmaking philosophy. By casting members of the Prolekult Theatre he selected his cast not as individuals but as types representing the collective masses, a practice that became known as typage.

Critical reaction to *Strike* was divided. *Pravda* called it the 'first revolutionary creation of our cinema', but other critics decried it for formalism, a charge that would follow Eisenstein his whole career. Despite a muted audience reception Eisenstein was commissioned to make a film by the Central Committee to mark the failed revolution of 1905. Once again he envisaged an

eight-part epic, *The Year 1905*, that would cover all the events in that crucial year, but bad weather hindered his ability to meet the deadlines for the October Revolution anniversary celebrations. During filming in Odessa Eisenstein made up his mind to narrow his focus to one element. In that single decision cinema's most influential masterpiece was born.

THE BATTLESHIP POTEMKIN

The naval mutiny on the Battleship *Potemkin* covered only half a page in *The Year 1905*'s 105-page script, but Eisenstein decided that it could represent symbolically the entire insurrection. He shot it in ten weeks, using non-professional actors cast for their looks rather than acting ability, creating a masterpiece of bold storytelling, stylized compositions and rhythmic editing. The film's most celebrated sequence – the massacre of civilians by tsarist troops on the steps at Odessa – is a virtuoso catalogue of Eisenstein's ideas about editing, and it remains one of the most powerful sequences ever committed to film.

'Art is conflict.'
Sergei **Eisenstein**

Following a gala premiere at Moscow's Bolshoi Theatre the film was ignored by Russian audiences – it was deemed too highbrow and formalistic – but was a huge international success, putting Soviet cinema on the map and turning Eisenstein into a celebrity. The film had a poor initial run in America, although interest soared after top silent stars Mary Pickford and Douglas Fairbanks, on a promotional tour of the Soviet Union, pronounced it 'The greatest film ever made!'

After a month of shooting *The General Line*, a project designed to promote the collectivization of agriculture, Eisenstein was told to abandon the project and start on *October*, a commemoration of ten years of the 1917 revolution. Eisenstein was granted full co-operation of the authorities, Leningrad was placed at his disposal – including government buildings and the tsar's palace – and he was given permission to draw extras from any strata of society. He narrowed his focus to the events in Petrograd between February and October 1917, and he worked tirelessly, two units shooting simultaneously, to have his first cut ready on 7 November 1927. However, political events conspired to thwart him: Trotsky's expulsion from the Communist Party following Stalin's takeover meant that Eisenstein was ordered to recut the film at the last minute to minimize Trotsky's involvement and influence, with Stalin overseeing the changes personally. The delays meant that only a few reels were ready for the actual festivities, the final finished film emerging several months later.

In many respects, *October* exceeded *The Battleship Potemkin* in Eisenstein's explorations into the essence of cinema. While American movies had discovered sound, Eisenstein attempted to convey sound visually, suggesting the rat-a-tat of machine-gun fire by filming the flickering

THE ODESSA STEPS

The Odessa steps sequence in *The Battleship Potemkin* remains one of the most famous in all cinema. As the tsar's troops move down the steps, slaughtering all the civilians in their path, Eisenstein conjures up some powerful moments – most memorably the pram rolling down the stairs after the baby's mother has been mercilessly gunned down. So powerful is the scene that many believe it to have been based on a real historical event. In fact, Eisenstein invented it to demonize the imperialist regime. There have been many parodies, but the most famous is the train-station shootout in *The Untouchables*.

EISENSTEIN'S THEORIES OF MONTAGE

Whereas editing in Hollywood movies was meant to be invisible, always to be used in support of seamless storytelling, Eisenstein's notion of montage proposed something much more radical, in which two completely unrelated shots could be juxtaposed to create a new feeling or idea in the viewer. It is the contrast between the two images that moves the story forward in the mind of the audience. In creating this emotional response Eisenstein identified five types of montage: metric, rhythmic, tonal, overtonal and intellectual.

of the lens diaphragm and the quivering of crystal chandeliers. Unlike *Potemkin* these ideas were considered too radical by contemporary critics, but to modern audiences they give *October* a real vibrancy.

Eisenstein was wounded by the criticism, and he returned to *The General Line* and began to simplify his experimentation. For the first time he allowed an easily identifiable heroine – illiterate peasant Marfa Lapinka – to play a central role in the story. The film was finished in 1929 but was delayed for seven months after Stalin ordered changes to the closing scenes. Although the changes made it more palatable to the authorities they would not officially sanction it, leading to a title change from *The General Line* to *Old and New* to suggest it was not officially endorsed.

DISAPPOINTMENTS ABROAD

Because of his tussles with authorities and rejection by home audiences, Eisenstein started to visit countries where he was feted as a hero. He travelled in Europe, where he spent time on the set of Fritz Lang's *Metropolis*, and then moved on to America seemingly to investigate the new innovation of sound but actually to win a Hollywood contract. After a few tentative offers from United Artists and MGM Eisenstein finally signed with Paramount but found his tenure unsatisfying and frustrating. Following four months of failed promises and unmade projects – he was bitterly disappointed that his dream project, *An American Tragedy*, was given to Josef von Sternberg – Eisenstein and Paramount parted ways in October 1930, the studio underlining the point by buying him a one-way ticket home and announcing his departure date.

But Eisenstein didn't return home. Having been inspired by a meeting with documentary filmmaker Robert Flaherty he rekindled a dream about working in Mexico. The venture proved even more frustrating than his Hollywood experience. After being placed under arrest on arrival he roamed the countryside making a poetic travelogue, *Que viva Mexico*. He was shooting without a script, and the relationship between him and his American backer, leftist novelist Upton Sinclair, grew strained when Sinclair had seen no footage after 11 months of filming. In 1932 Sinclair pulled the plug on the project, leaving Eisenstein stranded, insolvent and with no access to his footage – which Sinclair later sold to be used in a low-grade thriller, *Thunder Over Mexico*.

After returning home Eisenstein was inconsolable. While he continued to try to get his *Thunder Over Mexico* footage back he was constantly attacked in the Soviet press for his long absence and his deviation from the dominant mode of socialist realism. He was out of favour and only offered projects that he would obviously turn down; all his own projects, such as a history of Moscow and a version of Karl Marx's *Das Kapital*, were rejected. However, he defied his detractors, and in 1935 started work on his first sound feature, *Behzin Meadow*. But illness delayed the shoot and production was halted in March 1937 by Soviet film boss Boris Shumyatsky. A special conference was set up to condemn the movie, and Eisenstein was forced to make a public confession and apology for his filmmaking transgressions. 'It was one of the most bitterly painful experiences in my creative life,' he later admitted.

SALVATION

Eisenstein's submission to the party line led to his next film, *Alexander Nevsky* (1938). As the threat from Nazi Germany grew, the Soviets needed a film to boost morale. Eisenstein found it in the story of a 13th-century prince who repelled German invaders – a blatant move to flatter Stalin. As an insurance policy against radical experimentation Eisenstein was assigned a cast and crew of Shumyasky's trusted collaborators. It was a departure from Eisenstein's theoretical filmmaking, and it remains his most purely entertaining film, full of pomp and pageantry, blood and thunder – a battle on cracking ice is remarkable – scope and splendour, aided by a brilliant score by Prokoviev. *Alexander Nevsky* was a huge success at home and abroad, and it restored Eisenstein's position as the Soviet Union's pre-eminent filmmaker, winning the Order of Lenin in February 1939. Interestingly enough the film was withdrawn from release when the USSR signed the German–Soviet Pact later that same year.

Following this triumph Eisenstein started work on *The Fergana Canal*, a celebration of the fertilization of deserts in Uzbekistan, but, like many of Eisenstein's projects, it was abandoned. After directing a Wagner opera on stage he began work on *Ivan the Terrible*, a three-part epic about Ivan IV, the tsar who first unified Russia in the 16th century. *Part I*, completed in 1944, was a huge success, winning the Stalin Prize and accelerating the production of *Part II*. But on the completion of editing Eisenstein suffered a major heart attack and was immediately hospitalized.

During his convalescence *Part II* was shown to Stalin, who despised it, and in September 1946 the Central Committee of the Communist Party publicly denounced Eisenstein, suggesting that Ivan had been depicted as being 'as weak and indecisive as Hamlet'. The movie was subsequently banned and didn't resurface until 1957. He had ditched the rapid-fire montage of his earlier works, instead drawing together grand opera, Japanese kabuki and Russian iconography into an absorbing drama, the one flash of fireworks coming with a crude colour sequence that was used to signify the psychological states of the characters rather than any aesthetic decoration.

Eisenstein ignored his doctor's orders and returned to work in September 1946 with a planned history of Moscow – as ever, his ambitious plans encompassed seven episodes, each one here corresponding to the colours of the rainbow – but the project never materialized. He had hoped to complete *Part III* of *Ivan the Terrible*, which Stalin had surprisingly agreed to, but his ailing health saw the film postponed time after time. He continued writing, theorizing and teaching – his writings collected over the years in *The Film Sense* (1942), *Film Form* (1949), *Notes of a Film Director* (1959) and *Film Essays With a Lecture* (1968) have all become indispensable texts for filmmakers and film students.

Eisenstein died of a heart attack on 11 February 1948, 19 days after his 50th birthday. He may have died under a cloud in his homeland, but he remains undoubtedly one of cinema's giants.

George
Cukor

'Cukor is one of my favourite
directors. He was a master at
directing women.'

Pedro **Almodóvar**

1889–1983

George Cukor had impeccable taste and one of the longest directorial careers in movie history, weathering the changes in public taste and the changing face of Hollywood by selecting his projects and actors with discretion and an unerring sense of timeless quality. He was raised in the theatre, but his string of comedies, melodramas and literary and theatrical adaptations don't feel like filmed stage plays, as his fluid camera work and skill at staging action were so silky and effective.

He is often perceived more as a polished entertainer than as an artist, but Cukor stamped his work with a critical yet affectionate look at humankind. He loved to explore the gap between illusion and reality, and his characters are often forced between cherished dreams and sober reality. Yet it is as a director of actors – especially women – that he has earned a place in film history.

FROM BROADWAY TO HOLLYWOOD

George Dewey Cukor became transfixed by the theatre at an early age. He was already acting as a teenager, and he worked as a stage manager before graduating to directing Broadway plays in his mid 20s. In 1929, when the advent of film sound saw a migration of talent from theatre to movies, Cukor moved to Hollywood and became a dialogue coach, working on Lewis Milestone's *All Quiet on the Western Front* (1930). Cukor subsequently co-directed three movies for Paramount, handling the acting and dialogue while experienced silent directors staged the action, before making his solo directorial debut with *Tarnished Lady* in 1931. It was prescient that his first film had him dealing with a formidable and difficult star – Tallulah Bankhead – as it would soon become his stock-in-trade.

> 'There is always some part of me left bloody on the scene I've just directed.'
>
> George **Cukor**

In 1932 he followed producer David O. Selznick to RKO where he helmed Katharine Hepburn's debut, *A Bill of Divorcement*, and comedy of manners *Dinner at Eight* before reuniting with Hepburn for a deft adaptation of Louisa May Alcott's classic novel *Little Women* in 1933. His partnership with Selznick came to an end after he was sacked ten days into the shooting of *Gone With the Wind* (1939), following constant creative disputes with his stubborn producer.

After Cukor was fired, stars Vivien Leigh and Olivia de Havilland continued to visit him at home for extracurricular coaching. 'He was my last hope of ever enjoying the picture,' Leigh later noted. Despite his being fired, all the scenes Cukor shot ended up in the finished film. He also undertook intermediate work as a director on *The Wizard of Oz* (1939) after original director Richard Thorpe was dismissed. Cukor's main input was to revamp the look of the main characters, suggesting Judy Garland remove her blonde wig. Coincidentally, both *Gone With the Wind* and *The Wizard of Oz* were taken over by Victor Fleming.

Must-see Movies

Camille (1937)
The Women (1939)
The Philadelphia Story (1940)
Adam's Rib (1949)
Born Yesterday (1950)
A Star Is Born (1954)

A FEMININE TOUCH

Perhaps the defining feature of Cukor's career is his skill at directing a vast array of female stars. He guided Greta Garbo to her greatest performance in *Camille* in 1936 – ironically, in 1941 he also directed *Two-Faced Woman*, the film that reputedly prompted her decision to retire.

Following *A Bill of Divorcement* Cukor directed Katharine Hepburn a further nine times, later cementing her onscreen relationship with Spencer Tracy in *Adam's Rib* (1949) and *Pat and Mike* (1952). But it was *The Philadelphia Story* (1940) that remains their greatest collaboration as well as Cukor's most joyously entertaining film. It is a sparkling, talk-driven comedy, the plot following Tracy Lord (Hepburn), who is the daughter of a wealthy Philadelphian family, ready to marry a dull executive but torn between her errant ex-husband (Cary Grant) and a cynical journalist (James Stewart). The Oscar-winning film is graced with great performances, a witty script and Cukor's sure hand. Although it was remade as the musical *High Society* with Bing Crosby, Frank Sinatra and Grace Kelly, the original can never be bettered. Cukor also brought the best out of comedienne Judy Holiday in the sparkling 1950 comedy *Born Yesterday*, which saw the neophyte actress beat Bette Davis and Joan Crawford to an Oscar.

In 1954 Cukor pulled an astonishing performance out of a troubled Judy Garland in *A Star Is Born*. Cukor had previously filmed the story of a destructive relationship between a musical star on the rise and her declining mentor in *What Price Hollywood?* (1932), but here he syringes it with savagery and unbridled emotion, built around stunning central turns from Garland and James Mason. It was cut to ribbons by Warner Bros just after its premiere, but it remains one of the landmarks of the genre, a rare musical that is as good in its dramatic interludes as it is during its songs.

Aged 77 and seemingly in the final throes of his career, Cukor directed the US–Soviet co-production *The Blue Bird* in 1976. He continued to make films until the very end including, in 1981, when he was 83 – and so possibly the oldest director ever of a major studio production – *Rich and Famous*, starring Jacqueline Bisset and Candice Bergen. He died on 24 January 1983, the day before he was due to see a restored version of *A Star Is Born*.

BLUNT TACTICS

For all his reputation as a director of subtlety and nuance Cukor wasn't averse to using shock strategies to realize his vision. When Maureen O'Sullivan couldn't produce tears for a big deathbed scene in *David Copperfield* Cukor simply twisted her feet until she did. When making *The Women* Cukor directed a cast that included three notoriously temperamental leading ladies: Joan Crawford, Norma Shearer and Rosalind Russell. It was traditional to call the biggest star to the set first, so to avoid bruising any egos Cukor would simply shout 'Ready, ladies!' and all three would immediately appear. When this ruse was rumbled he resorted to sending three underlings to knock on all three dressing-room doors at exactly the same time.

Alfred
Hitchcock

'That's what Hitchcock did. A shower.
A bird. All these things that are
absolutely ordinary, he made them
extraordinary.'

Janet **Leigh**

1899–1980

'The Master of Suspense' was a title that came to define the work and reputation of Alfred Hitchcock. But in many ways it is a reductive definition of his brilliance, as Hitchcock was master of many things, including memorable set pieces, cinematic technique, psychological complexity as well as shameless self-promotion. The only thing he couldn't do was bore an audience.

Hitchcock planned his films right down to the smallest detail, storyboarding his iconic shots and rarely deviating from the scripts. His famous and misquoted dictum, 'actors are cattle' – he actually said actors should be 'treated like cattle' – belies the fact that many of the Hollywood greats did their best work under his skilful guidance. During his lifetime he was considered a director of limited range, a mere entertainer uninterested in serious themes. But his real skill was in turning conventional, often far-fetched thrillers into treatises on emotional dysfunction, sexual paranoia and religious guilt. He was cinema's greatest manipulator, guiding the minds and nerves of audiences into uncomfortable places but doing so with such silky skill and technical virtuosity that audiences were happy to succumb to his miraculous sleight of hand.

> 'The only way to get rid of my fears is to make films about them.'
>
> Alfred **Hitchcock**

THE BIRTH OF A STYLE

The son of a poultry dealer and fruit-and-vegetable importer, Alfred Joseph Hitchcock was born into a strict Roman Catholic family in Leytonstone, London, on 13 August 1899. He started his career in the film industry as a titles designer for the British arm of the Jesse L. Lasky Feature Play Company. When the studio was taken over by Gainsborough, Hitchcock's services were retained, and he worked his way up the chain – from title designer to art director to assistant director – to direct his first picture, the Anglo-German co-production *The Pleasure Garden* in 1925.

However, Hitchcock himself considered his next film, *The Lodger* (US title *The Case of Jonathan Drew*, 1926), his first true effort as a director. This is the story of a man suspected of being Jack the Ripper, and the film established many of the traits and trademarks we now think of as Hitchcockian, especially the theme of an innocent accused of a crime he did not commit. *The Lodger* was also the first film to include a cameo appearance from the director. That same year he married film editor and script girl Alma Reville – who would later become a screenwriter and trusted sounding-board for Hitchcock's ideas – and the couple remained together until Hitchcock's death in 1980.

Hitchcock's next major film was *Blackmail* (1929), Britain's first talking picture. Once again this film introduced a number of notable Hitchcock firsts. For example, it concludes with a chase through London's British Museum; similar chases through famous landmarks and monuments would end many of his later thrillers. Perhaps more tellingly, however, actress Anny Ondra became the first in a succession of icy blonde heroines that later included Grace Kelly, Eva Marie Saint, Kim Novak and Tippi Hedren. Hitchcock commented that audiences were more suspicious of brunettes; he also thought that blondes photographed better in black and white.

Must-see Movies

The 39 Steps (1935)
Shadow of a Doubt (1943)
Rear Window (1954)
Vertigo (1957)
North by Northwest (1959)
Psycho (1960)

SUPREME SUSPENSE

In 1934 Hitchcock announced his arrival as the king of the thriller genre, putting together a five-year run of masterful suspense dramas that staked his claim as Britain's best film director. In 1934 he directed *The Man Who Knew Too Much*, starring Leslie Banks and Edna Best as a British couple who become embroiled in kidnapping, international intrigue and political assassination. The film underlined his fascination with the sinister lurking within the serene, an idea that delighted Hitchcock so much he remade a more accomplished Hollywood version in 1956 starring James Stewart and Doris Day.

The 39 Steps (1939), based on a John Buchan novel and starring Robert Donat as a man struggling to prove his innocence, was an even bigger commercial and critical hit. It is a film full of romance, comedy and tension that features top-secret plans and a chase running the length and breadth of Britain. These plans highlight a key feature in Hitchcock's work, the MacGuffin – his term for the element that propels the plot in motion but has no other intrinsic value. Hitchcock repeated that formula three years later with *The Lady Vanishes*, a brilliant comedy thriller with Michael Redgrave and Margaret Lockwood searching for a missing old woman (Dame May Whitty) on board a Balkan express train. Both *The 39 Steps* and *The Lady Vanishes* represent a key tenet in Hitchcock's brilliance: the ability to make the most ridiculous plots engaging.

DIAL H FOR HOLLYWOOD

The Lady Vanishes earned Hitchcock the New York Film Critics Best Film award, and Hollywood beckoned. After one last British effort, a disappointing adaptation of the Daphne du Maurier novel *Jamaica Inn* (1939), Hitchcock signed with producer David O. Selznick to direct pictures in Hollywood. His first American film, *Rebecca* (1940), was based on another du Maurier novel. As a psychological melodrama it deviated from the suspense genre that had forged his reputation, and *Rebecca* is sumptuous, suspenseful and romantic. Here Hitchcock puts Joan Fontaine through the emotional wringer as the second wife of an urbane aristocrat (Laurence Olivier) as she tries to compete with the memory of the eponymous first wife. It earned Hitchcock a Best Director Oscar nomination, and the film won the Best Picture award.

In starting from such lofty heights, the rest of the 1940s proved hit and miss for Hitchcock. In between such relatively minor, but still entertaining, works as *Foreign Correspondent* (1940), *Mr and Mrs Smith* (1941), *Suspicion* (1941), *Saboteur* (1942) and courtroom drama *The Paradine Case* (1948), Hitchcock delivered some cast-iron masterpieces. *Shadow of a Doubt* (1943) saw Hitchcock move his fascination with suspense away from plot-driven thrillers into a more psychological character study. Joseph Cotten delivers a brilliant performance as a suave, intelligent killer wanted for the murder of rich widows, who returns to the bosom of his family in a picture-perfect Californian small town. It is a chamber piece rather than a full-blown symphony, but the film was reputedly Hitchcock's personal favourite. He often built his films around technical exercises, challenging himself to see if he could be creative within limitations. This approach can be seen in his 1944 movie *Lifeboat*, a film made entirely on one set, and *Rope* (1948), which is a character study of two

student murderers constructed in a series of ten-minute takes. Later, in 1954, he experimented with 3D in *Dial M for Murder*, a film he only took on to satisfy his contract with Warner Bros but which was blessed with great performances from Ray Milland and Grace Kelly.

Hitchcock's other outstanding works from the 1940s both starred his beloved Ingrid Bergman. *Spellbound* (1945), a psychoanalytical thriller featuring Bergman as a psychiatrist, is notable for its famous dream sequence designed by Salvador Dalí. The following year Hitchcock made *Notorious*, Bergman paired this time with Cary Grant. On the surface it is a dazzling spy thriller built around the hunt for missing uranium, but underneath it is a portrait of a twisted sadomasochistic love affair between Bergman's playgirl and Grant's spy. It also boasts one of Hitchcock's most virtuoso shots as the camera swoops across a crowded party to a close-up of a key.

UNDISPUTED GREATNESS

The 1950s were Hitchcock's richest and most rewarding decade. *Strangers on a Train*, based on a Patricia Highsmith novel and adapted by Raymond Chandler, carefully orchestrates a brilliant premise – two strangers hatch a hypothetical plot to murder the *bêtes noires* in each other's lives – into a masterpiece of manipulation and character development. In 1954 Hitchcock returned to his technical gimmicks, once again attempting to make a film shot on one set from a single viewpoint as he had with *Lifeboat*. His elegant solution to the challenge was *Rear Window*, the story of a laid-up professional photographer (James Stewart) who believes he witnesses a murder through his telephoto lens in the apartment opposite. It is cinema's greatest meditation on the nature of voyeurism and its relationship to film, and in it Hitchcock brilliantly mixes unbearable tension with the sexy repartee between Stewart and his high-class girlfriend Grace Kelly.

By this time Hitchcock had collected around him a group of core collaborators – editor George Tomassini, cinematographer Robert Burks, title designer Saul Bass and composer Bernard Herrmann. This core group worked at the height of their powers on *Vertigo* (1957), a film that proved to be Hitchcock's darkest, most personal work. James Stewart stars as a retired detective who falls for the woman (Kim Novak) he is hired to investigate, but he can't prevent her death. Months later he spots someone (Novak again) who bears an uncanny resemblance to the dead woman, and he is drawn into a mire of subordination, control and deceit. This is a complex, dense work, and Hitchcock takes this arbitrary plot and turns it into something profound, a painful meditation on romantic suffering and a sardonic self-portrait exposing his desire to control and make women over.

The 1950s weren't all so heavy. Hitchcock supplied breezier entertainment in classy crime caper *To Catch a Thief* (1955), the 1956 remake of *The Man Who Knew Too Much* and *North by Northwest* (1959). This latter is a catalogue of Hitchcock's favourite obsessions, encompassing a MacGuffin (stolen microfilm), an innocent man on the run (Cary Grant), a mysterious blonde (Eva Marie

CAMEO CRAZINESS

Hitchcock famously made cameos in 37 of his films, in every film from *Rebecca* onwards. Initially, he was a face in a crowd or just walking through a scene, but as the cult around him grew so the appearances grew more elaborate, and included a recurring joke where he would carry a musical instrument. His most innovative cameo comes in *Lifeboat*, a film set entirely on board a boat: he appears in the 'before-and-after photos' of a newspaper diet advertisement.

Saint), a memorable action set piece (the crop-duster chase) and a finale on a national monument (Mount Rushmore), all in an unfathomable plot. It might well be Hitchcock's most exuberantly entertaining film.

Hitchcock started the 1960s with what would become his signature work. *Psycho*, based on a little-known novel by horror writer Robert Bloch, became the – dead – mother of modern horror. Whereas Hitchcock's previous work always had a dash of Hollywood pizzazz, here he reflected the sleazy, lurid character study of motel owner Norman Bates in a cheaper, cruder production on a budget of US$800,000 with a crew mostly drawn from his television show. *Psycho*, from killing the star off in the first reel accompanied by Bernard Herrmann's shrieking violin score to introducing new levels of screen violence, is a film that has been imitated many times but never bettered.

THE SHOWER SCENE

The most famous scene in Hitchcock's career – and possibly in the history of cinema – is the shower scene in *Psycho*. In filming the murder of Marion Crane (Janet Leigh) in the Bates Motel shower Hitchcock used over 50 shots in just under two minutes, the editing mirroring the violent jabs of the knife. It is an urban myth that the scene was actually directed by titles designer Saul Bass – Leigh confirmed that Hitchcock was present the whole time. What isn't an urban myth is that chocolate syrup was used for the blood because it looks so realistic in black and white.

BELATED RECOGNITION

Hitchcock never again reached the dizzying heights of *Psycho* but still delivered compelling and fascinating work in his next two pictures. In *The Birds* (1963), in which marauding avians attack a coastal town, he avoids suspense for full-on terror; while *Marnie* (1964) is a vivid character portrait of a troubled, frigid kleptomaniac (Tippi Hedren) and the man (Sean Connery) attracted to her neurosis. *Marnie* was critically mauled on release, but it was later favourably re-evaluated. It is unusual in Hitchcock's canon for such expressionistic techniques as blatantly artificial set design and flashes of red to delineate Marnie's psychological scarring.

Hitchcock's final four films – *Torn Curtain* (1966), *Topaz* (1969), *Frenzy* (1972) and *Family Plot* (1976) – retread his interests without the complexity or the panache of his best work, but they still contain moments of brilliance. *Torn Curtain*, for example, has a remarkable fight scene that, unlike every other movie fight, depicts just how difficult it is to kill someone. Although pigeon-holed as a mere craftsman throughout his career, and having never won an Oscar, his genius was finally recognized with an honorary Oscar just months before his death. His speech consisted of a simple 'Thank you'. When he died on 29 April 1980 he was the only director from the silent era still working. He kept his sense of mischief until the end, his gravestone reading: 'I'm in on a plot.'

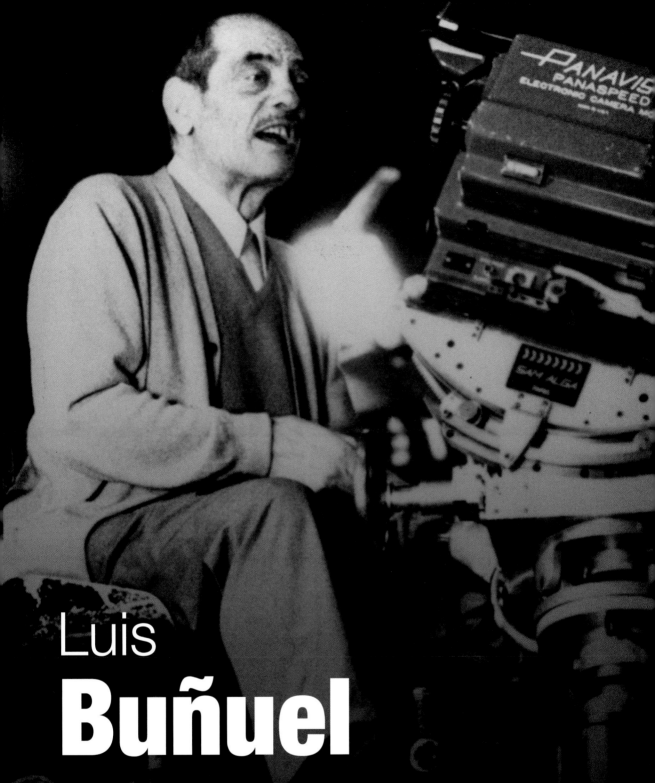

Luis
Buñuel

'Buñuel is the best director
in the world.'

Alfred **Hitchcock**

1900–83

'Thank God I'm an atheist,' said Luis Buñuel in 1960. It was an accidental aphorism, but this declaration in French newspaper *L'Express* highlights the suspicion of religion and infectious sense of playfulness that courses through his work. He was a pioneer of cinematic surrealism, and he launched ferocious attacks on the church, fascism and conventional bourgeois morality, building images with a dreamlike logic, delicious irony and swathes of black humour. A quarter of a century since his passing he remains cinema's greatest iconoclast.

Must-see Movies

Un Chien andalou (1929)

L'Âge d'or (1930)

Los Olvidados (1950)

Belle de jour (1966)

The Discreet Charm of the
 Bourgeoisie (1972)

Buñuel was born on 22 February 1900 and raised in Calanda, Spain. Being the son of well-to-do landowners and educated by Jesuit priests his rebellion against the bourgeoisie and the church may have started early. He later enrolled at Madrid University, forming friendships with Salvador Dalí and playwright and poet-to-be Federico García Lorca. In 1925 he studied cinema at the Académie du Cinéma in Paris, and, following a brief apprenticeship as an assistant director, he collaborated with Dalí on his first film, *Un Chien andalou* (*Andalusian Dog*), in 1928.

THE SULTAN OF SURREALISM

Running 17 minutes the film is a series of unconnected incidents that unfold with a fantastical randomness: ants emerge from the wound in the palm of a hand, dead donkeys lie on two pianos, priests are pulled along the ground and, in one of cinema's most shocking moments, an open eye is slashed in half with a razor in close-up. At the film's Paris premiere on 26 June 1929 Buñuel hid behind the screen with stones in his pocket for fear of being lynched by an outraged audience. He need not have worried. The film was enthusiastically received in surrealist circles, and French filmmaker Jean Vigo called it 'a major work of importance in every respect'.

Buñuel followed this with *L'Âge d'or* (*The Golden Age*) in 1930. Here he embroiders the plot of two lovers whose sexual desires are thwarted by the conventions of society with provocative and outrageous images: a blind man being kicked, a cow on a bed and actress Lya Lys seductively sucking the toe of a statue. Overbrimming as it is with anticlerical and blasphemous sentiments, the film was attacked by the right-wing press and banned in Spain for 50 years.

'Religious education and surrealism have marked me for life.'

Luis **Buñuel**

In 1932 Buñuel left Paris for Spain and made *Land Without Bread*, a powerful and horrifying documentary about peasant poverty in northern Spain that keeps the shocking imagery of his surrealist films – such as the human grotesques caused by inbreeding – but adds searing social

THE BUÑUEL APPROACH

Despite coursing with the seeming anarchy of surrealism Buñuel's filmmaking style was both economical and structured. His films were shot in a few weeks on low budgets and rarely strayed from the script, shooting in continuity to minimize the editing time. Buñuel also eschewed the use of traditional music soundtracks, with films such as *Diary of a Chambermaid* and *Belle de jour* containing no music at all, which adds to their discomforting feel.

realism. It was banned in his homeland and was the last film Buñuel made for 13 years.

BACK TO BLASPHEMY

Having been prevented from making his own films Buñuel moved between making musical comedies and Republican propaganda in Spain and dubbing dialogue for the studios in America. He eventually settled in Mexico in 1946 and resumed his directorial career, taking on more commercial projects. After two unremarkable efforts – *Gran Casino, El Gran Calavera* (*Magnificent Casino* and *The Great Madcap*, 1947 and 1949) – Buñuel entered the big league with *Los Olvidados* (*The Young and the Damned*) (1950), a portrait of juvenile delinquents eking out a violent existence in Mexico City's slums. Other important films from this period include the black comedy *El* (*This Strange Passion*, 1955), *The Criminal Life of Archibaldo de la Cruz* (1955) and *Nazarín* (1958).

In 1961 Buñuel made *Viridiana* in Spain, his first film in his homeland for 29 years. The movie, which was sponsored by the Spanish government, was another scathing satire on the church and fascism, the key set piece depicting a re-enactment of the Last Supper played out by beggars and degenerates. Astonishingly, government officials did not see the film until its Cannes opening in 1961, where it won the Palme d'Or. Like much of Buñuel's Spanish output it was immediately banned.

Yet this didn't temper Buñuel's scorn, his anti-establishment stance striking a nerve with the 1960s counterculture. *The Exterminating Angel* (1962) sees the guests of a high-society dinner party trapped in the dining room together. *Belle de jour* (1967) has a tour-de-force performance from Catherine Deneuve as the bored wife of a doctor who takes pleasure spending her afternoons working in a brothel entertaining kinky clients. 'I attribute [*Belle de jour*'s success] more to the marvellous whores than my direction,' was his evaluation of his biggest success to date.

SHOCKING SEVENTIES

Buñuel entered the 1970s with *Tristana*, examining the complicated, tortured relationship between an orphaned girl (Deneuve) and her protector (Fernando Rey) with an assured mixture of intensity and ironic detachment. Harking back to *The Exterminating Angel*, *The Discreet Charm of the Bourgeoisie* once again put affluent dinner-party guests into hell. More shocking than the film itself is that Buñuel won the Best Foreign Film Oscar in 1972 for *Bourgeoisie* – the *enfant terrible* had joined the establishment.

He won again five years later with *That Obscure Object of Desire*, an exploration of a businessman's (Rey again) frustrated passion for his maid. When Maria Schneider, originally cast as the maid, left the project three weeks into the shoot Buñuel, with typical surrealist thinking, cast two actresses (Carole Bouquet, Angela Molina), each revealing different sides to the same woman and exacerbating Rey's indecision. Full of trademark barbs and wit Buñuel's final film is a fitting testament to his talent.

Shortly before his death he was awarded the Grand Cross of the Order of Isabella by the Spanish government – perhaps in a last-gasp gesture of reconciliation. Buñuel passed away on 29 July 1983, as old as the century that had been enriched by his scurrilous, surrealist vision.

Walt
Disney

'I'm sometimes frightened of
the films of Walt Disney.
Frightened by the absolute
perfection of his films.'

Sergei **Eisenstein**

1901–66

For many people Walt Disney *is* animation,

the finest exponent of the feature-length cartoon. The irony is that Disney was a poor animator, his real skill lying in storytelling and showmanship. Although he was not a director in the traditional sense he exerted complete creative control over his output, be it movies, television or theme parks. As a testament to his imagination he holds the record for winning the most Academy Awards for an individual – 26 – and created some of the world's most iconic fictional characters along the way.

His name became a byword for trustworthy family entertainment, and Disney cultivated a warm, avuncular image – but the personality belied a serious, withdrawn, naturally suspicious man with a controlling nature. Some critics feel his work is too saccharine and anodyne, but a Disney film is the first cinema experience for many of us, an integral part of children's culture. He was at once a visionary artist, a technical innovator and a consummate businessman, so his status as one of the most important, popular and influential artists of the 20th century is undeniable.

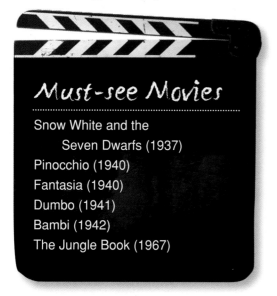

Must-see Movies

Snow White and the
 Seven Dwarfs (1937)
Pinocchio (1940)
Fantasia (1940)
Dumbo (1941)
Bambi (1942)
The Jungle Book (1967)

FROM A RABBIT TO A MOUSE

Walt Elias Disney's love of drawing began as a child in his hometown of Marceline, Missouri. When the family moved to Chicago he started drawing cartoons for the school paper and taking classes at the local art institute. After lying about his age he became a Red Cross ambulance driver during the First World War, returning in 1919 to start work at a commercial art studio in Kansas City. There he met upcoming artist Ub Iwerks, and the pair began working together. In 1923, along with Disney's older brother Roy, they set up a company and studio in an uncle's garage, churning out a clutch of cartoons including *Laugh-o-Grams*, a series of fairytale adaptations and animation–live-action hybrids called *Alice in Cartoonland* and a new cartoon franchise, *Oswald the Lucky Rabbit*, in 1927.

The following year Disney and Iwerks created Mickey Mouse, the character that made Disney's fortunes. Mickey's first two outings, *Plane Crazy* and *Gallopin' Gaucho* (both 1928), were silents, but, always one to embrace new technology, later that same year *Steamboat Willie* became the first Mickey Mouse film with sound, with Walt himself providing the sound effects and Mickey's distinctive high-pitched voice. In the depths of the Depression Mickey embodied the indomitable American spirit and struck a huge chord with audiences. Following his success Disney surrounded Mickey with a menagerie of equally memorable characters that spun off into profitable merchandising: Donald Duck, Minnie Mouse, Goofy – originally named Dippy Dawg – and

Pluto. If Mickey remains Disney's most iconic character Donald Duck was the most durable, the duck eclipsing the mouse's popularity in 1949.

If Iwerks' animation added the artistry, then Walt added the smarts and polish. He was a great gag man and an intuitive story editor, and he also had a great eye for detail – when his animators spliced a single frame of a naked woman into a Mickey Mouse cartoon Disney spotted the image at 24 frames per second and wanted to know what a naked woman was doing in the middle of a Mickey Mouse cartoon.

> ### 'I'm not interested in pleasing the critics. I'll take my chances pleasing the audiences.'
> Walt **Disney**

Disney was always eager to embrace novelty and innovation. The team, encouraged by the success of their early sound efforts, initiated the *Silly Symphonies* series – the first was *The Skeleton Dance* in 1929 – that seamlessly matched onscreen action to pre-recorded music rather than the traditional method of creating scores to fit the images.

Silly Symphonies were often used as test beds for improving animation techniques, including realistic human animation, distinctive character design and special effects such as weather. *Flowers and Trees* (1932) had been a black-and-white production until Disney saw an early test of the Technicolor process. The film was reshot and became a huge success, the first animated film to win an Oscar. *The Old Mill* (1937) was the first movie to employ the Multiplane camera, a technical revolution that allowed for a greater sense of depth and perspective in animation. It was to become instrumental in Disney's next venture.

THE GOLDEN AGE

In 1934, with Disney now a veritable animation factory, Walt began a long-held dream of making a full-length animated feature. *Snow White and the Seven Dwarfs* was known in the film industry as Disney's folly, an unprecedented gamble that put his reputation on the line and pushed his resources to breaking point. At one stage during the film's three-year, finance-draining production the studio ran out of money, and Walt had to show a rough version to loan agents at the Bank of America to obtain the funds to finish the project.

Snow White became a perennial children's classic and is a joyous version of the Grimm Brothers' fairytale – but one that doesn't skimp on the sinister Gothic subtext. On its release on 4 February 1938 the film was a huge financial success, earning US$8 million on its initial run, and the profits were ploughed into a new studio in Burbank. The film earned Disney one full-sized Oscar and, in a nice tribute, seven miniature statuettes.

THE DARK SIDE OF DISNEY

Since Disney's death many biographers have attempted to uncover a dark side to Uncle Walt. These accusations include lifelong anti-Semitism – the short cartoon *The Three Little Pigs* depicted the Big Bad Wolf as a Jewish barber – intense right-wing politics and a refusal to lower the flag at Disneyland on the day that President Kennedy was shot. But what is certain is that Disney had a strained relationship with his workforce, reaching its nadir in a strike at the Disney Studio in 1941 with animators rallying against his authoritative rule and rigid naturalistic animation style.

THE DISNEY SONGBOOK

As much as Disney's films contributed to the art of animation they also contributed massively to popular music, delivering a never-ending stream of memorable songs, including 'Whistle While You Work' and 'Some Day My Prince Will Come' (*Snow White*), 'When You Wish Upon a Star' (*Pinocchio*) and 'Zip-a-dee-doo-dah' (*Song of the South*). The Sherman brothers (Robert B. and Richard M.) are perhaps Disney's most successful songwriting team, penning such unforgettable tunes as 'A Spoonful of Sugar' and 'Supercalifragilisticexpialidocious' (*Mary Poppins*) and 'The Bare Necessities' and 'I Wanna Be Like You' (*The Jungle Book*).

The film ushered in what cinema historians have dubbed the Golden Age of Animation, a white-hot period of creativity for Disney. In many ways Disney's debut feature is the perfect expression of the filmmaking ethos that guided his whole career. His best-loved work – *Snow White, Pinocchio, Dumbo, Bambi, Cinderella* – are all underpinned by the same ideals: clean fairytale structures delivering soothing morals, all told with a reliance on memorable, sharply defined characters, broad humour, popular music and dazzling visuals.

Occasionally there were departures from house style. *Fantasia* (1940) was an ambitious attempt to marry beautiful animation to the greatest classical music. The film enraged music purists, who believed that the music was cheapened by such popular imagery – 'The Sorcerer's Apprentice' sequence, for example, is visualized with Mickey Mouse leading an army of dancing mops – and the film was initially unsuccessful at the box office. Yet the film's often surreal imagery has become highly regarded in animation circles, and it eventually became profitable.

BRANCHING OUT

Although his feature-film department was conquering all before it, Walt refused to rest on his laurels, constantly launching new ventures. In 1950 *Treasure Island* became Disney's first live-action feature, followed in 1954 by *20,000 Leagues Under the Sea*, *The Shaggy Dog* (1959) and Walt's long-cherished project *Mary Poppins* (1964), the studio's most successful film of that decade.

Disney was also the first movie mogul to move into television, producing a weekly anthology show that included clips from his old films and a *Davy Crockett* mini-series that initiated a craze for coonskin caps among American children. He also launched a daily show, *The Mickey Mouse Club*, in 1955 that continued into the 1990s. But, in the same year, perhaps the most radical extension of the Disney empire was the creation of Disneyland, a 160-acre (65-hectare) fantasy amusement park based in Anaheim, California, that remains one of the world's most popular tourist attractions.

While he diversified into other areas Disney increasingly withdrew from supervising feature animation personally. Instead, he turned the day-to-day operations over to a group he dubbed the Nine Old Men, a reference to Franklin Roosevelt's description of the nine US Supreme Court judges. During his lifetime this trusted group presided over some of the studio's most famous hits – *Lady and the Tramp* (1955), *Sleeping Beauty* (1959) and *One Hundred and One Dalmatians* (1961).

Disney was a chain-smoker his whole life – although he carefully managed never to be seen smoking in front of children – and he was diagnosed with lung cancer in late 1966, dying on 15 December that year. The final projects he was working on included *The Jungle Book* (1967) and planning Disney World, a more ambitious version of Disneyland. It is a long-standing urban myth that Disney was cryogenically frozen and his refrigerated corpse kept underneath the *Pirates of the Caribbean* ride in Disneyland; the more prosaic truth is that Walt was cremated two days after his death.

William
Wyler

'As a director, Wyler is
probably the most indefatigable
perfectionist I've ever seen.'

Dana **Andrews**

1902–81

William Wyler was a bona fide perfectionist,

his penchant for retakes and desire to hone every last nuance the stuff of legend. He earned the right to be so fastidious by becoming one of Hollywood's most bankable moviemakers of the 1930s and 1940s, turning a series of tasteful literary adaptations into huge box-office and critical successes.

His films operated on a mixture of taut scripts and unsung technical prowess and were dominated by heartfelt, often award-winning acting. With 12 Best Director Oscar nominations and three wins he was certainly an Academy darling, but his reputation goes beyond such glitzy acclaim – Wyler became one of the greats by turning intimate, domestic human drama into the stuff of classic cinema.

KEEPING IT IN THE FAMILY

Wyler's career is a great advertisement for nepotism. He was born in Mulhouse, Alsace – then part of Germany – on 1 July 1902. He spent time in Paris studying violin at the National Conservatory, which brought him into contact with Carl Laemmle, head of Universal Pictures, who was a distant cousin of Wyler's mother. 'Uncle' Carl landed Wyler a job at Universal, learning the industry from the bottom up. After working as an assistant director on the Lon Chaney version of *The Hunchback of Notre Dame* (1923) Wyler landed his first directorial job at the tender age of 23, directing *Crook Buster* in 1925, the first of 40 two-reel, action-packed westerns he directed for Universal. 'I used to spend nights thinking of new ways to get off and on a horse,' he quipped.

Must-see Movies

Jezebel (1938)
Wuthering Heights (1939)
Mrs Miniver (1942)
The Best Years of Our Lives (1946)
Roman Holiday (1953)
Ben-Hur (1959)

Wyler graduated to features, earning a small reputation with dramas such as western *Hell's Heroes* (1930) – his first talkie – *A House Divided* (1931) and *The Gay Deception* (1935). He left Universal in 1936 and began a fruitful association with Sam Goldwyn. Their first collaboration that same year, *These Three*, linked Wyler with cinematographer Gregg Toland, another key creative ally. Wyler also directed *Dodsworth* in 1936, an emotionally compelling study of the disintegration of a marriage, starring Walter Huston and Mary Astor. It earned Wyler his first Oscar nomination, sparking a 20-year run of almost unbroken greatness.

AN EXACTING STYLE

Dodsworth did more than cement Wyler's critical credentials, it also established the free-flowing style that would recur throughout his career. Wyler constructed his movies in long takes, orchestrating his actors and decor into precise compositions that created tensions and drama without resorting to editing. Such exacting working methods often brought him into conflict with his performers. Although more actors have won Academy Awards in Wyler's movies than in those of any other

director, few actors worked with him more than once. Bette Davis, who appeared in three Wyler movies – *Jezebel* (1938), *The Letter* (1940), and *The Little Foxes* (1941) – walked off *The Little Foxes* for two weeks after clashes with Wyler about the direction of her character. However, she still did her best work under his guidance.

While shooting *Wuthering Heights* in 1939 Wyler forced actress Merle Oberon to retake a storm scene over and over, subjecting her to blasts of cold water hosed through propeller blades until she started to vomit, afterwards being hospitalized with a fever. On the same film Wyler fought bitterly with co-star Laurence Olivier over the latter's theatrical acting style. 'This isn't the Opera House at Manchester,' Wyler bellowed. Olivier later credited the director with refining his movie-acting style and opening him up to the possibilities of cinema.

FROM INTIMATE TO EPIC

After the Oscar-winning *Mrs Miniver* (1942), starring Greer Garson in tribute to England's fortitude during the Blitz, Wyler enlisted in the US Air Force and was attached to a bomber group stationed in Britain. He made two important feature-length documentaries about the war, *The Memphis Belle* (1944) and *Thunderbolt* (1947). His first feature drama after the war, *The Best Years of Our Lives* (1946), was a huge success, telling the story of three GIs readjusting to life back home. The movie was mounted with impeccable craftsmanship by Wyler and features great performances from established stars Fredric March, Myrna Loy and Dana Andrews, but all are upstaged by real-life wartime amputee Harold Russell, who won two Oscars, one

> 'I may not make a good picture, but I still gotta believe it.'
>
> William **Wyler**

for Best Supporting Actor, the other for inspiring other veterans. Lean, modern and moving, it remains one of the most satisfying achievements in American cinema.

After this Wyler continued his hot streak, joining Paramount in 1949 and making *The Heiress*, which won an Oscar for Olivia de Havilland, and *Roman Holiday* in 1953, a delightful romantic comedy that cast Audrey Hepburn opposite Gregory Peck in her first film role.

But as the 1950s progressed Wyler's intimate style fell out of favour. Having done his best work in interior dramas he made popular huge-canvas pictures such as *The Big Country* (1958) and *Ben-Hur* (1959), the latter an epic on every level and still the joint-record Academy Award winner with 11 Oscars. But these big, broad dramas, while hugely enjoyable, lacked the subtlety and nuance of his best work. *The Collector* (1966), a tense, nasty adaptation of a John Fowles novel, became his last notable film. *Funny Girl*, a 1968 musical vehicle for Barbra Streisand, proved to be Wyler's last hit, and he retired after the failure of *The Liberation of L.B. Jones* in 1970.

THE HUNT FOR PERFECTION

Wyler was such a perfectionist that he earned the nickname 90-take Wyler. On the set of *Jezebel* Wyler forced Henry Fonda through 40 takes of one particular scene, his only guidance being 'Again!' after each take. When Fonda asked for more direction Wyler responded, 'It stinks.' Similarly, when Charlton Heston quizzed the director about the supposed shortcomings in his performance in *Ben-Hur*, Wyler dismissed his concerns with a simple, 'Be better.'

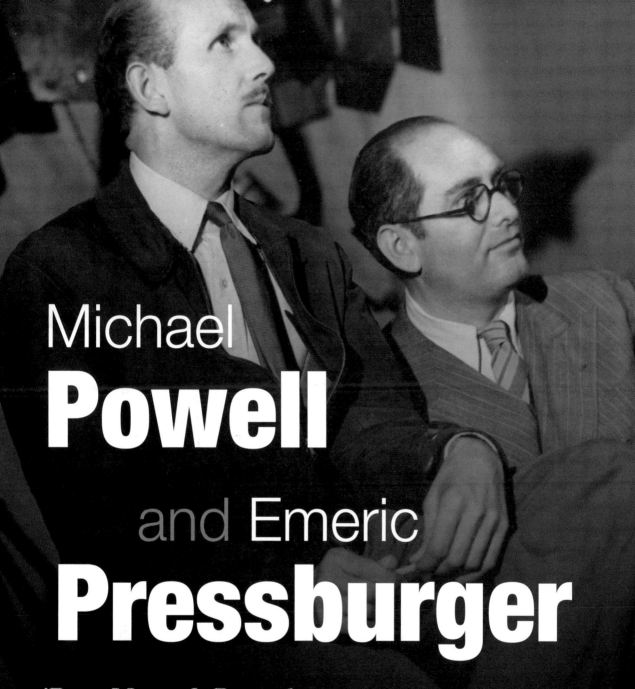

Michael
Powell
and Emeric
Pressburger

'Powell and Pressburger gave me
a lot of courage, just by watching
their films, because they were
incredibly daring.'

Bertrand **Tavernier**

1905–90 (Powell) / 1902–88 (Pressburger)

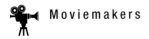

Michael Powell and Emeric Pressburger are
cinema's greatest moviemaking partnership. Powell directed and
Pressburger wrote, but the clean-cut distinctions do not do justice to
the uniqueness of their collaboration and vision. Poetic and passionate,
their films stood in direct contrast to the prevailing mood of realism that
coursed through British cinema, and, as such, their work achieved an
international recognition that few UK filmmakers ever managed.

Their best work operates in a hinterland between the romantic and the real. The fanciful
technical trickery, the bold camera movements and the delirious use of colour and light represent
the romance. The real is contained in the penetrating psychological insights and the deep
emotionalism, often buried deep beneath British stiff upper lips. That Powell and Pressburger
mastered both elements resulted in cinematic alchemy.

AN UNLIKELY ALLIANCE
Michael Powell first met Emeric Pressburger
through Alexander Korda. Powell, born in Kent
on 30 September 1905, had worked as an actor
and assistant director in both France and Britain,
working with Alfred Hitchcock on *Champagne*
and *Blackmail* before graduating to directing two
dozen unremarkable features. In 1937 his first
substantial drama, *The Edge of the World*, caught
the eye of Korda, who put him under contract.
Emeric Pressburger, born in Miskolc, Hungary,
on 5 August 1902, had drifted around the
Austrian, German and French film industries
working as a screenwriter before he was recruited
by Korda and put together with Powell.

> ## Must-see Movies
> The Life and Death of
> Colonel Blimp (1943)
> A Matter of Life and Death (1946)
> Black Narcissus (1947)
> The Red Shoes (1948)
> Peeping Tom (1960, Powell only)

They made an unlikely match, completely
opposite in their backgrounds and personalities. Yet their first collaboration in 1939, *The Spy in
Black*, a profitable espionage thriller, revealed a common attitude to filmmaking, and the pair
formed a partnership. They followed this with a string of war-related pictures: *The Lion Has Wings*
(1939), *Contraband* (1940), *49th Parallel* (1941) and *One of Our Aircraft Is Missing* (1942), the first film they
made with a joint writer-director credit.

TECHNICOLOR DREAMS
In 1943 Powell and Pressburger created their own production company, the Archers, the
company logo of which consisted of arrows flying into a target. The Archers began a run of
remarkable and influential films marked by wit, infectious playfulness and cinematic invention,
almost handcrafted by a regular group of superb technicians – including cinematographers
Erwin Hillier, Jack Cardiff and Christopher Challis, art directors Hein Heckroth and Alfred
Junge and composer Brian Easdale. Typically, these films were conceived on an ambitious scale
and rendered in vivid Technicolor hues.

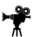

The Life and Death of Colonel Blimp (1943) follows a touching lifelong friendship between a British officer, Clive Candy (Roger Livesey), and his Prussian counterpart, played by Anton Walbrook. The movie thrives on experimentation – Deborah Kerr plays three different women in Candy's life – and is a scathing attack on military ideals and national pride, which led Winston Churchill to try to ban the film because it gave the wrong impression of the British fighting man. But at its core it is the moving study of a 40-year friendship between two different men that can easily be read as a portrayal of Powell and Pressburger themselves.

> 'Our passion was to make films. It's not a job, it's not a craft, it's a passion.'
>
> Michael **Powell**

A Matter of Life and Death (US title *Stairway to Heaven*, 1946) was designed to promote good relations between Britain and America but does so much more. It is the story of an RAF pilot who goes on trial for his life in Heaven after he fails to die in a plane crash, and the film moves through affecting romance, pointed satire and enchanting fantasy with remarkable assurance. In Powell and Pressburger's vision the afterlife is realized in beautiful monochrome and the earth captured in startling Technicolor, blurring the distinctions between reality and fantasy. It was critically mauled in Britain for being stuffy, but found huge favour in America, and it remains the most accessible, heady illustration of the Powell and Pressburger ethos.

The Archers' next production could not have been more different. *Black Narcissus* (1947) recreated a stylized Himalayas in the grounds of Pinewood Studios to tell the story of a community of nuns whose buried passions and jealousies are ignited by the arrival of a British agent. The action is captured in breathtaking stylized images – the film won Oscars for camera work and art direction – and the movie breathes with a barely concealed hysteria and subtle eroticism. Few movies have used external studio artifice to amplify the interior lives of their characters so vividly.

The following year Powell and Pressburger poured the flights of fantasy of *A Matter of Life and Death* and the passion of *Black Narcissus* into *The Red Shoes*. Real-life ballerina Moira Shearer stars as a dancer caught between her love for a young composer (Marius Goring) and the monstrous influence of her Svengali (a terrifying Anton Walbrook). As a meditation on the passions and torments of creating art it is among the best-loved films about dance ever made, featuring a 17-minute ballet sequence filled with wonder, beauty and terror. Three years after this stunning success the Archers and Moira Shearer returned to the ballet milieu with *The Tales of Hoffmann*, a sumptuous dance adaptation of Jacques Offenbach's opera that pushed cinematic experimentation with dance at the expense of storytelling even further.

PRACTICAL MAGIC

Powell and Pressburger's films are full of little magical flourishes that lift them out of the ordinary. In *A Matter of Life and Death*, to avoid using the traditional fade-in from black, Powell took the simple step of breathing on the lens, creating a dreamlike transition to a beach scene. For *Black Narcissus* the backdrops of the Himalayas were actually black-and-white photographs blown up then enhanced by using pastel chalks to create a stunning, stylized look. During *The Red Shoes* cinematographer Jack Cardiff manipulated film speeds to give the effect of dancers hovering in the air. Simple, effective, transcendental.

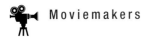

SMALL-SCALE BRILLIANCE

Around these extravagant fantasies the Archers made smaller but no less imaginative efforts. *A Canterbury Tale* (1944) relocates Geoffrey Chaucer's stories from the 14th century to wartime Britain in shimmering black and white, as an American GI, a British soldier and a Land Girl encounter eccentric characters in a small town on the road to Canterbury. *I Know Where I'm Going* (1945) explores mysticism and romance on a small Scottish island, while *Gone to Earth* (1945) stars Jennifer Jones as a Shropshire girl who has an affinity with nature.

Gone to Earth was the first time Powell and Pressburger had worked for an American producer, David. O. Selznick. 'We decided to go ahead with Selznick the way hedgehogs make love: very carefully!' quipped Powell. It proved an unhappy experience for the pair, with Selznick cutting 30 minutes from the film and ordering new scenes to be shot. This shift from the UK production company Rank to American producers seemed to blunt the Archers' creative edge. After *The Tales of Hoffmann* they managed only three more films – *Oh Rosalinda!* (1955), *The Battle of the River Plate* (1956) and *Ill Met by Moonlight* (1957) – before amicably ending their partnership to pursue solo projects.

THE PARTNERSHIP DISSOLVES

In 1960 Powell released *Peeping Tom*, his first film since parting company with Pressburger. The vicious critical attack he received virtually ended his career, forcing him to relocate to Australia to make uninspired films such as *Age of Consent* (1969), staring James Mason. Despite the brilliance of *Peeping Tom* there is something missing in Powell's work without Pressburger, his films lacking the grace and wisdom on which their collaborations had soared.

And this is perhaps why the pair reunited for two final ill-advised comedies, *They're a Weird Mob* (1966, with Pressburger writing under the pseudonym Richard Imrie) and *The Boy Who Turned Yellow* (1972). Happily, these sad footnotes to such great careers didn't stop their work being re-evaluated by a younger generation of filmmakers. In 1980 Francis Ford Coppola hired Powell as the creative director 'in situ' of his American Zoetrope studio, and Martin Scorsese did much to encourage a critical reappraisal of their output, funding restorations of their films and continually championing their work in interviews. He also introduced Powell to his editor Thelma Schoonmaker, and the pair married in 1984, Powell 40 years her senior.

On the set of *The Red Shoes* Powell and Pressburger had instructed their technicians to 'Shoot the works', a clarion call for artistic courage and unstinting creativity. By their deaths – Pressburger on 5 February 1988, Powell on 19 February 1990 – this ambition had been well and truly fulfilled.

A SOLO MASTERPIECE

Peeping Tom was Michael Powell's first film after the Archers. It centres on a serial killer (Carl Boehm) who films his female victims in their final moments as he stabs them with a tripod. Powell himself plays the killer's father in flashback, the man who spawned the monster. On its release in 1960 – the same year as Hitchcock's *Psycho*, to which it is an interesting companion piece – *Peeping Tom* was dismissed as reprehensible, but the film's reputation has rightly been reassessed as cinema's most complex treatise on the relationship between movies, violence and voyeurism.

John
Huston

'The eccentric's eccentric.'
Paul **Newman**

1906–87

John Huston – director, writer, actor, painter,

boxer, gambler, hell-raiser – was both a rebel and a renaissance man. As a moviemaker he traded in tough narratives that dramatized a contemporary male-dominated universe and was never afraid to tackle tough issues head on.

As a man he was cinema's Ernest Hemingway – the writer was a friend – the lynchpin in a Hollywood dynasty, married five times, sentimental, sensitive, driven by an unbridled lust for life. Even compared with the larger-than-life characters he created, Huston was a titan.

FROM BEGGING TO BOGART

John Marcellus Huston, the son of Hollywood star Walter Huston, was born on 5 August 1906 in Nevada, Missouri, a town reputedly won by his grandfather in a poker match. Huston – a boxing champion, vaudeville and Broadway actor, Mexican cavalry officer and journalist all by

Must-see Movies

The Maltese Falcon (1941)
The Treasure of the Sierra
 Madre (1948)
The Asphalt Jungle (1950)
The African Queen (1951)
The Dead (1987)

the age of 23 – landed a job as a Hollywood screenwriter in 1929, first for MGM, then for Universal. In 1932 he left Hollywood for a writing position at Gaumont British, but when the job failed to materialize he found himself singing on street corners in London and sleeping in Hyde Park. Later, in Paris, he sketched tourists for money, but in 1933 he returned home; legend has it he was given the fare by a Montmartre streetwalker.

In 1937 he embarked on his second stab at screenwriting, winning Oscar nominations for *Erlich's Magic Bullet* in 1940 and *Sergeant York* in 1941. That same year Huston made his directorial debut with *The Maltese Falcon*, based on the novel by Dashiell Hammett and starring

Humphrey Bogart as private eye Sam Spade, the role that turned him into a star. Huston preserves Hammett's sharp dialogue and sleazy amorality, with a top-flight cast translating an impenetrable plot into superb cinematic entertainment. Huston demonstrates an astonishing confidence for a novice director, and *The Maltese Falcon* played an important role in establishing Huston's credibility.

FANTASTIC FIFTIES, STUMBLING SIXTIES

After directing three acclaimed combat documentaries during the Second World War and earning the Legion of Merit, Huston's first post-war film was *The Treasure of the Sierra Madre* (1948), a rugged portrayal of the destructive nature of greed that stars Bogart along with Huston's father Walter. It harked back to his days in Mexico and was a huge critical success, garnering Academy Awards for Best Picture, Director and Screenplay. Huston Sr also won a Best Supporting Actor Oscar.

Huston directed Bogart in two further pictures – the gangster melodrama *Key Largo* (1948) and the jungle riverboat adventure *The African Queen* (1951), co-starring Katharine Hepburn – and the actor became the embodiment of the Huston hero: macho, cynical and world weary. The

THE HUSTON DYNASTY

John Huston represented the middle generation in one of Hollywood's most famous dynasties. John's father Walter was a respected Broadway actor who shone in movies such as *Dodsworth*, *The Devil and Daniel Webster* and *Yankee Doodle Dandy* before winning an Oscar for *The Treasure of the Sierra Madre*. Daughter Anjelica, after surviving castigation for starring in her father's films, has carved out a major career by mixing strong dramas (*The Grifters*), popular comedies (*The Addams Family*) and smaller quirky independent movies (*The Royal Tenenbaums*). Her brother Danny has also become a reliable supporting player in the likes of *The Aviator, The Constant Gardener* and *Children of Men*.

making of the movie was thinly disguised in Clint Eastwood's 1990 film *White Hunter Black Heart*, with Eastwood playing a Huston-like figure.

In 1950 Huston made the atmospheric crime drama *The Asphalt Jungle*, beautifully etching the story of a jewellery heist with compelling pace while never losing sight of the rounded and believable characters. After critical successes with US Civil War drama *The Red Badge of Courage* (1951) and *Moulin Rouge* (1952), a biopic of Toulouse Lautrec, the rest of the 1950s saw Huston's work vary wildly both in content and quality, from the sublime adult romance of 1957's *Heaven Knows Mr Allison* to the stodgy *Moby Dick* from 1956.

The 1960s saw a further drop in Huston's fortunes, as he turned out uneven work that included the biopic *Freud* (1962), the Old Testament epic *The Bible* (1966) and a string of oddities such as *The List of Adrian Messenger* (1963), *Night of the Iguana* (1964), the spoof James Bond effort *Casino Royale* and the camp *Reflections in a Golden Eye* (both 1967) – which, bizarrely, remained his favourite of his work. Only 1961's *The Misfits*, the final film for both Clark Gable and Marilyn Monroe, found critical approval.

SOARING SEVENTIES

The new decade saw a renaissance for Huston, turning out great films to rival his best work, including 1972's atmospheric boxing drama *Fat City*, rousing Kipling epic *The Man Who Would Be King* (1975), which paired Michael Caine with Sean Connery, and a searing satire of Deep South religious values *Wise Blood* (1979), based on the novel by Flannery O'Connor. It was a run that Huston couldn't keep going into the 1980s, producing

'I fail to see any continuity in my work from picture to picture.'

John **Huston**

the terrible thriller *Phobia* (1980), the risible soccer drama *Escape to Victory* (1981) – which, curiously, paired Sylvester Stallone with Pelé – and the excruciating, much-hyped US$35-million musical *Annie* (1982), all of which have strong claims to be the worst film he ever made.

Throughout this whole period Huston suffered from chronic emphysema, which makes what happened next all the more remarkable. Huston's penultimate film, *Prizzi's Honor*, made in 1985, is a sparkling jet-black comedy of mafia mores starring Jack Nicholson, Kathleen Turner and Anjelica Huston, who picked up an Oscar for Best Supporting Actress. But even more amazingly, after a career of thunderous movie classics Huston's final bow was a beautiful, intimate, low-key swan song, *The Dead* (1987), based on the novel by James Joyce. Huston was so ill that insurance companies refused to cover the production, but the director turned in one of his most affecting, heartfelt works. He fell ill with pneumonia and passed away on 28 August 1987.

Roberto
Rossellini

'Rossellini doesn't like cinema
much, he prefers life.'

François **Truffaut**

1906–77

Roberto Rossellini is a major, if often overlooked, figure in the history of world cinema. The controversies surrounding his early days as a fascist propaganda filmmaker and his later scandalous relationship with Ingrid Bergman have perhaps created a barrier to appreciating his towering achievements. For Rossellini did nothing less than encapsulate the mood of a world living in the aftermath of the Second World War, creating a new level of cinematic realism and changing the face of Italian cinema for ever.

Rossellini was the son of the architect who, fittingly, built the first cinema in Rome, and he grew up with a love of both cinema and everything mechanical, combining these passions by gaining technical knowledge in all areas of filmmaking. After his first short films, *Daphne* (1936) and *Prélude à l'après-midi d'un faune* (1937), Rossellini was co-opted to make propaganda films for the fascists because of his friendship with Vittorio Mussolini, son of Benito Mussolini. In 1940 he started making a documentary about life on board an Italian hospital ship that was subsequently turned into a drama, *The White Ship*, his first feature. It was a disturbing period in Rossellini's career – however much his admirers play down the content of these films they are fascist doggerel. Interestingly, when asked in 1955 to write a personal account of his work by French film journal *Cahiers du cinéma* Rossellini made no reference to this period of his career at all.

THE WAR TRILOGY

As if to answer these criticisms Rossellini completed a trilogy of films that acted as a stunning riposte to anyone who doubted his political sympathies. *Rome, Open City* (1945) was inspired by real events, the hunting down, capture and torture of a communist resistance leader and his comrades by the Gestapo. Rossellini shot on real locations with a mostly non-professional cast and imbued the drama with a blistering veracity that mainstream films did not have. The movie took the top award at the Cannes Film Festival and guaranteed Rossellini's place in cinema history.

Must-see Movies

Rome, Open City (1945)
Paisà (1946)
Germany Year Zero (1948)
Viaggio in Italia (1954)

The film subsequently became a landmark in Italian neorealism, a movement that detailed the economic and moral conditions of ordinary people in post-war Italy. Stylistically these films favoured loose structures over pat plots and employed actual locations with non-professional actors speaking conversational dialogue, all captured in a documentary style. Other key neorealist films include Luchino Visconti's *Obsession* (1943) and Vittorio de Sica's *Bicycle Thieves* (1948).

He followed *Rome, Open City* in 1946 with *Paisà*, exploring the traumatic process of the Allied liberation of Italy through six separate but linked stories. Rossellini completed the trilogy two years later with *Germany Year Zero*, a sombre story of the devastating effect of Nazi ideology on a young boy who poisons his father. Taken individually the films flit between the melodramatic, the mundane, the angry and the deeply moving, but as a whole the trilogy paints a coherent picture of ordinary people caught up in political tumult and of how war can scar both individual and national psyches.

COURTING CONTROVERSY

Rossellini's raw ragged vision of a war-torn Europe stunned audiences, particularly in America. In 1948 he received a fan letter from Swedish-born Hollywood star Ingrid Bergman, pledging her admiration for his work and offering to work for him for the 'sheer pleasure of the experience'. Bergman's letter ignited one of the most notorious and controversial relationships in Hollywood history. At the time they met both Rossellini and Bergman were married to other people, and the affair and their baby boy, Roberto, born before the couple had divorced and married one another, created an outcry, which led to both artists being shunned by Hollywood and their moving to Italy.

> **'Don't get married to an actress because they're also actresses in bed.'**
> Roberto **Rossellini**

As well as becoming his wife – the pair married on 24 May 1950 – Bergman was also Rossellini's muse, the central element of their six films together: *Stromboli* (1950), *The Greatest Love* (1952), *Joan of Arc at the Stake* (1954), *We, the Women of Life and Love* (1953), *Viaggio in Italia* (1954) and *Fear* (1954). None of these films attained the respect afforded the war trilogy, but 1954's *Viaggio in Italia* (*Journey to Italy*), a portrait of a couple's marital crises while on holiday in Naples, is a penetrating dissection of relationship ennui, offering a spiritual detachment in contrast to the neorealist films.

RENAISSANCE AND RETIREMENT

Both *Viaggio in Italia* and *Fear* painted a picture of relationship discord that, in hindsight, seemed to reflect the dissatisfaction within the Rossellini–Bergman marriage. In 1957 Jawaharlal Nehru, the Indian prime minister, invited Rossellini to make a documentary simply called *India*, and although still married to Bergman he began a torrid affair with novelist Sonali Das Gupta, who was developing scenarios for the film. Gupta's pregnancy led to separation from Bergman, and once again Rossellini was in a cauldron of controversy – audiences at the Moscow Film Festival booed and walked out of *India* and Nehru branded Rossellini a 'scoundrel'.

Rossellini partly repaired his reputation with films such as *General della Rovere* (1959) and *Escape by Night* (1960), but he was growing disenchanted with cinema and announced his retirement in 1963. Instead, he concentrated on television documentaries about historical figures – most significantly *The Rise of Louis XIV* in 1966, which gained a theatrical release internationally – directing for the stage and lecturing in America. He died of a heart attack on 3 June 1977.

INGRID BERGMAN

Ingrid Bergman was a huge star in Hollywood, whose hits included *Casablanca* (1942), *Gaslight* (1944) and a string of films for Hitchcock. Her relationship with Rossellini put an end to her Hollywood career for ten years and even led to her being denounced in the US Senate, with Colorado senator Edwin C. Johnson decrying her as 'a horrible example of womanhood and a powerful influence for evil'. She exiled herself to Italy after a floor vote resulted in her being declared *persona non grata*. She had three children with Rossellini, including actress Isabella Rossellini, best known for her role in *Blue Velvet* (1986).

Billy
Wilder

'That Wilder should
be horse-whipped!'

Louis B. **Mayer**

1906–2002

In a career that lasted just under 50 years

Billy Wilder's movies managed to offend pretty much everyone – the press, the US Congress, the Hollywood establishment and religious leaders all came under his scurrilous scrutiny. Wilder loved to revel in life's dark edges and squalid emotions, but he diluted the acidity levels with gleefully malevolent humour and reluctant romance. By flouting taboos and exploring adult themes he did much to help mainstream American movies come of age.

Wilder was blessed with a rich sense of character, audacious sense of structure and a great ear for dialogue, and he was one of the finest writers ever to come out of the Hollywood system. He only became a director to protect his scripts, but he still managed to come up with some of the greatest images in cinema: Gloria Swanson descending a staircase in *Sunset Boulevard*, Jack Lemmon and Joe E. Brown tangoing in *Some Like It Hot* and Marilyn Monroe's dress blown up by a gust from an air vent in *The Seven Year Itch*. He was the perfect synthesis of writer and director, and his words and pictures make unforgettable cinema.

Must-see Movies

Double Indemnity (1944)
The Lost Weekend (1945)
Sunset Boulevard (1950)
Ace in the Hole (1951)
Some Like It Hot (1959)
The Apartment (1960)

FLEEING TO HOLLYWOOD

Samuel Wilder, born in Vienna on 22 June 1906, originally intended to study law, but he got sidetracked into a career in journalism. He became a reporter first in Austria, then Germany, and he supplemented his income by becoming a hotel taxi dancer. During this period he tried to break into screenwriting and earned his first credit collaborating on Robert Siodmak's semi-documentary *People on Sunday* in 1929. Wilder then collaborated on numerous German screenplays, but his career was halted when the Nazis rose to power, forcing the Jewish Wilder to flee to Paris and then Hollywood via Mexico. The rest of his family were not so lucky. His mother and other family members were left behind in concentration camps.

He changed his name to Billy and arrived in Hollywood with little money and a scant command of English. He moved in with German character actor Peter Lorre and eked out a meagre existence working on irregular script collaborations. However, in 1938 Wilder began a long and fruitful association with screenwriter Charles Brackett, turning out some of the most literate, witty American screenplays of the 1930s and 1940s – in particular *Ninotchka* (1939), Ernst Lubitsch's sparkling comedy that gave Greta Garbo her signature role. Lubitsch became Wilder's idol, and he had a sign in his office that said: 'What Would Lubitsch Do?' Wilder and Brackett became established among Hollywood's finest screenwriters, and it was inevitable that their collaboration would broaden, with Wilder becoming the director, Brackett the producer and both men continuing to work on the screenplays. The collaboration lasted 12 years until 1950.

BLACK MAGIC

After his solo directorial debut, *The Major and the Minor* (1942), and *Five Graves to Cairo* (1943), a film about the North African campaign, Wilder established himself in 1944 with *Double Indemnity*, based on the novel by James M. Cain and written in collaboration with pulp-fiction master Raymond Chandler. It was a landmark in film noir, with Barbara Stanwyck playing cinema's greatest *femme fatale* as she seduces insurance salesman Walter Neff (Fred MacMurray) into murdering her husband in order to cash in the premium. The dialogue crackles, the cinematography is realistic *and* stylized and Wilder never soft-pedals the ruthlessness and blackness inherent in the story.

In 1945 Wilder followed this with an even darker picture, American cinema's first serious attempt to deal with alcoholism, *The Lost Weekend*, starring Ray Milland as a writer who seeks solace in the bottle. Wilder cast matinee idol Milland against type as the alcoholic – which made the journey all the more shocking for contemporary audiences – and he employed delirious lighting effects and deep-focus cinematography to create an aura of menace around the drinking.

> 'A director must be a policeman, a midwife, a psychoanalyst, a sycophant and a bastard.'
>
> Billy **Wilder**

Paramount initially considered not releasing the film under pressure from liquor lobbyists, but Wilder convinced them to open it in a limited engagement in New York where it garnered strong reviews. The film won Oscars for Best Director, Screenplay, Actor and Picture and became one of the biggest hits of the year.

Wilder's next two works – the lacklustre comedy *The Emperor's Waltz* and the patchy romance *A Foreign Affair* (both 1948) – failed to enhance his growing reputation. However, 1950's *Sunset Boulevard* put him right back on top. The film charts the relationship between a writer down on his luck (William Holden) and a fading movie star (silent-era icon Gloria Swanson), and it is dark and savage about the trappings of Tinseltown while painting a nostalgic, melancholic picture of a bygone movie age. It is full of original touches, such as making use of a dead narrator, and brimful of memorable lines – 'All right, Mr DeMille, I'm ready for my close-up'; 'I am big. It's the pictures that got small!' It is a macabre, multilevelled masterpiece.

THE CYNIC EMERGES

Sunset Boulevard marked an amicable end to Wilder's collaboration with Brackett, and without him the director's innate sense of cynicism and vulgarity came more to the fore. *Ace in the Hole* (1951), one of the toughest films ever to emerge from Hollywood, is a biting drama about a cynical hack (Kirk Douglas) who delays the rescue of a miner trapped underground to prolong a news story that would make his career. Wilder plies the film with trademark caustic dialogue – 'I've met a lot of hard-boiled eggs in my time, but you – you're twenty minutes' – and paints a picture of a media circus that perhaps seems even more relevant today.

Throughout the rest of the decade Wilder turned in a broad range of interesting work, often subverting traditional genres. Notable films include Second World War prisoner-of-war thriller *Stalag 17* (1953), romantic comedy *Sabrina Fair* (1954) and *The Seven Year Itch* (1955). *Love in the Afternoon* (1957), a romantic comedy, initiated his partnership with screenwriter I.A.L. Diamond, a collaboration that defined the second half of Wilder's career.

THE APARTMENT

The Apartment is perhaps Wilder's most typical film. It was inspired by a scene in *Brief Encounter* where a man lends his flat to illicit lovers, and Wilder and I.A.L. Diamond crafted a beautifully modulated tale of an office worker who offers his home to a philandering boss in return for promotion. Featuring brilliant performances by Jack Lemmon as the put-upon office drone, Fred MacMurray as the sleazy boss, and Shirley MacLaine as the elevator girl caught between them, it is a brilliantly observed satire of working life – feelgood fare with teeth – and the ideal film for crumpled romantics everywhere.

Following *Witness for the Prosecution* (1957), a compelling Agatha Christie courtroom drama, Wilder and Diamond conjured up *Some Like It Hot* (1959), still considered by many to be the funniest American film ever made. In typical fashion comedy gold is spun out of a desperate situation – the St Valentine's Day Massacre – as Wilder tells the story of two musicians (Tony Curtis and Jack Lemmon) who witness the event and cross-dress and join an all-female jazz band to escape the mob. Curtis gets the girl – Marilyn Monroe at her most beguiling – Lemmon gets the laughs and Wilder moves the action so fast you never stop to question the ludicrousness of it all. The film's famous last line is 'Nobody's perfect!' *Some Like It Hot* just might be.

A TWIST OF LEMMON

Wilder teamed up with Lemmon again for another masterpiece, *The Apartment* (1960), and continued the fruitful partnership five more times starting with *Irma La Douce* (1963). *The Fortune Cookie* (1968) is significant in that it marks the first pairing of Lemmon and Walter Matthau, one of cinema's great double acts. The partnership continued under Wilder's guidance with *The Front Page* (1974) and *Buddy, Buddy* (1981). Somehow Lemmon made Wilder's vitriol more palatable.

Away from Lemmon Wilder delivered *One, Two, Three* (1961), a fast-paced, scattershot attack on consumerism led by a boisterous performance from James Cagney. There was also *Kiss Me Stupid* (1964), a sex farce with Dean Martin playing a version of himself, and, best of all, *The Private Life of Sherlock Holmes* (1970), an affectionate and funny look behind the persona of the great detective, with Robert Stephens as Holmes and Colin Blakely as Watson. It was one of Wilder's personal favourites, and he was enraged when the studio cut his original version, reducing the original four stories to two.

Critics often complain that Wilder's films of the 1970s lack the bile and bite of his early work, with a sentimental undercurrent often creeping in. Post *Buddy, Buddy* Wilder found it difficult to get projects started. In his final years he seemed to spend a great deal of time accepting lifetime-achievement awards that he characteristically dubbed 'Quick! Before they croak' awards. When he died aged 95 on 27 March 2002 of pneumonia, French newspaper *Le Monde* announced the news with the headline: 'Billy Wilder is dead. Nobody's perfect.'

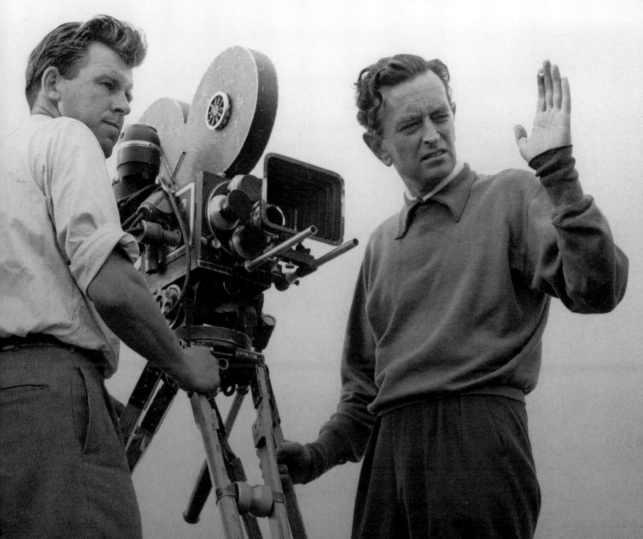

David
Lean

'David Lean makes movies that are
the equivalent of great novels.'

Steven **Spielberg**

1908–91

David Lean made 16 films in 50 years. It is hardly
a prolific work rate, but it speaks volumes for the quest for handcrafted perfection that courses through his oeuvre. His career started with small, intimate works often based on stage plays, but his vision was too grand to be contained by a proscenium arch, so he graduated to huge, historical epics, filled with stunning imagery, challenging locations and a thoughtful and sophisticated sensibility. But, whatever the dimensions, his principles remained the same: his small films are played out on vast emotional canvases; his big films are constructed with a minute attention to detail.

Lean was among cinema's most elegant craftsmen, but his content consistently challenged such elegance, cracking the veneers of middle-class England, the British officer class and colonial India. Winning the Best Director Oscar twice, revered by other filmmakers – Steven Spielberg, George Lucas, Martin Scorsese and Stanley Kubrick have professed admiration – Lean's legacy was to teach Hollywood that spectacle doesn't have to be empty-headed and that classic, literate filmmaking never goes out of style.

Must-see Movies

Brief Encounter (1945)
Great Expectations (1946)
The Bridge on the River Kwai (1957)
Lawrence of Arabia (1962)
Doctor Zhivago (1965)

The young Lean faced an uphill battle to get into movies. His strict Quaker parents prohibited him from watching 'sinful' films during his childhood in Croydon, England, so he resorted to sneaking out to the cinema while away at boarding school. In 1927, after working briefly in his father's accountancy office, Lean followed his passion, becoming a tea boy at Gaumont's Lime Grove Studios in London. He worked as a clapper loader in the camera department, graduating to editing newsreel by 1930, then started a career as a distinguished feature-film editor, working with such renowned British film directors as Anthony Asquith (*Pygmalion*) and Michael Powell (*49th Parallel, One of Our Aircraft Is Missing*).

THE BEST OF BRITISH

In 1942 Lean co-directed the moving wartime adventure *In Which We Serve* with Noël Coward. This collaboration continued over Lean's next three films, with Lean directing and Coward writing the family drama *This Happy Breed* (1944) and the rousing supernatural comedy *Blithe Spirit* (1945). But it was *Brief Encounter* (1945) that saw Lean's talent flourish fully. The touching tale of a doctor (Trevor Howard) and a housewife (Celia Johnson) meeting by chance at a train station and falling in love against their every impulse was based on Coward's one-act play *Still Life*. It was exquisitely shot by Robert Krasker in gleaming black-and-white cinematography, and Lean beautifully contrasts the ordinariness of the couple's situation with the expressionistic violence of passing trains and the overwhelming romanticism of Rachmaninov's Piano Concerto No. 2. Yet it is the restrained, nuanced

performances that Lean draws from his leads that make *Brief Encounter* one of the most poignant movie romances ever made.

Lean established his international reputation with two masterful adaptations of Charles Dickens novels. *Great Expectations* (1946) is rightfully considered the best interpretation of Dickens ever filmed. Lean, in detailing the life of Philip 'Pip' Pirrip (Anthony Wager as a child, John Mills as an adult), delivers rich characterization and unforgettable images that are the cinematic equivalent of Dickens's prose – the opening scene in a graveyard is a masterpiece of film editing, and Lean vividly creates an atmosphere of English Gothic. The film also launched the career of Alec Guinness, who became a frequent Lean collaborator, and the pair followed *Great Expectations* with *Oliver Twist* (1948). However, their treatment caused some controversy, with Guinness's portrayal of Fagin being criticized as anti-Semitic by Jewish pressure groups and many Dickens purists bemoaning the omission of some of the novel's characters. But, if not as perfect as *Great Expectations*, it is still a superlative version of a literary classic.

The early 1950s represent Lean's least impressive period, but he still managed to craft interesting work. *The Sound Barrier* (1952) proffers the first of Lean's obsessive male heroes with Michael Redgrave excellent as the aircraft designer driven to create the first aircraft to fly supersonically. It is also interesting for the uncharacteristically documentary style Lean employs. The film's other star was Lean's second wife, Anne Todd – he was a notorious ladies' man, marrying six times in all.

The Sound Barrier was followed by the wry comedy *Hobson's Choice* (1954), the story of Salford cobbler Horatio Hobson (Charles Laughton) caught in a war of attrition with his wilful daughter Maggie (Brenda de Banzie). *Summertime* (1955) detailed an affair in Venice between a lonely American spinster (Katharine Hepburn) and an antique-shop owner (Rossano Brazzi). *Summertime* is a kind of *Brief Encounter* with better weather, and it introduced a favourite Lean theme, that of the journey as a quest for self-knowledge. It also established Lean's love of location shooting and shifted the perception of him from a purely British director to a filmmaker of international repute. Both of these changes were to prove instrumental in the next phase of his career.

THE EPIC YEARS

In 1957 Lean joined forces with American producer Sam Spiegel to make *The Bridge on the River Kwai*, which was based on a real incident during the Second World War. It is the story of a British officer (Guinness again) in charge of a group of British prisoners of war forced to build a bridge for the Japanese over a river in Burma, and it remains one of the finest depictions of the folly of war and the madness it induces. The film neatly exemplifies what it was that separated Lean's epics from the other big productions that were fashionable in the 1950s and 1960s. *The Bridge on the River Kwai* perfectly juggles the exciting with the thoughtful, Lean knitting interior

THE SEARCH FOR THE PERFECT SHOT

Stories of Lean's quest to capture the ultimate in imagery are legendary. On *The Bridge on the River Kwai* Lean dragged his crew 150 miles (240 km) to capture the perfect sunset. Also, at one point during the shoot, Lean was nearly swept away by a current when lining up a shot in a river – actor Geoffrey Horne saved his life. On *Ryan's Daughter* Lean almost killed his cast and crew, waiting hours to shoot just the right swell of waves off the coast of Ireland. He also refused to let divers intervene as Trevor Howard, Sarah Miles and John Mills bobbed precariously in a rickety little craft.

psychological conflict with exterior, explosive (literally) spectacle into a compelling, completely satisfying whole. Among the film's seven Academy Awards, Lean won his first Oscar for Best Director.

He won his second Oscar for his next film, *Lawrence of Arabia* (1962), which remains his towering achievement. It was shot over 15 months in Saudi Arabia, Morocco, Spain and Britain, and Lean invested the story of T.E. Lawrence's experiences during the Arab revolt against the Turks with breathtaking sweep and majesty: Omar Sharif's first appearance as he emerges out of a mirage over several minutes is still remarkable in its audacity, and the set piece in which Lawrence leads a land attack against the coastal city of Aqaba is astonishing cinema. But Lean anchors the fireworks in a detailed study of a flawed human being, brilliantly portrayed by Peter O'Toole, revealing the contradictions and confusions within an enigmatic hero. This is the lovely irony at the centre of *Lawrence of Arabia*: this study of human imperfection is one of the most perfectly realized films ever made.

Lean stayed in epic mode for his next production, *Doctor Zhivago* (1965), a lush adaptation of Russian author Boris Pasternak's love story set against the backdrop of the Bolshevik Revolution. The film falls short of the greatness of *The Bridge on the River Kwai* and *Lawrence of Arabia*, but it still delivers unforgettable sequences in its depiction of the revolution and Zhivago's trek across the great sweep of the Russian landscape.

Lean's next film was the biggest mis-step in his career. *Ryan's Daughter* (1970) was yet another huge-scale production – US$12 million, five years in the making – but this time in the service of the slight story of adultery in a small Irish town. Lean's direction is as meticulous as ever, guiding John Mills as the village idiot to an Oscar, but the lavish treatment swamped the small tale. The film received poisonous reviews, which, combined with public indifference, sent Lean into a long period of despair and self-enforced retirement.

> **'I think people remember pictures not dialogue. That's why I like pictures.'**
>
> David **Lean**

Although he flirted with numerous projects that were eventually made by other filmmakers – *The Bounty*, *Out of Africa* and *Empire of the Sun*, for example – Lean didn't actually direct for another 14 years. He emerged in 1984, aged 76, with a well-received, if low-key, adaptation of E.M. Forster's *A Passage to India*. That same year Lean received a knighthood. He was in the midst of mounting an epic production of *Nostromo*, set to star Marlon Brando, when he died of cancer on 16 April 1991.

THE CASE AGAINST LEAN

Despite his pre-eminent position Lean's work, particularly his epics, has generated much criticism and controversy. Filmmaker François Truffaut once wrote Lean's work off as 'Oscar packages', and respected critics Pauline Kael, Andrew Sarris and Bosley Crowther all dismissed Lean's epics as empty spectacles, with Crowther describing them as a 'chocolate-box view of history'. Still, Lean's epic period proved immensely popular with audiences – *Doctor Zhivago* was the biggest hit – and Lean himself remained unconcerned: 'I wouldn't take the advice of a lot of so-called critics on how to shoot a close-up of a teapot.'

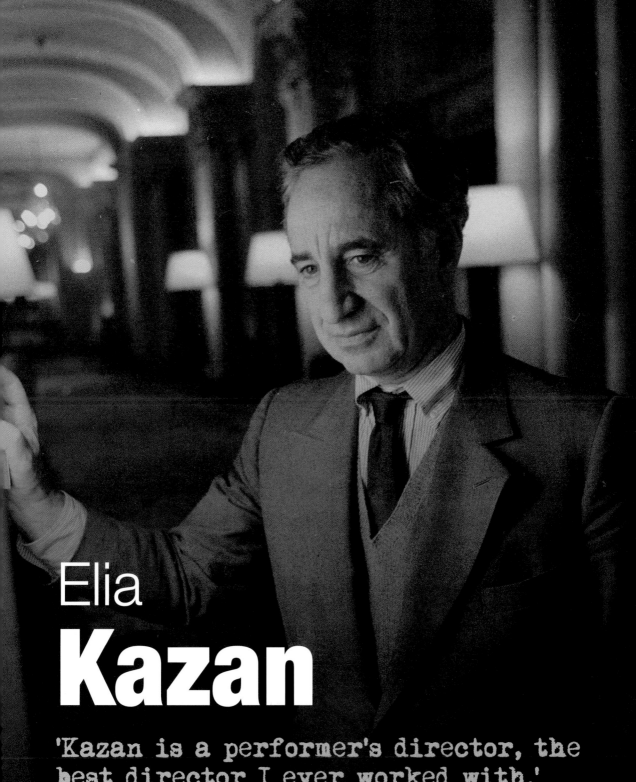

Elia
Kazan

'Kazan is a performer's director, the
best director I ever worked with.'

Marlon **Brando**

1909–2003

Elia Kazan changed movie acting for ever.

His skill, sensitivity and understanding of the acting process breathed fresh naturalism and passion into a new generation of actors. His whole cinema was based around the mythos of Method acting, using long takes with no edits to allow the performers the time and space to express themselves. Not only did Kazan discover two forces of nature in Marlon Brando and James Dean but he also drew the best out of undervalued actors and stalwart supporting players alike. That he directed 21 actors to Oscar nominations, resulting in nine wins, is testament to his status as the ultimate actor's director.

Yet it wasn't just acting that Kazan influenced. His run of provocative, issues-driven films helped set Hollywood's liberal agenda for years. Moreover, his personal brand of cinema, employing real locations over sets, unknowns over stars and realism over convenient genres, proved influential to a whole generation of independent filmmakers, paving the way for a sea change in Hollywood during the late 1960s. If his achievements are tainted by political controversy, the debt Hollywood – and actors everywhere – owes him is enormous.

STAGE TO SCREEN

Before Elia, pronounced E-ii-ah, Kazan discovered film directing, he had already conquered Broadway. He directed his first play in 1935 and went on to become one of the most important and celebrated theatre directors of the 1930s and 1940s, staging brilliant adaptations of works by Tennessee Williams, Arthur Miller and Thornton Wilder. After directing two shorts his debut feature was *A Tree Grows in Brooklyn* (1945), after which he started a run of dramas on contemporary concerns that would become his forte. *Gentleman's Agreement* (1947) tackled anti-Semitism and won Kazan his first Best Director Oscar, while *Pinky* (1949) dealt with issues of racism around a light-skinned black girl passing for white. Kazan's later issues-driven films include *Baby Doll* (1956), exploring child sexuality, and *Face in the Crowd* (1957), a scathing and prescient attack on the cult of celebrity.

'A good director's not sure when he gets on the set what he's going to do.'

Elia **Kazan**

THE METHOD MAN

In 1947, along with former Group Theatre members Cheryl Crawford and Robert Lewis, Kazan founded the Actors Studio in New York, an acting workshop that soon became famous for promoting the Method, a style of theatre and film acting involving total immersion of actor into character. Kazan had directed one of the Actors Studio's brightest talents, Marlon Brando, in a stage adaptation of Tennessee Williams' *A Streetcar Named Desire* and in 1951 cast him once again in the film version. The film gained sparks and tension from the clash of acting styles, the intuitive, energetic Brando as the brutal Stanley Kowalski opposite the more mannered, classical Vivien Leigh as Kowalski's Southern belle sister-in-law Blanche DuBois. The film popularized the Method

Must-see Movies

Panic in the Streets (1950)
A Streetcar Named Desire (1951)
On the Waterfront (1954)
East of Eden (1955)

form, made Brando a star and won four Oscars – astonishingly Kazan and Brando both missed out.

Yet for all the plaudits *Streetcar* felt like a step back cinematically. With *Boomerang* (1947), a courtroom drama, and *Panic in the Streets* (1950), a thriller shot on the streets of New Orleans, Kazan had been experimenting with a documentary style that energized the action, but *Streetcar* returned to the feel of filmed theatre. For his next film, *Viva Zapata* (1952), this time starring Brando as Mexican revolutionary Emiliano Zapata, he reconnected his growing visual confidence with a real feel for atmosphere and locales. Kazan often called it his first film.

His third collaboration with Brando, *On the Waterfront* (1954), won eight Academy Awards, including Best Director, and it is Kazan's undisputed masterpiece. Brando gives arguably the best performance in American film history as ex-boxer turned dockworker Terry Malloy, who is persuaded by a priest to inform on corrupt unions. But the film has so much more to recommend it: memorable dialogue – 'I coulda been a contender, Charley' – gritty New York street photography and a brooding Leonard Bernstein score. Interestingly, in the light of Kazan's 'naming of names' to the House Un-American Activities Committee two years before, the film is ambivalent about the act of informing.

After the success of *On the Waterfront* Kazan plucked another Actors Studio alumnus, James Dean, from obscurity and made him a star. *East of Eden* (1955), a Cain and Abel tale based on a John Steinbeck novel, displays an effective use of the widescreen format and ranks among Kazan's most accomplished work.

ORIGINAL WORK

After previously directing adaptations of stage plays the 1960s saw Kazan turn to his own writings. *America, America* (1963) is a warm, nostalgic but realistic re-creation of his uncle's journey to the New World and *The Arrangement* (1969), based on his own novel, detailed a businessman's attempts at suicide. He returned to mainstream Hollywood in 1976 with *The Last Tycoon*, a look at Tinseltown's golden age, written by Harold Pinter and starring Robert De Niro, Jack Nicholson and Robert Mitchum. However, it was a disappointment, and he made no more films until his death on 23 September 2003.

THE INFORMER

For 19 months between 1934 and 1936 Kazan had been a member of the Communist Party. This brief affiliation came back to haunt him in 1952 when he was called to testify in front of the House Un-American Activities Committee, the witch-hunts designed to flush out communist sympathizers. Kazan admitted his former membership. Controversially, and under studio pressure, he also supplied names of other Hollywood figures involved. The move cost Kazan friends – Arthur Miller for one – and cast a pall over his career that some just can't shake. When the Academy presented Kazan with an honorary Oscar in 1999 the audience was divided, some clapping, others – such as Ed Harris, Nick Nolte and Richard Dreyfuss – refusing to clap or pointedly sitting on their hands.

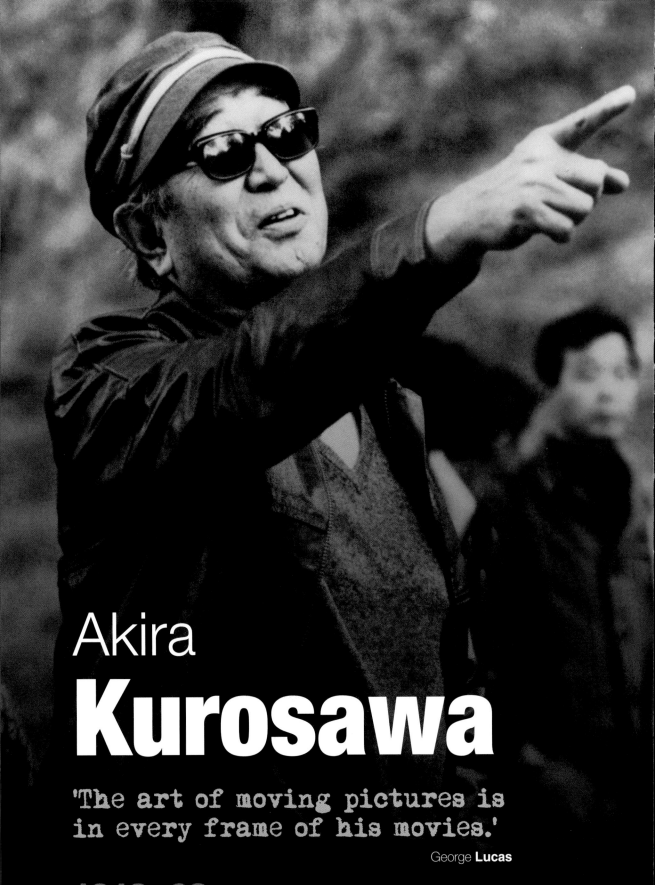

Akira
Kurosawa

'The art of moving pictures is
in every frame of his movies.'

George **Lucas**

1910–98

Akira Kurosawa's nickname was the Emperor.

Given to him for his dictatorial directorial style and his uncharacteristic height – he was over 6 feet (1.8 m) tall – it could also stand for his position as Japan's pre-eminent film director. As a storyteller he had the capacity to tackle the heavyweights of literature yet somehow make them his own; as a filmmaker, he was a master craftsman and a virtuoso stylist, most famously forging stunning collisions of Japanese history and western excitement.

His films are characterized by compassion and a deep regard for the ambiguities of human nature, yet what makes this all the more remarkable is that he mostly did all this while creating the most exciting action scenes ever to run through a projector. He was largely ignored in his homeland but revered everywhere else, and his talent transcended genre, period and nationality. Kurosawa was a filmmaker for the world.

EARLY LIFE

Akira Kurosawa was the seventh child of a strict army-officer father and grew up in the Omori district of Tokyo. He showed an early love of Western painting and literature, both of which were to inform his cinematic work. After studying painting at art school he stumbled into the film industry in 1936 by responding to a newspaper recruitment announcement for assistant directors at Toho Studios. Once accepted Kurosawa fell under the tutelage of renowned director Kajiro Yamamoto, earning a six-year apprenticeship that gave him a thorough grounding in all areas of filmmaking. Perhaps not coincidentally, many of Kurosawa's later films deal with intense master–pupil relationships.

Must-see Movies

Rashomon (1950)
Seven Samurai (1954)
Throne of Blood (1957)
Ran (1985)

By 1941 Kurosawa was writing scenarios and directing whole sequences for Yamamoto's films. In 1941, aged 33, he made his directorial debut with *Judo Saga*, an economically told story about the flowering of judo as a martial art. His subsequent films of the 1940s, such as *The Most Beautiful* (1943) and kabuki-inspired *They Who Step On the Dragon's Tail* (1948), continued this development of style and technique, but it wasn't until gangster melodrama *Drunken Angel* (1948) that Kurosawa came into his own, displaying a complete proficiency of filmmaking technique.

Drunken Angel was notable in another respect. It brought lead actors Toshiro Mifune and Takashi Shimura into Kurosawa's work, and both would become important collaborators. After developing their testy relationship in noir policier *Stray Dog* (1949), medical drama *The Quiet Duel* (1949) and soap opera *Scandal* (1950), Mifune and Shimura starred in *Rashomon* (1950), the film that propelled Kurosawa to international fame. *Rashomon* is the story of the rape of the wife of a samurai as seen through a number of conflicting perspectives, and Kurosawa delivered a brilliantly handled treatise on the subjective nature of truth, marked by outstanding storytelling

control, stylized composition and a great performance from Mifune as a bandit. It was the first Japanese film to be released outside of the homeland and went on to win both the Best Film at Venice and a Special Best Foreign Picture Oscar.

THE SAMURAI MASTER

In 1954 Kurosawa co-wrote and directed *Seven Samurai*, one of the great masterpieces of cinema history. Seven hungry, luckless samurai are hired to defend a poor farming village from marauding bandits, and Kurosawa takes the simple adventure story and makes it rich, moving, funny and exciting. In creating memorable characters out of all seven warriors – no mean feat – he presents his heroes as rounded, dignified outcasts led by Shimura's wise leader and Mifune's crazed hothead. If the depths of humanity are not enough, Kurosawa also stages the most astonishing battle scenes ever committed to film – the climactic showdown in the rain is the stuff of cinematic legend.

Kurosawa's next foray into the samurai genre came with 1957's *Throne of Blood*, an adaptation of Shakespeare's *Macbeth*. The director finds neat parallels between feudal Scotland and feudal Japan, with Mifune as the samurai spurred on by his wife (Isuzu Yamada) to treachery and murder, and Kurosawa replicates Shakespeare's verbal dexterity in astonishing visual techniques, many

> ## THE TRICKS OF HIS TRADE
> Kurosawa used a number of techniques to give his films their unique look. He favoured telephoto lenses that flattened the image and allowed the cameras to be far away from the actors, so producing less self-conscious performances. He also loved to use weather to heighten atmosphere, such as the heavy rain of *Rashomon* and *Seven Samurai* – he even added black calligraphy ink to the water to make it look better on film – the cold wind of *Yojimbo* and the eerie fog of *Throne of Blood*. Ever the perfectionist, on *Ran* he demanded that a stream be made to run backwards simply because it looked better.

'In films, painting and literature, theatre and music come together. But a film is still a film.'

Akira **Kurosawa**

appropriated from Japanese kabuki and Noh theatre traditions. The mist-shrouded forests and castles create an unsettling, eerie aura, and the final images of Mifune pierced by hundreds of arrows are spellbinding.

Kurosawa continued to examine his fascination with samurai history and iconography in *The Hidden Fortress* (1958), which sees Mifune's warrior protect a beautiful princess carrying treasure through a perilous civil war. If it lacks the richness of *Seven Samurai* Kurosawa's first film in the widescreen format is a true visual spectacle. *Yojimbo* (1961) continues his fascination with the western, evident in the plot of a samurai (Mifune again) offering his services to two rival factions and prepared to go with the highest bidder but, more obviously, in the widescreen set-ups in the broad streets of the small town. Along with its virtual sequel, *Sanjuro* (1962), these films also see an element of black humour and parody introduced, undercutting the graphic, stylized violence.

CHAMBER PIECES

Around these samurai classics Kurosawa made some great smaller-scale movies, adapting an eclectic mix of classic and pulp literature, from Russian greats Fyodor Dostoevsky – *The Idiot* (1951) – and Maxim Gorky – *The Lower Depths* (1957) – to American crime writer Ed McBain – *The Bad*

Sleep Well (1960) and *High and Low* (1963). But, just as Kurosawa's best samurai film is from his own screenplay, so his best chamber piece is also original. *Ikiru* (*To Live*, 1952) is a poignant study of an elderly civil servant living with terminal cancer who emerges from his own self-absorption by forcing through the building of a children's playground. It is the complete opposite of the blood and thunder of his samurai films, being both a quiet, intensely moving human drama and a bleak metaphor for Japan's post-Second World War malaise.

Red Beard (1965), which charts the relationship between a doctor and his intern, proved pivotal in Kurosawa's career. It was his last film in black and white, his last film, after 16 collaborations, with Mifune and his last film within the Japanese studio system. Without that stability Kurosawa struggled to get projects off the ground. When he finally got to work in his beloved Hollywood – directing the Japanese segments of *Tora! Tora! Tora!* (1970) – 20th Century Fox replaced him mid production. Kurosawa returned to Japan to direct *Dodes'ka-den* (1970) about the lives of the inhabitants of a small shanty town. The film's poor reception sent him into a depressed state, and in December 1971 he attempted suicide by slashing his wrists 30 times with a razor.

Once his cuts healed he returned to work and form with *Dersu Uzala* (1975), an epic adventure shot in Siberia over four years about the friendship between a Russian explorer and a nomadic trapper. It was the only film he made in another language – Russian – and outside his homeland, and it won the Best Foreign Film Oscar and a Gold Medal at the Moscow Film Festival.

In 1979 Kurosawa made a stunning return to the samurai genre with *Kagemusha*. The film – funded in part by lifelong fans Francis Ford Coppola and George Lucas – tells the story of a doppelgänger for a medieval lord who takes over his position after the lord dies. It is brilliant in its almost dreamlike slow-motion battle scenes, and the film shared the top prize at the Cannes Film Festival. Kurosawa saw the film as a dry run for *Ran* (meaning 'chaos', 1985), his epic transposition of *King Lear* to 16th-century Japan and his final masterpiece of complexity, colour and masterfully staged action. It was a decade in the planning, and it became Japan's most expensive film ever at US$11 million. The movie earned four Academy Award nominations, including Best Director, and he considered it the best film of his career.

In comparison Kurosawa's final three films were minor works. *Dreams* (1990) is a mixed bag of short stories based on his dreams, including an episode with Martin Scorsese portraying Vincent Van Gogh. *Rhapsody in August* (1991) stars Richard Gere in a disappointing drama about memories of the bombing of Nagasaki. His final film, *Not Yet* (1993), is a meditative swan song, the character study of a retiring university lecturer that has the sense of a filmmaker aware he is nearing the end. He died of a stroke in Setagaya, Tokyo, aged 88.

KUROSAWA AND HOLLYWOOD

As much as Kurosawa was influenced by the West, so the West has 'borrowed' from Kurosawa, and this can be most clearly seen in the remakes. *Seven Samurai* became popular western *The Magnificent Seven* (1960) and science-fiction B-movie *Battle Beyond the Stars* (1980). *Yojimbo*, one of Clint Eastwood's favourites, inspired *A Fistful of Dollars* (1964) and the Bruce Willis gangster film *Last Man Standing* (1996). *The Hidden Fortress* was a huge influence on *Star Wars* (1977), both in its plot and in the idea of telling the story from the perspective of the lowliest characters – the humble peasants of *The Hidden Fortress* becoming R2-D2 and C-3P0.

Orson
Welles

'I know a little about Orson's
childhood and seriously doubt
if he ever was a child.'

Joseph **Cotten**

1915–85

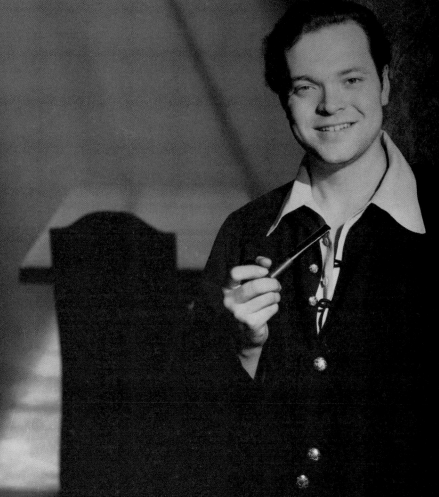

Orson Welles was cinema's boy wonder.

At the tender age of 25 he made *Citizen Kane*, unquestionably the most stunning directorial debut in cinema history. What followed was – inevitably – a spectacular, poignant fall from grace, an artistic rollercoaster ride that ran the gamut of fleeting genius and ignominious failure, rampant ambition and thwarted plans. As much as unfeeling producers and financiers stymied Welles's visions he was also the architect of his own downfall, a slave to his own hubris and runaway passions.

Still, even his biggest failures are more interesting than the best works of many other filmmakers, and his ability to elevate pulp material or energize challenging Shakespearian adaptations is without peer. At the end of his career he may have been best known for his obesity, sherry commercials and television talk-show appearances, but this reputation as a bon vivant should never be allowed to obscure his huge contribution to the art of moviemaking.

BROADWAY BRAT

As a child George Orson Welles redefined precocious. His father was an inventor, his mother a concert pianist and Orson grew up gifted in painting, music and magic; he was acting out scenes from Shakespeare aged five. In 1931, on a visit to Ireland, legend has it that he bluffed his way into Dublin's Gate Theatre Company by convincing them he was a well-known Broadway star.

This falsehood began a sparkling theatrical career, with Welles, in league with producer John Houseman, taking New York by storm. In 1937 the pair formed the Mercury Theatre Company to foster new talent and stage experimental plays. The striking dramatic stagings Welles explored – informed by the expressionist theatre of the 1920s – prefigured the look of many of his films. The company turned to radio in 1938,

'I started at the top and worked down.'

Orson **Welles**

The Mercury Theatre on the Air delivering naturalistic performances of stage plays that bucked the trend of more mannered, stilted radio productions. But it was the Mercury radio production of H.G. Wells's *The War of the Worlds* that became a phenomenon. Unsurprisingly, Hollywood came calling.

On the strength of his theatre and radio work Welles was signed to RKO film studios and given creative carte blanche. He accepted the contract as a means to fund *Five Kings*, an ambitious Shakespearian anthology for the Mercury players. After toying with adapting Joseph Conrad's *Heart of Darkness* he turned to co-writing, directing, producing and starring in a project variously titled during production *American* and *John Citizen USA*.

THE GREATEST FILM EVER MADE

Citizen Kane (1941), a thinly disguised biopic of newspaper magnate William Randolph Hearst, is the story of a newspaper reporter investigating the last word of press baron Charles Foster Kane – 'rosebud'. Welles, telling the tale in flashback through the various people Kane knew,

Must-see Movies

Citizen Kane (1941)

The Magnificent Ambersons (1942)

The Lady from Shanghai (1947)

Othello (1952)

Touch of Evil (1958)

builds up a compelling, psychologically rich patchwork of a complex life, making the point that, ultimately, the inner lives of human beings are unknowable.

Often topping critics' lists of the greatest films ever made, *Citizen Kane* is a landmark film for many reasons, achieving greatness on every level. It is brilliantly acted by the Mercury players, audaciously structured, superbly scripted and intellectually challenging, but *Kane* really gets by on its dazzling application of cinematic technique. Every scene, every moment, every frame courses with cinematic intelligence and chutzpah. Welles uses every weapon in the moviemaking arsenal – deep-focus photography, quick cuts, weird angles, astonishing lighting and a rich, complex soundtrack – but it is never ostentation for ostentation's sake. It is always there to underline meaning.

Perhaps such an original and audacious work was never going to find a huge audience, but this was not the only factor in *Kane*'s eventual commercial failure. William Randolph Hearst had tried to stop the production at every turn and, once it was released on 1 May 1941, resorted to giving the film scathing reviews across all of his newspapers. Despite a smattering of good notices in non-Hearst outlets the film was effectively buried. Unlike some critical favourites it is endlessly rewatchable and, nearly 70 years on, remains the epitome of brilliant, bravura filmmaking.

FOLLOWING KANE

After the financial failure of *Kane* RKO supervised Welles closely on his next picture, *The Magnificent Ambersons* (1942), an ambitious, adroitly assembled portrait of a dysfunctional upper-class family in the early 20th century. Once shooting was finished Welles travelled to South America to make a documentary, *It's All True*, designed to counter Nazi propaganda about Latin America. In his absence an RKO screening of *Ambersons* proved disastrous, and the studio slashed Welles's 160-minute cut to 80 minutes, adding the requisite happy ending. The film proved another commercial disaster, and RKO fired Welles and the whole Mercury staff.

The fracas over *Ambersons* signalled the start of a rocky relationship between Welles and Hollywood. He started his next film, *Journey into Fear* (1943), but it was taken on by Norman Foster after Welles's RKO contract was terminated. *The Stranger* (1946), a thriller for producer Sam Spiegel, proved commercially successful, but Welles dismissed it as 'the worst of my films'.

WAR OF THE WORLDS

On Hallowe'en 1938 the *Mercury Theater on the Air* radio show aired a production of H.G. Wells's *The War of the Worlds* that rocked America. By using pointed pastiches of news announcements and technical breakdowns Welles's adaptation was so convincing that many listeners genuinely thought that aliens were invading New Jersey. Contemporary reports suggested that out of the 6 million people who listened 1.7 million believed it to be true, and the event has become a pop-culture urban legend, shrouded in mystery – conspiracy theorists argue it was an experiment in psychological warfare – and half-truths.

THE SECRET OF ROSEBUD

The meaning of Rosebud, the last word of Charles Foster Kane in *Citizen Kane*, is one of cinema's greatest mysteries – and if you don't want to know stop reading now. Welles called it 'a gimmick' and 'dollar-book Freud', but Rosebud is revealed as the sledge that Kane lost in childhood. Sources of the origin of the word vary, but the most persistent rumour – perhaps because it is the most scurrilous – is that Rosebud was the name William Randolph Hearst gave to the most sensitive part of his mistress Marion Davies's anatomy, the in-joke being Kane/Hearst died with Rosebud on his lips. Whatever its roots Steven Spielberg paid US$65,000 for the prop sledge to remind him 'there is always quality in movies'.

The best movie from this period was *The Lady from Shanghai* (1947), a confused but dazzling film noir built on double crosses and corrupted innocence, and starring Welles and his wife at the time, Rita Hayworth. Columbia boss Harry Cohn, already angered that Welles's marriage to Hayworth compromised her box-office potential, was furious at the way she was presented, Welles cutting off her luxurious red hair and dyeing it blonde. The couple fought constantly throughout the production and divorced soon afterwards, Hayworth quipping, 'I can't take his genius any more.'

EXILE TO EUROPE

After the box-office failure of *Shanghai* and an ill-judged version of *Macbeth* (1948) Welles started a self-imposed exile in Europe. He was gaining success as an actor and embarked on a string of – usually sinister – supporting roles in which he proved more charismatic and compelling than the leads. In 1949 he gave his greatest performance as elusive black marketeer Harry Lime in Carol Reed's *The Third Man* (1949). His next film as director was *Othello*, in which he also played the title role. Although it was made over a period of years in between acting assignments – at one point he borrowed equipment from the set of *The Black Rose* (1950) in which he was starring to shoot some scenes – it emerged in 1952 as one of the most cinematic Shakespeare adaptations committed to film.

In 1958 Welles returned to America to make *Touch of Evil*, a bizarre thriller starring Charlton Heston as an improbable Mexican cop. He was originally approached just to star in the movie but mistakenly believed he was in line to direct, so Heston fought the producers for Welles to be allowed to take the helm. He immediately rewrote the script, turning a cheap drugstore novel into a crime classic through complex character dynamics, a tangible sweaty atmosphere and high style, including a spectacular moving-camera shot that reveals a bomb in a car. Welles returned to Europe, and subsequent ventures included an expressionist version of Franz Kafka's *The Trial* (1962), and another Shakespeare adaptation, *Chimes at Midnight* (1965), in which Welles plays Falstaff, that impresses and irritates in equal measures.

The final films of Welles's career were a mixed bag of oddities. *The Immortal Story* (1968) was a slow-moving, meditative one-hour film for French television, *The Other Side of the Wind* (1972) was a biting Hollywood satire that was never released and *F for Fake* (1974) was a heady brew of found documentary footage and clips from Welles's career linked by his own narration. In 1975 he returned to America, receiving the American Film Institute's Lifetime Achievement award. During his last 15 years he was reduced to making cameos in the likes of *The Muppet Movie*, *Magnum, PI* and *Transformers: The Movie* as well as television commercials – most famously for sherry and frozen peas – and becoming a regular on the talk-show circuit. He died on 10 October 1985 and was found slumped over his typewriter. He left many projects unfinished, including a long-cherished film version of *Don Quixote* – the image of a man tilting at windmills couldn't be more apt.

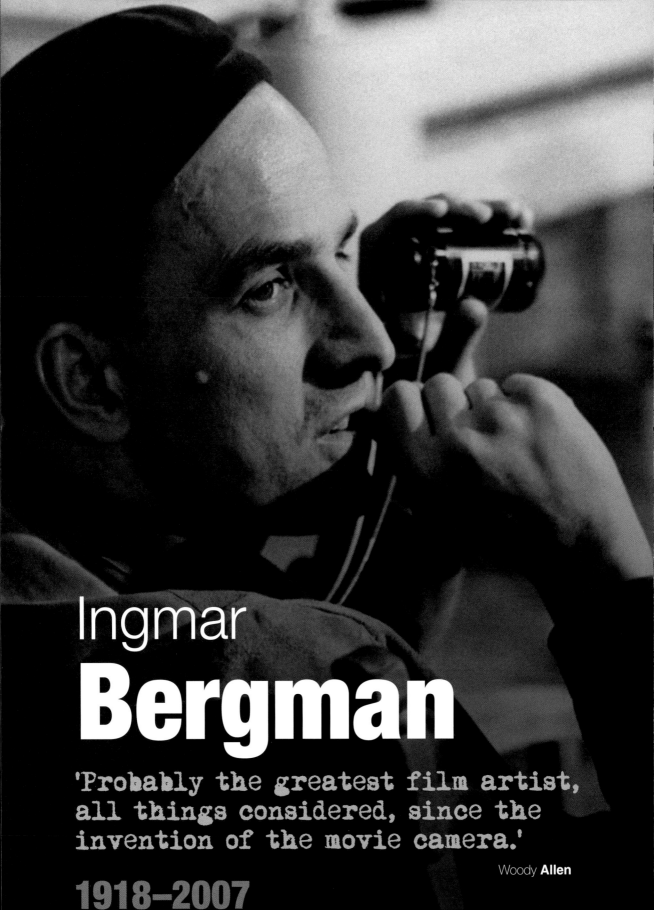

Ingmar
Bergman

'Probably the greatest film artist,
all things considered, since the
invention of the movie camera.'

Woody **Allen**

1918–2007

Ingmar Bergman employed the highly

collaborative medium of movies for purely personal expression to a degree unmatched by any other director. He put his soul, anxieties and longings on film without compromise or mediation, chronicling isolation, angst, guilt and death with an unflinching gaze. Yet Bergman married this naked emotion with cinema's keenest intellect. He never shied away from the 'big themes' about man's place in the universe or the existence of God and found visual ways to explore these high-minded ideas without sacrificing the profundity. As Polish director Krzysztof Kieślowski put it, 'This man is one of the few film directors – perhaps the only one in the world – to have said as much about human nature as Dostoevsky or Camus.'

Must-see Movies

Smiles of a Summer Night (1955)
The Seventh Seal (1957)
Wild Strawberries (1957)
Persona (1966)
Cries and Whispers (1972)
Fanny and Alexander (1982)

It is not difficult to work out why Bergman's films are filled with trauma, darkness and religious guilt given the facts of his childhood. He was raised in Uppsala, Sweden, the son of a Lutheran pastor, who subjected him to a strict, disciplined regime, beating him and locking him in a dark closet if he broke the rules. While his father was preaching Bergman became struck by the religious imagery yet claimed to have lost any vestiges of religious belief by the age of eight. Instead, his new religion became the theatre, using a magic lantern aged nine to recreate Strindberg plays under the playroom table, with young Ingmar acting out all the voices.

THE SHAPE OF THINGS TO COME

After studying art and literature at Stockholm University, followed by a spell as a trainee director at a local theatre, Bergman entered the film industry in 1941 as a script doctor. He got his big break when Carl Anders Dyming, head of Svensk Filmindustri, commissioned him to write the screenplay for Alf Sjöberg's *Frenzy* (1944). The film proved an international success and led to Bergman's directorial debut in 1945 with *Crisis*.

Bergman's early films are not necessarily important in themselves but more for the light they shine on his later works. Drawn from his own screenplay, *The Devil's Wanton* (1949) follows the events that lead to the suicide of a young prostitute, and it is peppered with references to the philosophical notions that consumed and tormented him throughout his whole career. Also, for the first time, an expressionistic style is emerging. *Three Strange Loves* (1949) deals with the interior lives of women, another recurring obsession. But, for the most part, this initial period is derivative and melodramatic. 'I just grabbed helplessly at any form that might help me,' he admitted later.

BERGMAN'S BREAKTHROUGH

Bergman began to find his own voice in two studies of adolescent love, *Summer Interlude* (1950) and *Summer With Monika* (1952). Both films contrast idyllic summer romances with the disillusionment of breakup and are given a glorious lyrical feel by cinematographer Gunnar Fischer. The following year Bergman took another step forward with *Sawdust and Tinsel*, a story of love and deceit set against the backdrop of a small-time circus, with the director delivering a visual tour de force: the silent dream sequence in which a clown is humiliated by his wife in front of a platoon of soldiers is among Bergman's most memorable sequences. Although it was ignored on release it is now seen as pivotal in Bergman's career.

His big breakthrough came two years later with *Smiles of a Summer Night*, an evocative comedy of manners set during a weekend in a country mansion. This charming film belies Bergman's reputation as cinema's greatest peddler of misery, serving up frivolity, mischief and passion all under the beautiful, sensuous light of a Swedish summer. It was enormously influential – among other things it inspired Stephen Sondheim's stage musical *A Little Night Music* – and it invested Bergman with prestige and artistic freedom.

Bergman used this newfound creative independence wisely, making two films in 1957 – *The Seventh Seal* and *Wild Strawberries* – that cemented his reputation as the leading light in European art cinema and film's pre-eminent artist. Shot in 35 days *The Seventh Seal* is a sombre and profound meditation on God and mortality set in the Middle Ages. A knight (Max von Sydow, who became Bergman's onscreen alter ego) returns from the crusades and refuses to accompany Death until he can find a sliver of hope in a world riddled by plague, flagellation and religious persecution. Bergman's 17th film as a director examines the very essence of faith in images of horror and joy, creating one of cinema's most provocative, challenging and enduring masterpieces. It also includes Bergman's most famous and parodied sequence: the knight challenges the Grim Reaper to a game of chess – if the knight wins he lives, if he loses . . .

> 'No form of art goes beyond ordinary consciousness as film does, straight to our emotions, deep into the twilight room of the soul.'
>
> Ingmar **Bergman**

Wild Strawberries is perhaps the warmest and most accessible of Bergman's films. In this story of a retired professor (Victor Sjöström) travelling with his daughter to pick up an honorary doctorate, Bergman skilfully weaves together dreams, memories and reality, creating a framework on which to hang a bittersweet meditation on ageing and isolation. The symbolism, such as handless clocks and runaway hearses, may now feel heavy handed, but Bergman draws a mesmerizing performance from 78-year-old Sjöström as the lecturer. Sjöström had been Sweden's greatest film director, and *Wild Strawberries* feels like a poignant passing on of the crown to a new king.

THE CULT OF BERGMAN

The rapturous reception afforded *The Seventh Seal* and *Wild Strawberries* saw Bergman's reputation soar to unprecedented heights – few filmmakers either before or since have been embraced so wholeheartedly by both the film world and the broader cultural elite.

The veneration continued with *The Virgin Spring* (1959), another stark study of medieval cruelty and superstition. Von Sydow is the father whose faith is severely tested when he confronts the three shepherds who raped and murdered his daughter. Surprisingly, for something so clogged with atmosphere and emotion, the film won the Best Foreign Film Oscar, Bergman's first Academy Award. By now his reputation as a harbinger of gloom was complete.

Bergman's next Oscar came the following year for *Through a Glass Darkly*. Harriet Andersson excels as the woman descending into madness on a remote Baltic island while her husband and father look on. For once a Bergman summer is devoid of joy as the film's symbolism charts a journey into bleak emotional territory. The movie is the first in a loose trilogy – along with *Winter Light* (1962) and *The Silence* (1963) – built around the themes of sanity versus madness and the wavering of religious faith. The films are grim and challenging, *Winter Light* perhaps the bleakest film Bergman made. *The Silence* caused a stir on its original release because of its explicit erotica and traces of lesbianism. As a by-product of his artistic candour Bergman's films often contained frank treatments of sex and violence – something not available in American cinema at that time – giving his work an unexpected commercial selling point.

THE MOVE TO FÅRÖ

Although many critics regard the period from *Wild Strawberries* to *The Silence* as among Bergman's finest achievements he himself dismissed them as 'bogus'. As such, Bergman initiated a change in his filmmaking practices, setting up home and a studio on the remote Swedish island of Fårö and shifting his focus away from existentialism to more penetrating, psychological character studies.

After recovering in hospital from debilitating dizziness Bergman dreamed up *Persona* (1966), in which Liv Ullmann plays an actress, mysteriously struck dumb, who is looked after by a nurse (Bibi Andersson) in a seaside cottage. By playing on the actresses' close resemblance to one another Bergman plays out a psychodrama in which it becomes clear that the nurse is more troubled than her patient. To underline this Bergman uses numerous techniques of distraction, including a fractured narrative structure and disembodied offscreen voices – making apparent the apparatus of filmmaking – and the famous melding of the two actresses' faces, one of art cinema's signature images.

Bergman continued to explore the mindset of artists in *House of the Wolf* (1967), with von Sydow as an artist haunted by hallucinations. *Shame* (1968) and *The Touch* (1971) are more conventional tortured-relationship dramas (the latter featuring the unusual sight of Elliott Gould in a Bergman film) but are relatively minor works. He returned to greatness with 1972's *Cries and Whispers*, the story of two sisters returning to the family manor house where a third sister is dying of cancer. It is an astonishing chamber piece of sisterhood and the failure of love to combat

Moviemakers

loss, and the performances are unforgettable. But what really sticks in the mind is the stunning cinematography by Sven Nykvist and set design, a blood-red palette that is at once beautiful and emotionally ferocious. It is perhaps Bergman's most emotionally gruelling film but also among his finest.

REAL-LIFE TRAUMA

Throughout his film career Bergman never let go of his love of the stage, conducting a life in theatre alongside cinema. In 1976 he was preparing August Strindberg's *Dance of Death* at Stockholm's Royal Dramatic Theatre when, without warning, plain-clothes police interrupted the rehearsal and arrested Bergman for tax evasion. He suffered a nervous breakdown caused by the

BERGMAN'S WOMEN

As well as all his other attributes Bergman is also considered one of cinema's greatest directors of women. His stock company of top-flight actresses included Bibi Andersson, Harriet Andersson, Ingrid Thulin, Gunnel Lindblom and Liv Ullmann. Bergman was obsessed with photographing faces, and his films are redolent with big close-ups of these beautiful female faces. He was by all accounts a charming, charismatic man, and he had long personal relationships with Harriet Andersson, Bibi Andersson and Liv Ullmann, with whom he had a son. There are rumours that all seven actresses in *All These Women* were former Bergman mistresses.

embarrassment and was soon hospitalized in a state of depression. Although he was eventually cleared of the charges Bergman vowed to never work in Sweden again, despite protestations from the prime minister and leading lights in the Swedish film industry.

In his self-imposed exile Bergman's work suffered. *The Serpent's Egg* (1977), his first English-language work, was a study of the causes of Nazism, and *Autumn Sonata* (1978), which paired Bergman for the first time with Swedish superstar Ingrid Bergman, were both disappointments. But just when critics thought his best work was behind him *Fanny and Alexander* (1982) marked a return to Sweden and greatness. Having been inspired by stories of his maternal grandparents Bergman turned the story of a large Swedish family in the early 20th century into a compendium of his interests and passions, a sober retrospective of his life's work. Yet, in old age, Bergman had left the angst behind. *Fanny and Alexander* was a mellow, accessible affirmation of life and love, which found a huge audience and brought Bergman more Oscar success at 65.

Bergman directed one more film, *After the Rehearsal* in 1984, and wrote two more, Cannes Prize winner *The Best Intentions* and *Sunday's Children* (both 1992), the latter directed by his son Daniel, though *Fanny and Alexander* had the feel of a swan song. He officially retired from filmmaking in 2003 and, following a difficult recovery from hip surgery, died peacefully in his sleep on Fårö on 30 July 2007. The filmmaker so obsessed with mortality couldn't fend off his own passing – his own inevitable checkmate had come.

Federico
Fellini

'Fellini is enormously
intuitive; he is creative;
he is an enormous force.'

Ingmar **Bergman**

1920–93

Federico Fellini, the circus ringmaster of Italian movies, was a giant of world cinema. His deeply autobiographical work brought the European art film on to the world stage, winning the Academy Award for the Best Foreign Film four times. His work, informed as it was by his love of comic books, theatre – especially circus – women and food, progressively grew away from realism and storytelling into imaginative flights of fantasy, and his films are sensual and luxurious, revelling in astonishing sights and intoxicating sounds. So well defined and coherent was his world view that his surname has become an adjective, Felliniesque being a watchword for absurd, decadent extravagance.

Considering the deeply autobiographical nature of Fellini's work surprisingly little is known about his upbringing, the hard facts often embellished in both his films and in interviews. He was raised in Rimini, a resort city on the Adriatic. He became fascinated by the circuses and vaudeville performers that visited the seaside town, and both appear regularly in his work. After jobs as a reporter and caricaturist Fellini started writing jokes for actor Aldo Fabrizi and joined his theatrical troupe as a wardrobe master, scenery painter and bit-part actor. In 1943, having avoided the draft because of his poor health, Fellini met and married actress Giulietta Masina. Masina became a key figure in Fellini's work, and they remained married until his death.

COMING OF AGE

Fellini got his break in the film industry when, in 1945, Roberto Rossellini asked him to collaborate on *Rome, Open City*, a landmark film in the Italian neorealist movement. Fellini continued to work for Rossellini both as an assistant on *Paisà* (1946) and as an actor in *Ways of Love* (1948). He made his directorial debut, in collaboration with Alberto Lattuada, with *Variety Lights* (1950), a film about the intrigues of a humble travelling theatrical troupe, clearly informed by his time with Fabrizi. *The White Sheik* (1951) marked Fellini's first solo directorial effort and again made reference to his own life – the comedic story of a woman's affair with a comic-strip hero is infused with his love for comic books.

But neither of these early efforts caused any ripples critically or financially, and it took *I Vitelloni* (1953) to establish Fellini as a director to watch. The film details the antics of an aimless bunch of loafers who wander the streets, relieving the tedium through practical jokes, and it offers a detailed depiction of adolescent ennui and Italian provincial life, one that became a template for directors wanting to document their youth. It is also another chapter in the Fellini cine-autobiography, with the character of Morlando – obviously a surrogate for the director – leaving the small town to take his chances in the big city.

Must-see Movies

I Vitelloni (1953)
La Strada (1954)
La Dolce Vita (1960)
8½ (1963)
Amarcord (1973)

THE MUSIC MAESTRO

A key collaborator on Fellini's cinematic journey was composer Nino Rota. From Fellini's debut *The White Sheik* onwards, the Milanese-born Rota worked on all of Fellini's films until his death in 1979, adding whimsicality, lyricism and emotion to Fellini's often bizarre images. 'When I asked him about the melodies he had in mind to comment on one sequence or another,' Fellini said of Rota, 'I clearly realized he was not concerned with images at all. His world was inner, inside himself, and reality had no way to enter it.' Rota is also famous for composing music for Francis Ford Coppola's *The Godfather* (1972).

RISE TO GREATNESS

Up to this point all of Fellini's work had been rooted in a realist tradition, but his next run of films saw his penchant for the absurd and fantastical start to emerge. *La Strada* (1954) stars Masina as a simple waif who is bought by a circus strongman (Anthony Quinn) for a bowl of pasta, but who manages to retain her spirit in the face of his unstinting domination. It is a mix of tough realism, symbolic poetry, heartfelt sentiment, all held together by Masina's luminous performance. Although the film saw Fellini attacked by the Italian film community for jettisoning his neorealist principles *La Strada* still established him within the international film arena, winning the Oscar for Best Foreign Language Film.

After *Il Bidone* (*The Swindlers*, 1955) – a stark depiction of con men who pose as priests to cheat a group of farmers – Fellini struck gold again in 1957 with *The Nights of Cabiria* (*Le Notti di Cabiria*) with Masina brilliantly essaying a good-hearted prostitute dreaming of a better life but rooted to the misery of her circumstances. It was another international hit and Foreign Film Oscar winner, later being remade in Hollywood as musical *Sweet Charity* (1969). Many critics group *La Strada*, *Il Bidone* and *The Nights of Cabiria* together as the Trilogy of Loneliness.

> 'If I were to make a film about the life of a soul, it would end up being about me.'
>
> Federico **Fellini**

Astonishingly, Fellini managed to up the ante even further in 1960. *La Dolce Vita* is a three-hour odyssey through the decadence and hedonism of contemporary Rome as seen through the eyes of jaded journalist Marcello (Marcello Mastroianni). Full of unforgettable images – a helicopter transporting a statue of Christ over rooftops with sunbathing women; Anita Ekberg bathing in the Trevi Fountain – the film is a savage satire on worthless hedonism. It also anointed Mastroianni as Fellini's alter ego, this time as the young man seduced by the big city. The film was a huge success, helped by accusations of immorality by the Catholic Church, and it won the Grand Prize at the Cannes Film Festival. It also gave the world the term paparazzo, named after a photographer character in the film.

After contributing an essay on sexual hypocrisy in 1962 to anthology film *Boccaccio '70*, Fellini made what many consider his masterpiece. Perhaps a candid response to his overwhelming success and the subsequent pressure he felt, *8½* is about an internationally acclaimed filmmaker (Mastroianni) who did not know what to make next. The title came from the number of films that Fellini had made to date – seven solo ventures and three collaborations that he counted as halves – and *8½* is the first time that the surreal and dreamlike takes over from plot in Fellini's work, often making it difficult to discern where reality begins and imagination ends. This

complex and imaginative movie goes way beyond cinema as autobiography; it is cinema as confession and psychoanalysis.

FLIGHTS OF FANTASY

After *8½* Fellini's films increasingly indulged his predilection for fantastic narratives and bizarre imagery, with large doses of coarse comedy thrown in for good measure. Consequently, his work at this time rarely attained the power and critical adoration of his previous output. *Juliet of the Spirits* (1965), his first colour film, was a journey into the female psyche, while *Fellini Satyricon* (1970) represented his most outrageous work to date, an incomprehensible riot of sex, nudity, dwarves, earthquakes, suicides and grotesques; it is probably the film that best describes the common usage of Felliniesque.

FELLINI'S PLAYGROUND

Perhaps more than any other director Fellini's name became synonymous with a single film studio – the legendary Cinecittà in Rome. He shot most of his films there, be it recreating decadent Rome for *La Dolce Vita* or constructing an entire ocean liner for *And the Ship Sails On*. Fellini first came to the studio as a young journalist on assignment to interview a young actress for a magazine article, an event recreated in his 1987 film *Fellini's Intervista*. The older Fellini comments on this rite of passage, describing Cinecittà as a 'fortress or perhaps an alibi'. Other filmmakers, including Martin Scorsese and Wes Anderson, have used the studio in homage, but Cinecittà will always remain Fellini's paradise.

The Clowns (1970) continued to explore his lifelong fascination with the circus, while *Fellini's Roma* (1972) offered a kaleidoscopic view of the Italian capital.

Fellini came back to top form and storytelling cohesion in 1973 with *Amarcord*, a loving recreation of his childhood in Rimini and another winner of the Best Foreign Language Oscar. He finished off the 1970s with *Fellini's Casanova* (1976), starring Donald Sutherland as the ageing lothario, and *Orchestra Rehearsal* (1978), a smaller chamber piece that uses squabbling musicians as a parable for Italian politics.

Although his reputation had taken a critical downturn – partly because some of his key works were unavailable – Fellini continued to work into the 1980s: *City of Women* (1980) is an outrageous fantasy; *And the Ship Sails On* (1983), a paean to a bygone era, has a rich gallery of characters – and a homesick rhinoceros – gathering on an ocean liner to pay tribute to a deceased opera star; and *Ginger and Fred* (1986) provides a lovely vehicle for Mastroianni and Masina as a fading but sprightly dance couple brought out for one last television reunion. His two final films, *Fellini's Intervista* (1987) and *Voice of the Moon* (1990), are strange, sad and nostalgic reflections on his career.

After receiving a Special Achievement Oscar in 1993 Fellini suffered a stroke in August that year and, following a heart attack, died on 31 October, aged 73 – one day after his and Masina's fiftieth wedding anniversary. Masina died a mere five months later from lung cancer. Fellini's casket was paraded through the streets of Rimini, from the piazza to the local movie theatre where he had watched his first films. To the very end his life and his cinema were inextricably intertwined.

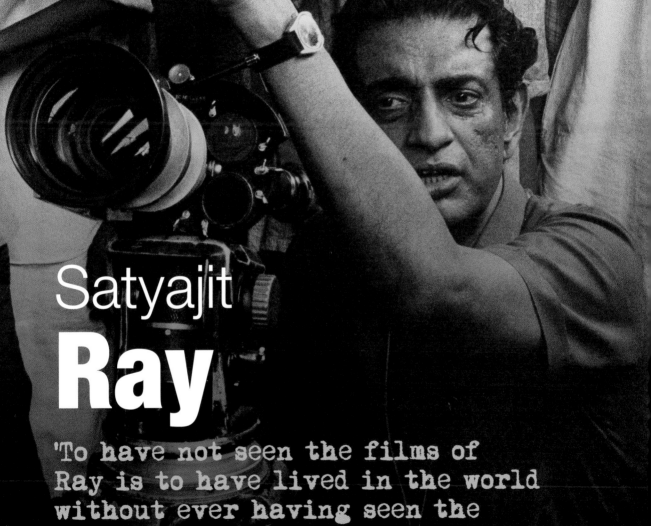

Satyajit
Ray

'To have not seen the films of
Ray is to have lived in the world
without ever having seen the
moon and the sun.'

Akira **Kurosawa**

1921–92

By making films within an industry that only consisted of escapist musical melodramas Satyajit Ray ushered in a whole new era of realism to Indian cinema and beyond, exploring hearts and minds with generous sympathy and gentle satire. His cinema did everything to underline this humanity. His genius was in combining such surface elements as reaction shots, the natural world and music – often composed by himself – to convey inner feelings. And in undertaking such an interior journey Ray transformed the exterior perception of an entire continent.

Satyajit Ray was born into a cultured Calcutta family on 2 May 1921. He majored in economics at the University of Calcutta but found his real calling was in the study of painting and art history at Santiniketan, the centre of learning run by Hindu poet and family friend Rabindranath Tagore. In 1942 he returned to Calcutta to work in an advertising agency, and during his time as an illustrator discovered the book *Pather Panchali*, a classic Bengali novel by Bibhutibhushan Bandopadhyay. He was soon consumed with turning the rites-of-passage story into a film.

> 'The director is the only person who knows what the film is about.'
>
> Satyajit **Ray**

Galvanized by a trip to London, where he was inspired by watching the best of world cinema – in particular *Bicycle Thieves* – Ray tried to raise money for the project but couldn't secure professional backing. However, with the encouragement and support of filmmaker Jean Renoir, who was making *The River* in India at the time, Ray began shooting at weekends, investing his entire salary, selling all his possessions and pawning his wife's jewels to keep the production going. On the verge of abandoning work after 18 months, Ray was saved when New York's Museum of Modern Art agreed to show the finished film, which meant the state government of West Bengal stepped in to sponsor the movie.

THE APU TRILOGY

The debut film that emerged from this chaotic production was a masterpiece. *Pather Panchali* (*Father Panchali*, 1955) is a quiet study of rural Bengali life centring on a young boy Apu (Subir Bannerjee, who was discovered living next door to Ray's wife), who lives on the brink of poverty with his family in a small village. There is no real story as such. Instead, it is the accumulation of beautifully observed details, capturing the nuances and rhythms in family life, that creates a beautiful and moving experience. *Pather Panchali* made a huge impact at the Cannes Film Festival, winning a Special Jury Prize – although critic François Truffaut reputedly walked out in boredom – and putting Indian cinema on to the world stage.

The following year Ray delivered the second chapter of Apu's life, *Aparajito* (*The Unvanquished*), which charts the boy's growing distance from his mother and his acceptance of a university place on a scholarship. In this film we see a prime example of Renoir's wider effect on Ray's filmmaking, which extended beyond simple patronage. Ray was influenced by a number of

Renoir's techniques such as long takes and an affinity with the natural world, and Ray often used environment to portray emotion.

Aparajito brilliantly draws distinctions between Apu's quiet village past and his bustling big-city present, and Ray concluded the story three years later with *Apur Sansar* (*The World of Apu*), a more turbulent take on his adult life with Apu struggling to come to terms with an arranged marriage and a difficult relationship with his son. It is more conventionally structured than the previous films but still full of great naturalistic performances, telling moments and heartfelt scenes, and it is an optimistic end to one of cinema's great trilogies.

AFTER APU

Ray's subsequent filmmaking grew more sophisticated and pointed, but he never really attained the power of the Apu trilogy again. *The Big City* (1953) explores a woman's emancipation through selling knitting machines to rich housewives; *Kanchenjungha* (1962) audaciously used 100 minutes of film time to capture 100 minutes of real time in the life of wealthy Bengalis on holiday; and *The Lonely Wife* (1964) is a warm, generous portrait of the breakup of a marriage. Broadening his view to take in social concerns, *Distant Thunder* (1973) detailed famine in a small village and *The Middle Man* (1975) is a satirical look at shady dealings in big business.

Until 1977 all his films had been made in Bengali, but *The Chess Players* was released that year in Hindi and English. The story centres on two noblemen who are more concerned with chess than the impending Indian Mutiny and stars Richard Attenborough in a supporting role. Ray's output slowed down in the 1980s after he suffered several heart attacks, one of which forced him to hand over *The Home and the World* (1982) to his son Sandip. Confined to working only in the studio he delivered a static, stagebound version of Henrik Ibsen's *An Enemy of the People* (1989), but in 1992 he returned strongly with *The Stranger* (1992), the story of the return of a long-lost uncle to the family fold.

THE ALIEN

In 1967 Ray wrote a script called *The Alien* and went to Hollywood to set it up. The project was slated to star Marlon Brando and Peter Sellers, but when Brando dropped out the project collapsed and Ray returned to India disillusioned with his whole American experience. Years later, in 1982, when Steven Spielberg's *E.T. The Extra-Terrestrial* was released, Ray saw striking similarities to *The Alien*, suggesting Spielberg's film 'would not have been possible without my script being available throughout America in mimeographed copies'. Spielberg denied the claim, reminding Ray he was in high school in 1967.

Ray's heart complications continued, and he died on 23 April 1992, but not before being awarded with an Honorary Oscar just weeks earlier. He was a huge cultural figure in India, and his influence knew no limits, with filmmakers as diverse as James Ivory, Abbas Kiarostami and Wes Anderson acknowledging their debt. The specifics of his work may be Indian, but he created films that spoke to everyone – except perhaps François Truffaut.

Robert
Altman

'He was subversive, and he turned
us viewers into subversives too.'

Mike **Leigh**

1925–2006

Robert Altman was a genuine movie maverick

operating within a Hollywood system that runs on commercial conformity. He was the scourge of the film establishment, and his work generally cast an astute, scathing eye over the breadth of American culture, often exploding genres and character archetypes; Altman was fascinated by people with imperfections, people as they really are, not as the movies would have you believe. Not all his films work, but they are all blessed with great moments – an actor's performance or a stunning display of technique – that remind you why you fell in love with cinema in the first place.

Robert Altman found success late in life. He was born on 20 February 1925 and, after serving as a bomber pilot during the Second World War, attempted numerous abortive business ventures, including a dog-tattooing concern, before trying his hand at film. Altman spent six years making industrial documentaries in his home town of Kansas City, Missouri, before he made his feature-film debut with *The Delinquents* (1957), a cheap exploitation film about juvenile crime. He moved into television, and took ten years to make another feature, *Countdown* (1967), a space-race drama that launched the careers of James Caan and Robert Duvall.

> 'We're not against each other. They sell shoes, and I make gloves.'
>
> Robert **Altman**
> on Hollywood

Altman's breakthrough film was *M*A*S*H* (1970), a job he was only assigned to after it had been rejected by dozens of directors. It stars Elliott Gould and Donald Sutherland as doctors serving in a field hospital during the Korean War, and Altman delivered an exuberant black farce that struck a chord with an audience in the grip of the Vietnam War. It was a huge success, earning the top prize at Cannes and becoming the biggest box-office hit of Altman's career. It also became a long-running television series that toned down a lot of Altman's black humour in the transition.

THE MYTH BUSTER

Altman used the success of *M*A*S*H* as a springboard for a series of films that interrogated and revised traditional Hollywood genres, debunking the codes and conventions of these formulas: *McCabe and Mrs Miller* (1971) and *Buffalo Bill and the Indians* (1976) exposed the myths of the old West; *The Long Goodbye* (1973) injected the hardboiled detective genre with deep-seated ambiguity; *Thieves Like Us* (1974) played variations on the crime thriller; *California Split* (1974) made irreverent fun of the buddy movie, a staple of 1970s cinema; *Quintet* (1979) reinvented post-apocalyptic science fiction; and even *Popeye* (1984) syringed huge doses of cynicism into a big-budget children's film.

But *Nashville* (1975), his 'anti-musical', was his masterwork. It was produced to coincide with the American bicentennial in 1976 and is a satirical view of America, filtered through the country-music industry, in which Altman brilliantly knits together the stories of 24 main characters into a kaleidoscopic view of a nation in crisis. Ironically, Altman's attempt at an anti-musical throws up some great music, including the Oscar-winning song 'I'm Easy', written by actor Keith Carradine.

Throughout all these films Altman developed a distinctive style, involving multilayered soundtracks, busy widescreen compositions, a spare but effective employment of zoom shots and telling use of a wandering camera. He was also a strong director of actors – favourites included Elliott Gould, Sally Kellerman, René Auberjonois and Keith Carradine – encouraging his casts to participate actively in the development of their characters and to improvise.

Must-see Movies

M*A*S*H (1970)
McCabe and Mrs Miller (1971)
Nashville (1975)
The Player (1992)
Short Cuts (1993)

OUT IN THE COLD

Altman's consistent failure at the box office – especially *Popeye* – saw him retreat from the mainstream in the early 1980s. But he continued to be prolific, working on small-scale productions often based on stage plays, such as *Come Back to the Five and Dime, Jimmy Dean, Jimmy Dean* (1982), *Streamers* (1983), *Secret Honor* (1984) and *Fool for Love* (1985). At the time this felt like a director in the doldrums, but in hindsight this period produced some of his best work. *Tanner 88* (1988) is a scathing satire of a presidential campaign that regained the smarts and edge of his 1970s output.

In the 1990s Altman came back to huge acclaim and popularity with *The Player* (1992), the best satire on modern Hollywood. Tim Robbins plays a Hollywood executive who is taunted by a screenwriter he once ignored into murder, and the movie is packed with 65 star-name cameos, which were only made possible because all the actors worked at the minimum rate to honour Altman. The film sends up the stupidity of the system – the script pitching, the deal making – with insight and relish, and, surprisingly, Altman was Oscar nominated by the very people he lampooned.

Short Cuts, his next film in 1993, based on short stories by American writer Raymond Carver, was Altman's most ambitious project since *Nashville*. It is a sprawling, multicharacter panorama of intersecting lives in Los Angeles, bookended by an almost biblical plague of medfly and an earthquake, and a compelling vision of contemporary living that features a clutch of sensitive performances by an all-star cast. But the real hero is Altman, who weaves a complex tapestry of tenderness, comedy, dysfunction and despair into a modern masterpiece.

It is a deeper work than *The Player*, and *Short Cuts* placed Altman back into the Hollywood fold, although with typical irascibility he switched between commercial projects – *The Gingerbread Man* (1998) – and curios such as *Cookie's Fortune* (1999) and *Dr T and the Women* (2000). His most popular film of the new century remains *Gosford Park* (2001), a typical take on the country-house murder-mystery genre. Just five months after completing *Prairie Home Companion* in 2006, a whimsical, lyrical ode to country-music radio, Altman died of complications from leukaemia on 20 November 2006, aged 81.

WIRED FOR SOUND

Altman was one of the very few filmmakers who paid full attention to the possibilities of sound. He layered his soundtracks into dense audio experiences, often overlapping the dialogue, so that audiences are forced to make a concerted effort to listen and get involved. He was also not above putting jokes on his soundtracks, a reward for viewers paying attention: listen out for the movie announcements that appear on the camp PA system in *M*A*S*H* or the musical theme for *The Long Goodbye* that turns up in many unexpected places, even as a doorbell chime.

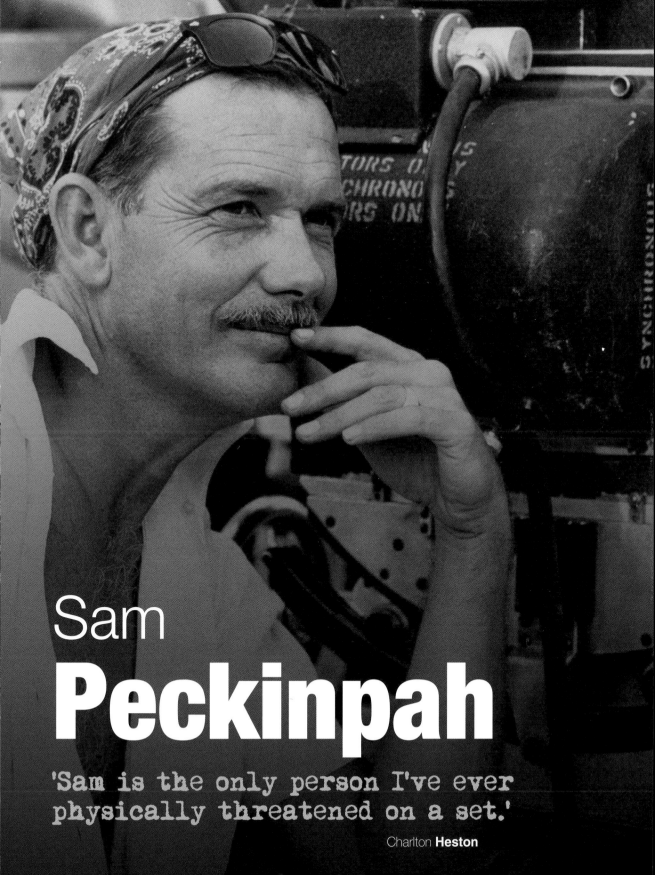

Sam
Peckinpah

'Sam is the only person I've ever
physically threatened on a set.'

Charlton **Heston**

1925–84

Sam Peckinpah was the wild man of the Wild West.

He was renowned for his violence on screen – his nickname was Bloody Sam – and his violent outbursts off screen. His combative personality, fuelled by drink and drugs, brought him into constant conflict with casts, crews and executives. He was a brilliant orchestrator of action, his films ushering in a new level of bloodletting, but this, along with his rebellious reputation, should not obscure the fact that he was also a thoughtful, poetic filmmaker.

His films revised the old views of the West, rejecting conventional movie morality for something more ambivalent, presenting complex characters often unsure of their place in an ever-changing world. Elegiac and lyrical, Peckinpah's work is poetry – with a splash of blood.

FROM MARINE TO MOVIES

Sam Peckinpah was the descendant of pioneer settlers, the son of a cowboy lawyer, so it was perhaps inevitable that he would end up chronicling the Wild West. After a youth marked by boozing and brawling Peckinpah served with the Marines in China after which he enrolled in Fresno State University, where pursuit of the woman who became his first wife – actress Marie Selland – got him interested in theatre. On graduation he worked as a theatre director, then for television station KLATV as a prop man and CBS as an assistant editor, getting his big break as an assistant and dialogue director to filmmaker

Must-see Movies

Ride the High Country (1962)
Major Dundee (1965)
The Wild Bunch (1969)
The Ballad of Cable Hogue (1970)
Pat Garrett and Billy the Kid (1973)

Don Siegel. Most significantly, Peckinpah also co-wrote and played a small role in Siegel's *Invasion of the Body Snatchers* (1956), now considered a classic of 1950s science fiction.

Peckinpah then returned to the small screen, cutting his teeth directing episodes of western dramas, including *Gunsmoke, The Rifleman* and *The Westerner*. He was put forward by Brian Keith, star of *The Westerner*, as the director of *The Deadly Companions* (1961), Keith's upcoming project. Peckinpah's debut is the forgotten movie of his career, a competent but unremarkable western that caused few ripples. It is interesting to note that Peckinpah clashed with producer Charles B. Fitzsimmons over his staging of scenes, so setting a precedent for Peckinpah feuding with the moneymen on his movies.

'I can't direct when I'm sober.'

Sam **Peckinpah**

Peckinpah's second film is his first masterpiece. *Ride the High Country* (1962) has Randolph Scott and Joel McCrea as two gunslingers hired to transport a shipment of gold from a mining community through treacherous terrain, with Scott's cowboy becoming overwhelmed with a desire to steal the bullion for themselves. It is beautifully photographed in CinemaScope by Lucien Ballard, a future key collaborator, and is the first iteration of Peckinpah's dominant themes: the difficulty in being

THE ULTIMATE BLOODBATH

Along with Arthur Penn's *Bonnie and Clyde* (1967), *The Wild Bunch* represented a new level of violence for American cinema. During the production some 90,000 rounds of bullets were fired, which exceeded the number shot in the real Mexican Revolution of 1914 on which the film is partly based. The final shoot-out took 12 days to film, and 10,000 squibs were fired off to replicate bullet hits. But it is not just the special effects that make the sequence so violent. The final showdown edits together 325 shots in five minutes – shots averaging under a second in duration – creating a brilliant bombardment of image and sound.

honourable in a brutal world and men who have outlived their time, struggling to find their way in a changing age. This was given added poignancy by the casting. Scott and McCrea were icons of the western genre, and *Ride the High Country* proved the final work of both actors, a fitting testament to two great careers.

BORN TO BE WILD – THEN MILD

On the strength of *Ride the High Country* Peckinpah was given the reins to *Major Dundee* (1965), the story of a cavalry officer (Charlton Heston) who puts together a makeshift army to catch and kill the Apache who wiped out his New Mexico outpost. Peckinpah, swamped by the scale of the project, drank heavily throughout the shoot, losing control of the budget, the schedule and his temper. His abusive behaviour towards the cast so incensed Heston that he threatened to run the director through with his sabre if he did not show more respect. The film was recut by producers and released in a variety of versions, but Peckinpah's vision remains a dark and violent debunking of cowboy archetypes, with Heston's square-jawed hero revealed as racist and borderline psychotic.

After being fired from *The Cincinnati Kid* Peckinpah was a brave choice to rewrite and direct western *The Wild Bunch* (1969). This tale of a gang of ageing outlaws trying to eke out a living on the Texas–Mexican Border is another of Peckinpah's character studies of an all-male group, portrayed by a brilliant clutch of veteran character actors, including William Holden, Ernest Borgnine, Robert Ryan, Ben Johnson and Peckinpah favourite Warren Oates. The film is bookended by two ferocious action sequences, the final one, with the gang taking on the Mexican army, setting a new level of onscreen violence. But beyond the mayhem it is a thoughtful meditation on men out of time struggling to get to grips with the modern world and a plaintive requiem for a seemingly moribund genre – a film for the moment and for all time.

After the cataclysmic violence of *The Wild Bunch* Peckinpah started the 1970s in a less ferocious mood. *The Ballad of Cable Hogue* (1970) is a gentle comedy about a small-time prospector (Jason Robards) who, after he discovers water in the desert, looks to make a financial killing when he sets up business on the stagecoach route. Proof that Peckinpah had more colours in his palette than just claret, this funny, nostalgic and sublime film remained one of his own favourites.

Following the controversial *Straw Dogs* (1971) Peckinpah returned to this gentler mode with *Junior Bonner* (1972), a low-key drama following the life of a rodeo rider, played by Steve McQueen. 'I made a film where nobody got shot, and nobody went to see it,' he later remarked. Peckinpah stayed with McQueen for his next effort, *The Getaway* (1972), a thriller co-starring Ali MacGraw. The film was polished, professional and successful but lacking true Peckinpah touches and concerns.

BACK IN THE SADDLE

Peckinpah returned to his old obsessions with *Pat Garrett and Billy the Kid* (1973), about the gunman-turned-sheriff Garrett (James Coburn) coming to terms with his past and confronting his former partner Billy (Kris Kristofferson). Peckinpah's final western paid brooding tribute to the genre, filling the cast with former western stars such as Jack Elam, Dub Taylor and Slim Pickens. It also features Bob Dylan – whom Peckinpah had previously never heard of – in a small role. The singer also contributed the film's score, including the song 'Knockin' on Heaven's Door'.

With the crew struck by influenza, curtailed budgets and a director wedded to the bottle, *Pat Garrett* was the most difficult shoot in a career littered with difficult shoots. It also saw the worst of Peckinpah's rebellious behaviour: watching the rushes with cast, crew and executives Peckinpah was so dissatisfied with the footage that he stood on a chair and urinated on the screen. Once again the film was taken away from him, his 124-minute version slashed to 106 minutes and crucified by critics. When Peckinpah's version was released on video in 1988 it was hailed as a lost masterpiece, a moving attempt to explore the real lives behind the legends.

After all this in-fighting with studio bosses Peckinpah finally got complete control over his next film, *Bring Me the Head of Alfredo Garcia* (1974). Warren Oates is a piano player pursued by bounty hunters because a wealthy Mexican landowner has offered a cool US$1.5 million for the severed head of a gigolo he has in his possession. Shot in his beloved Mexico, where he made four films, it is half violent tragedy, half black comedy and has developed a cult following – for its title if for no other reason – following initial box-office rejection.

THE END OF THE TRAIL

Alfredo Garcia's financial failure forced the director to take on commercial ventures. *The Killer Elite* (1975) was a weak thriller, *Convoy* (1978) was a road movie based on a novelty hit record by C.W. McCall and *The Osterman Weekend* (1983), his last film, a star-filled suspense thriller that, for one last time, was meddled with by producers.

The best film of this final phase was *Cross of Iron* (1977), a Second World War drama filled with brilliantly choreographed action and another penetrating study of machismo in crisis. It was the last hurrah of a talent who, following his death on 28 December 1984, left a mark on many filmmakers who followed him: Walter Hill, Quentin Tarantino, Paul Schrader, John Woo and Park Chan-Wook have all been splattered by his genius.

Stanley
Kubrick

'Kubrick gave new meaning
to the word meticulous.'

Jack **Nicholson**

1928–99

Nothing in a Stanley Kubrick film happens by accident. Every scene, every shot, every frame is subject to the most intense scrutiny and intelligent rigour. It gave Kubrick a reputation as an eccentric – an image compounded by his reluctance to appear in public. But he worked hard to attain the status that allowed him to nitpick creatively, slowly building his reputation as a master filmmaker to the point where he controlled everything from the first stages to the final cut, all within the Hollywood studio system.

His work – whether delivering brilliantly rendered recreations of the past, frightening commentaries on the present or dark, complex visions of the future – is marked by symmetrical compositions, stately camera moves and inspired use of existing rather than original music. But, above all, Kubrick's work delivers a cool, intellectual thrill to the most human and emotional subject matter, resulting in uncompromising art comparable to the best in any medium.

FROM SHOESTRING TO SPARTACUS

Stanley Kubrick's obsession with image-making started when, aged 12 and growing up in the Bronx, his father bought him a Graflex stills camera. After landing a job at 17 as a photo-journalist for *Look* magazine and making three little-seen documentaries, Kubrick made two features – war film *Fear and Desire* (1953) and noir thriller *Killer's Kiss* (1955) – on shoestring budgets and single-handedly doing all the technical tasks himself. The experience provided invaluable grounding for his future mastery of the medium.

Kubrick's next production was a significant step up. Having formed a production company with producer James Harris the new partnership acquired the rights to the novel *Clean Break* and fashioned it into *The Killing* (1956), the story of a band of small-time crooks who plot to hold up a racetrack. Kubrick's first film with a professional cast and crew is masterfully handled, the story told through an innovative non-linear timeframe and a fresh documentary style, and it was his first critical success. *The Killing* is now considered a classic caper movie, becoming enormously influential on the likes of *Reservoir Dogs* and *The Usual Suspects*.

'If it can be written or thought, it can be filmed.'

Stanley **Kubrick**

Emboldened by this success the next Kubrick–Harris production was more ambitious. Set during the First World War and filmed in Munich, *Paths of Glory* (1957) follows the defence by Colonel Dax (Kirk Douglas) of three soldiers charged with cowardice by their superiors as an example to other troops. Kubrick delivered a searing anti-war tract, full of horrifying scenes of combat, and it marks the start of his trademark visual style – Dax's march through the trenches in one unbroken tracking shot is a classic image in the Kubrick canon. The film proved controversial on release, the depiction of the army offending the French authorities to the extent that the film remained banned in France until 1975.

After returning to America Kubrick spent six months working on *One Eyed Jacks* (1961), a western starring Marlon Brando, but subsequently left the project after falling out with Brando,

who ended up directing the film himself. He began a two-year period of inactivity in which he failed to get any projects off the ground, this barren spell ending only when Kirk Douglas asked him to take over the reins of Roman epic *Spartacus* (1960) after Anthony Mann had been dismissed. With Douglas producing as well as starring, Kubrick ran into numerous creative ructions with his producer and crew. However, the resulting film is a cut above most lumbering sword-and-sandals movies of the period – Peter Ustinov won an Academy Award as Best Supporting Actor – but Kubrick was dissatisfied: 'It was the only film I did not have complete control over,' he later commented.

MOVE TO ENGLAND

In 1962 he moved to Britain to put some distance between himself and Hollywood and to make *Lolita*, an adaptation of Russian writer Vladimir Nabokov's notorious novel. Escaping the strict US censorship laws Kubrick layered the story of middle-aged Humbert Humbert's (James Mason) infatuation with his pre-teen stepdaughter (Sue Lyon) with black comedy and a hip style far removed from *Spartacus*.

Kubrick originally conceived *Dr Strangelove: Or, How I Learned to Stop Worrying and Love the Bomb* (1964) – adapted from the book *Red Alert* by Peter George – as a thriller, but he increasingly found the story of a renegade general's push for nuclear Armageddon darkly absurd. Peter Sellers gives a tour-de-force performance in his three roles as bemused airman, president and the eponymous Dr Strangelove, an ex-Nazi physicist turned presidential advisor. Sparked by a blackly funny script – 'Gentlemen, you can't fight in here, this is the war room!' – Kubrick's film is less an anti-war statement and more an expression of distrust of the military and the political systems that provoke war. It gave Kubrick his first Best Picture nomination and set up the total creative freedom he craved.

His next film, *2001: A Space Odyssey* (1968), was his magnum opus and remains, for many, the greatest science fiction movie ever made. Kubrick penned the screenplay with author Arthur C. Clarke based on Clarke's short story 'The Sentinel', but, with only 45 minutes of dialogue in the 160-minute running time, *2001* was really written in the director's mind's eye. From the startling editorial cutting of a bone thrown by an ape into a spaceship to the vision of a giant, vulnerable foetus/Star Child floating through space, Kubrick conjured up astonishing images that embodied huge ideas about everything from the end of faith to man's dependence on technology. In realizing Kubrick's vision *2001* set a new standard for visual effects, and one that has never been bettered. In fact, for all his Oscar nominations, the only Academy Award Kubrick ever won was for designing special effects for this film.

But *2001* doesn't just get it right visually, it also has a spectacular soundtrack. Kubrick had commissioned *Spartacus* composer Alex North to write a score but in the end decided not to use it, favouring instead the classical pieces he had played during editing. As a result, spaceships soar and spin to Johann Strauss II's 'The Blue Danube' in a dazzling interplanetary ballet. Generally favouring existing pieces to new composition because it allowed for more control,

Moviemakers

Kubrick used music cleverly throughout his career, often as ironic counterpoint. For example, *Dr Strangelove* plays out nuclear apocalypse to the strains of Vera Lynn singing 'We'll Meet Again', *A Clockwork Orange* accompanies a rape scene with 'Singin' in the Rain' and *Full Metal Jacket* ends with war-weary soldiers combing a battlefield singing the theme to the *Mickey Mouse Club*.

LIKE CLOCKWORK . . .

After the five-year struggle to get *2001* off the ground Kubrick looked for a quick, low-budget project. *A Clockwork Orange* (1971), another striking vision of the future and based on British writer Anthony Burgess's novel, has no shred of *2001*'s curiosity, replacing wonder with an aggressive nihilism. Malcolm McDowell plays the psychotic leader of a gang of thugs – 'droogs' in the Russian-derived slang used in the film – leading them on a crusade of rape, brutality and pillaging. If *2001* is partly about a machine that becomes human, *A Clockwork Orange* details how humans can become (killing) machines. In Britain the film spawned copycat violence with hooligans dressed up in the distinctive braces and bowler hats of the droogs. This, along with a death threat, prompted Kubrick to withdraw the film from release in the UK, where it remained unseen, at least legally, until its re-release in 2000 after his death.

After three films that dealt with the future, Kubrick went forward, into the past. His next production *Barry Lyndon* (1975), based on the William Makepeace Thackeray novel, is the picaresque tale of the dalliances of an 18th-century rogue. It took 300 shooting days to make and is shot through with impeccable craft. Most famously, Kubrick made use of a German camera lens originally designed for NASA that allowed him to shoot using only candlelight, creating beautiful scenes reminiscent of 18th-century paintings. Attacked as cold and soulless by the critics, *Barry Lyndon* is Kubrick's most maligned film critically but also one of his most lyrical and absorbing.

THE HORROR, THE HORROR

It took Kubrick five years to mount his next production, an adaptation of Stephen King's novel *The Shining* (1980). As was standard with Kubrick's book-to-film translations, the film took liberties with the tone of the source material, provoking King to disassociate himself from the project. Kubrick's version has Jack Nicholson's failed writer, Jack Torrance, becoming possessed in an isolated hotel. But like all of Kubrick's films, it is really about humankind's inability to achieve their goals or come to terms with their failings, whether it be trying to tame a teen temptress (*Lolita*), climb social hierarchies (*Barry Lyndon*) or get to grips with a novel, as in *The Shining*.

The Shining is the film, more than any other, that cemented Kubrick's reputation as a pedantic perfectionist, shooting 1.3 million feet (396,240 m) of film and reputedly forcing actress Shelley Duvall to do 127 takes for one scene. He also had a new toy to play with – *The Shining* is the first mainstream feature film to use the Steadicam, a specially weighted camera that seems to glide when carried by an operator. Kubrick makes stunning use of it throughout the film, eerily floating down hotel corridors or following a child on a tricycle.

THE ULTIMATE TRIP

Affected by hostile reviews attacking its funereal pace and impenetrable plot, box-office receipts for *2001* were so low in its first two weeks on release that it was nearly withdrawn. The saving factor was the 1960s counterculture crowd, who embraced the film as a backdrop to bliss out to – rumour had it if you dropped some LSD at the start of the film it would peak as the phantasmagoria of the 'Star Gate' climax kicked in. Noticing this trend, MGM repromoted the film with a new poster and a tagline proclaiming 'The Ultimate Trip'. Thus one of the most thematically complex and challenging movies ever made became a big hit.

Although not a critical success initially, *The Shining* did for the horror film what *2001* did for science fiction: it elevated and imbued a genre perceived as trashy with depth and subtexts. After a hiatus of seven years – the gaps in Kubrick's films were growing longer – he returned with another genre piece, *Full Metal Jacket* (1987), based on Gustav Hasford's Vietnam novel *The Short Timers*. The story is divided into two halves – the first follows the recruits through basic training while the second charts their progress in action – and the sense that emerges is that Kubrick is only really interested in the first section, which is another study in man's dehumanization of man. The film's latter half, shot in London's Isle of Dogs in a meticulous recreation of a Vietnam combat zone, fails to deliver on the power and punch of the early scenes.

SUPERSTAR SWAN SONG

To the outside world Kubrick's career lay dormant for the next ten years. Behind the scenes, however, he was exploring various projects, chiefly Holocaust drama *Aryan Papers* and *A.I. Artificial Intelligence* – a project picked up by Steven Spielberg after Kubrick's death and released in 2001. But Kubrick re-emerged in 1999 with *Eyes Wide Shut*. The film, based on Austrian playwright Arthur Schitzler's novel *Dream Story*, provoked reams of journalistic hyperbole. Because of the sexual nature of the source material, the Kubrickian secrecy of the two-year shoot and the casting of superstar couple Tom Cruise and Nicole Kidman, many speculated that what was being produced would be a celebrity sex odyssey. The film that emerged was completely different, a slow, vividly realized, dreamlike journey through a sexual underworld in which Cruise's character jeopardizes his marriage by drifting through a series of society orgies and strange occurrences.

THE KUBRICK GLARE

A favourite visual trope of Kubrick's is perhaps best described as the Kubrick glare – a close-up of a character, often in emotional freefall, with the head tilted slightly down but the eyes looking straight down the barrel of the camera lens. Famous examples include the opening shot of Alex (Malcolm McDowell) in *A Clockwork Orange*, Pte. Pyle (Vincent D'Onofrio) just before his suicide in *Full Metal Jacket* and William Harford (Tom Cruise) in the back of a taxi in *Eyes Wide Shut* – even the 'human' computer HAL 9000 gets the glare in his final moments in *2001*.

As ever, it was a hung jury critically, some reviewers loving it and others deriding it. It was a reaction that Kubrick didn't live to see, however. Four days after screening the final cut for cast, family and executives, the 70-year-old director died of a heart attack in his sleep. In the kind of sentimental act he never let slip into his films he was buried next to his favourite tree in the grounds of his home in Hertfordshire, England.

Sergio
Leone

'Sergio's films changed the style of
the western – they operacized them.'

Clint **Eastwood**

1929–89

Sergio Leone's impact on the western genre

was seismic. He took the beautiful, poetic vision of John Ford and flipped it upside down, turning the Wild West into something weird, wonderful and unreal. His stories were skeletal, but he made them unforgettable through a bizarre mixture of random violence, striking ponchos, black comedy, Mexican standoffs, great faces, small cheroots, hostile landscapes and big close-ups that show only the eyes. As such, Leone's baroque panache made westerns cool just when the genre was on its last legs, his high style making him one of the most parodied and influential directors of all time – action movies would never be the same again.

Must-see Movies

A Fistful of Dollars (1964)
For a Few Dollars More (1965)
The Good, the Bad and the Ugly (1966)
Once upon a Time in the West (1968)
Once upon a Time in America (1984)

Leone was the son of Italian film royalty. His father Vincenzo was a silent-film pioneer, his mother Francesca Bertini a big-screen diva. Working as an assistant director and occasional actor – in 1948 he appeared as a priest in Vittorio de Sica's neorealist classic *Bicycle Thieves* – Leone graduated to second-unit director and co-screenwriter on the so-called 'sword-and-sandal' historical epics that held sway in Italian cinema during the 1950s. After director Mario Bonnard fell ill during the production of *The Last Days of Pompeii* Leone took over but received no actual credit on the final film. This experience paved the way for his directorial debut in 1961 with *The Colossus of Rhodes*, a spectacular adventure – with faded cowboy star Rory Calhoun as an Athenian soldier – that introduced the synthesis of violence and dark humour he was about to unleash on an unsuspecting world.

THE DOLLARS TRILOGY

After the run of Italian historical epics came to an end Leone found himself at the forefront of a burgeoning new genre, the spaghetti western, an Italian spin on the American cowboy film. The first, *A Fistful of Dollars* (1964), which is the story of a mysterious Man With No Name who gets caught up in a feud between rival families ending in an explosion of violence, relocated Akira Kurosawa's *Yōjimbo* to the Wild West, or in reality the Spanish province of Almería where the film was shot.

Having been turned down by Henry Fonda, Charles Bronson, Ty Harding and James Coburn, Leone settled on Clint Eastwood to play the mysterious stranger. Eastwood was then a struggling actor best known for his work on television western *Rawhide*, but it remains one of the most inspired pieces of casting in movie history. Eastwood stripped the script of most of the dialogue, creating an aura of mystery and inscrutability, a man devoid of a past who gets by on his wits and a gun. *Fistful* instantly transformed Eastwood into a cultural icon with a persona the actor-turned-director has played with and developed throughout his subsequent career.

> **'I can't see America any other way than with a European's eyes; it fascinates me and terrifies me at the same time.'**
>
> Sergio **Leone**

Leone followed this up with two sequels, *For a Few Dollars More* (1965) and *The Good, the Bad and the Ugly* (1966). The latter is the most convoluted of the three, outlining a complex criss-crossing of fates set against the background of the US Civil War. Leone ups the black humour and the stylized violence but also adds different emotional colours, especially Eastwood's tender run-in with a dying man. A stunning troika, the Dollars trilogy spawned a deluge of spaghetti-western imitators, providing work for fading US action stars, though none can match the stunning originals.

ONCE UPON A TIME . . .

After the success of the Dollars trilogy Leone was courted by Paramount Pictures to direct his first American film, and the result was Leone's undisputed masterpiece. *Once upon a Time in the West* (1968) is a lavish, operatic western, a serious meditation on the mythology of the genre. Full of brilliant cinematic set pieces – the opening in which three hired guns await the arrival of a train is crafted with incredible tension – the film was mercilessly truncated by Paramount from 165 minutes to 140. Still, it was a huge hit in Europe and is now rightly seen as one of the great westerns.

Following *A Fistful of Dynamite* (1971), an enjoyable twist on his usual 'spaghetti' style but not as successful as the Dollars trilogy, Leone turned down *The Godfather* and stuck to producing, taking ten years to prepare his next production. *Once upon a Time in America* (1984) does for the gangster genre what *Once upon a Time in the West* did for the western; it is a dense, complex chronicle following the lives of two gangsters (Robert De Niro and James Woods) over four decades, shifting through time with audacious flashback techniques and meticulous period recreation. Once again it was re-edited – or 'butchered' in Leone's view – but later rediscovered in Europe to great acclaim.

Leone was working on an epic US$70-million epic about the battle of Leningrad during the Second World War when he died of a heart attack on 30 April 1989. Perhaps the most telling accolade came from Clint Eastwood, who dedicated his own 1992 revisionist western *Unforgiven* to Leone, the student honouring the master.

MORRICONE

A huge factor in the stylized feel of Leone's work is the music of composer Ennio Morricone. Scoring all of Leone's films from *A Fistful of Dollars* onwards, Morricone's compositions for the Dollars trilogy ape the traditional western scores of composer Dmitri Tiomkin but orchestrate them with original instrumentation, including rifle shots, electric guitars, jew's-harp, whip cracks and trademark whistling courtesy of Morricone's childhood friend Alessandro Alessandroni. Morricone worked in an unusual fashion, writing the music based on the script rather than the finished film, with Leone playing the score on set as mood music to help the actors, so imbuing the films with operatic dimensions from the outset.

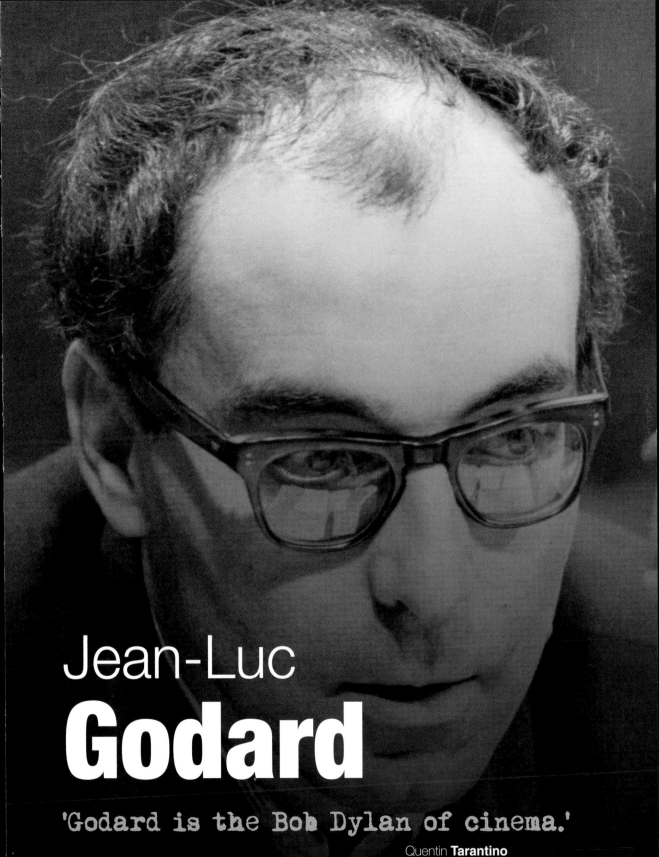

Jean-Luc
Godard

'Godard is the Bob Dylan of cinema.'
Quentin **Tarantino**

1930–

Jean-Luc Godard is the anarchic king of the

nouvelle vague (French New Wave). His work is proof that you can make great movies just by loving movies enough. It is infused with a passion for cinema and peppered with playful allusions to film history that write a whole new lexicon out of existing cinematic language. To see *Breathless* or *Contempt* for the first time is to get an object lesson in what cinema is actually capable of.

Transcending this revolution of form Godard later sought to find new ways to express political ideas and bring about change. He didn't always succeed in this lofty goal, but many of his once audacious techniques have now been appropriated by the mainstream, albeit in diluted forms. Godard fundamentally changed the way movies were conceived, put together and perceived – in a medium that was already 60 years old that was nothing short of miraculous.

CRITIC TO CREATOR

Like many revolutionaries Jean-Luc Godard grew up in the most comfortable surroundings. His father was a doctor and his mother a banker's daughter, and Godard was educated in Nyon, Switzerland, and then in Paris, enrolling at the Sorbonne to study ethnology. It was here that he first discovered his passion for cinema, haunting Left Bank cinemas and the Cinémathèque, which brought him into contact with François Truffaut, Jacques Rivette and Eric Rohmer, the core group that would go on to form the nucleus of the *nouvelle vague*. He started writing for film magazine *La Gazette du cinéma* then *Cahiers du cinéma* under the pseudonym Hans Lucas – a Germanized version of his first name – and his addiction to film watching grew so intense that he sold his grandfather's collection of first-edition books to finance it, an act that saw him cut off from any financial assistance by his father.

> 'Cinema is the most beautiful fraud in the world.'
>
> Jean-Luc **Godard**

While still writing for *Cahiers* Godard began a series of odd jobs, including a spell as a petty thief that led him to spend six days in a Swiss jail. After getting a job as a labourer on a dam-building project Godard used the earnings to buy a 35-mm movie camera and made a short film, *Opération 'Béton'* (1954), about the construction work.

After four more shorts Godard stunned the film world with his first feature. Co-written with Truffaut *Breathless* (*À bout de souffle*, 1960) follows a young French car thief (Jean-Paul Belmondo) who goes on the run with his American girlfriend (Jean Seberg). Godard invests the simple story with the spirit and archetypes of Hollywood gangster flicks but reinvigorates them with a stunning reinvention of cinematic technique, embroidering

Must-see Movies

Breathless (1960)
Vivre sa vie (1962)
Contempt (1963)
Bande à part (1964)
Pierrot le fou (1965)

THE TARANTINO CONNECTIONS

Quentin Tarantino, a huge fan of Godard's work, has peppered his own oeuvre with references to the director. In *Reservoir Dogs* the jewellery shop the thieves hold up is called Karina's in honour of Godard's muse and wife, Anna Karina. Tarantino later showed John Travolta and Uma Thurman the dance scene in *Bande à part* as an inspiration for their famous twist in *Pulp Fiction* – Tarantino also named his production company A Band Apart after the film's original title. But perhaps Tarantino's most bizarre tribute was in pretending, while a struggling actor, that Godard's *King Lear* was on his résumé, secure in the knowledge that few people had actually seen it.

the story with jump cuts – jarring edits that break continuity in time – shaky handheld camera work, monologues to camera and a fractured storytelling style. Spontaneous, vibrant and challenging, *Breathless* made a star of Belmondo, relaunched the career Seberg and confirmed Godard as the leading light of the *nouvelle vague*.

THE FIRST WAVE

Grabbing his opportunity *Breathless* started a breathless period of creativity and productivity for Godard. *Le Petit soldat* (*The Little Soldier*) was a savage response to the French–Algerian conflict, filmed in 1960 but banned by the French authorities until 1963. *Une Femme est une femme* (*A Woman Is a Woman*, 1961), in which a nightclub stripper wants to settle down and raise a family, is Godard's lightest, most likable film and is a love letter to Anna Karina, who became Godard's wife in 1961. Karina also starred in Godard's next, *Vivre sa vie* (*My Life to Live*, 1962), a brilliant, inventive character portrait of a prostitute structured in 12 vignettes.

Following *Les Carabiniers* (*The Riflemen*, 1963), a blistering anti-war allegory that was attacked so viciously that Godard took the unprecedented step of defending his own film in the pages of *Cahiers du cinéma*, he returned to the gangster milieu for his next film, *Bande à part* (*Band of Outsiders*, 1964), a sprightly, innovative story of two guys, a girl and a robbery. *Une Femme mariée* (1964) is the study of a wife caught between her airline-pilot husband and her actor lover – but the movie so enraged President de Gaulle for its depiction of French women as unfaithful that the authorities censored the title, changing it from *Married Women* to *A Married Woman* in order to make it seem unrepresentative of French behaviour.

Shifting genres again Godard delivered vividly realized science fiction with *Alphaville* (1965), a coruscating view of a technology-dominated, emotionless future, and audacious chase thriller *Pierrot le fou* (1965) that encompassed a study of violence, both global and emotional – in fact, the love–hate relationship between stars Jean-Paul Belmondo and Anna Karina is an obvious reflection on the Godard–Karina marriage that ended shortly after.

FROM CINEASTE TO RADICAL

After *Pierrot le fou* Godard's work shifted away from playful deconstructions of cinematic narratives to films-as-essays, with movies such as *Masculine-Feminine*, *Made in USA* (both 1966) and *Two or Three Things I Know About Her* (1967) increasingly becoming mouthpieces for political and social ideas.

Following the violent, politically charged *La Chinoise* (*The Chinese Girl*, 1967) Godard's period of prolific activity came to an end with *Weekend* (1967), the best of this series of essays. It is a ferocious attack on modern living, in which an upper-class couple get caught in a traffic jam that descends into cannibalism, but it is also a bravura piece of filmmaking, best exemplified by a virtuoso ten-minute tracking shot along miles of static cars, angry drivers and accident victims. In a period of political haranguing *Weekend* was a potent reminder of how exciting Godard's cinema could be.

In hindsight this series of cine-essays marked a period of transition for Godard from his status as a freewheeling formalist to a new politically informed filmmaker. Within the cauldron of cultural upheaval sweeping France in May 1968 Godard started to make 'revolutionary films for revolutionary audiences' within a collective called the Dziga Vertov Group – named after the revolutionary Russian filmmaker. Aimed at committed Marxists, leftist groups and students, his 1969 films *Pravda*, *British Sounds* and *Le Vent d'est* (*Wind from the East*) represented Godard's view that he wasn't just making political films, he was making films politically, expressing radical ideas through radical forms and denying the audience such traditional viewing pleasures as the emotional identification that allowed them space to ruminate on the ideas.

The most commercial – not to mention watchable – film of this period of radicalism is *Tout va bien* (*Everything's Going Fine*, 1972), which cast Jane Fonda and Yves Montand as the leads. Godard tells the story of an American journalist (Fonda) and her film-director husband (Montand) who arrive to report on a factory sit-in but get caught up in the political struggle. This played neatly on Fonda's radical image, and the film manages to blend Godard's aesthetic and political stand with something more mainstream and entertaining, slyly commenting on the need for movie stars to raise finance.

THE SECOND WAVE

Godard continued with these more esoteric television and video projects up to the 1980s when he returned to more conventional – by his standards – forms of filmmaking. *Slow Motion* (1980) marked a vigorous return to form, exploring his favourite themes of sexuality as consumerism and the relationship between sound and image but with slivers of story and a well-known French cast. Godard called it his 'second first film'.

What followed was a prolific period that rivalled his output in the 1960s: *Passion* (1982), a rumination on moviemaking, love and work; *First Name Carmen* (1983), a humorous updating of the opera; *Detective* (1985), a B-movie homage harking back to *Breathless*; and *Hail Mary* (1985), a controversial retelling of the Nativity set in a petrol station, which raised the hackles of the Catholic Church. Perhaps the most bizarre film of this phase was his version of *King Lear* (1987), with Godard assembling a random cast running from Woody Allen to Burgess Meredith, Norman Mailer to Molly Ringwald.

During this period Godard seemed to be drifting towards a more mainstream audience, but with characteristic unpredictability the past two decades have seen the return of a filmmaker defiantly pursuing his own uncompromising agenda, making cinematic puzzles – *For Ever Mozart* (1996) – visual essays – *Histoire(s) du cinéma* (1988–98) – and unconventional dramas – *In Praise of Love* (2001). In 2008 Godard barely registers on the international film scene, a disappointing but perhaps inevitable situation for someone who burned so bright for so long.

CONTEMPT

Le Mépris (*Contempt*), in which an international film crew who can only speak through interpreters mount a production of the *Odyssey*, is shot in luscious widescreen cinematography and is both a meditation on cinema's relationship with reality and the difficulty of communication. Starring Brigitte Bardot, Jack Palance and renowned filmmaker Fritz Lang as the director – with Godard himself playing his reverential assistant – it is Godard's most visually sumptuous film while still managing to be intellectually enriching.

François
Truffaut

'Truffaut's passion for cinema,
the desire that it stirred in him,
animates every film he ever made,
every scene, every shot.'

Martin **Scorsese**

1932–84

If the films of François Truffaut are about anything, they are about love – love of women, love of children and perhaps most of all, love of movies. Truffaut was the first film critic to cross the barricades to become a film director, and he lived, ate and breathed film. As a critic he vociferously defended the things he cherished and took a baseball bat to the rest; as a filmmaker he made movies that coursed with the possibilities of cinema – many of the films were even about films. His relationships were almost exclusively contained within the film world; he was markedly apolitical, and his self-proclaimed religion was Charlie Chaplin.

Yet, despite existing in a hermetically sealed cinematic bubble, Truffaut's work is full of insight and understanding about life and love. As a writer-director-producer – and sometimes actor – he specialized in intimate chamber pieces that exposed the frailty and contradictions of the human heart with delicacy and compassion, creating a blueprint for a new type of personal cinema. There are no villains in Truffaut's generous worldview, just recognizable people in conflict. At one stage during *Stolen Kisses* (1968), the formidable Mme Tabard (Delphine Seyrig) observes, 'People are terrific.' It could stand as a motto for all of Truffaut's work.

FROM DELINQUENT TO DIRECTOR

François Roland Truffaut had a strange, unhappy childhood. He was born out of wedlock in 1932 and was shunted between various nannies and his grandmother, who instilled in him a love of books. He played truant from school and drifted in and out of remand homes. Truffaut watched his first film, Abel Gance's *Paradise Lost*, aged eight, and thereafter sought constant solace in the cinema, frequenting Henri Langlois' Cinémathèque, where he was exposed to all kinds of cinema and, in 1948, he formed his own film club, Movie Mania, selling a typewriter stolen from his stepfather's office to finance screenings.

Movie Mania brought Truffaut into contact with influential critic André Bazin. When Truffaut was arrested for desertion from the French army in 1952 – he had unwisely enlisted to escape a failed love affair – Bazin used his political clout to get Truffaut released and gave

'Cinema is an improvement on life.'

François **Truffaut**

the young upstart a job at film magazine *Cahiers du cinéma*. Truffaut quickly earned a reputation as France's most ferocious critic – he was nicknamed the Grave Digger – launching brutal, scathing attacks against the French film establishment. In 1958 he was banned from the Cannes Film Festival for complaining about the flowers at the bottom of the screen, which were blocking the view of the critics in the stalls.

During his heady days at *Cahiers* Truffaut interviewed and befriended a number of filmmakers, including Jean Renoir, Max Ophuls and Roberto Rossellini, and his focus began to shift from criticism to production. After working as Rossellini's assistant, Truffaut formed his own production company, Les Films du Carrosse, named after Renoir's *La Carrosse d'or*, and began making shorts, one

Must-see Movies

The Four Hundred Blows (1959)
Shoot the Piano Player (1960)
Jules et Jim (1962)
The Wild Child (1970)
Day for Night (1973)

of which, *Les Mistons* (*The Mischief Makers*, 1957), about a group of children captivated by a young girl, contains many of the themes that peppered his later work. With fellow *Cahiers* critics Jean-Luc Godard, Eric Rohmer and Jacques Rivette he formed a group of filmmakers dubbed the *nouvelle vague*, their aim to revitalize French cinema. With finance coming from his marriage in 1957 to Madeleine Morgenstern, a film financier's daughter, Truffaut led the charge into feature films, and his first effort, in 1959, was a masterpiece: *The Four Hundred Blows* (*Les Quatre cents coups*).

THE ANTOINE DOINEL CYCLE

Like many first novels, *The Four Hundred Blows* was ripped from the fabric of Truffaut's youth. Like Truffaut, its 12-year-old hero, Antoine Doinel (Jean-Pierre Léaud), came from a broken home, skipped school, stole typewriters and ended up breaking out of reform school. He fashioned the screenplay with Marcel Moussy, who tempered Truffaut's desire to settle a score with his parents, and allowed Léaud plenty of scope to improvise; in so doing Truffaut created a cinematic autobiography that is poignant, funny, lyrical, unsentimental and authentic. *The Four Hundred Blows* cemented the reputation of the *nouvelle vague* and earned Truffaut a Best Director award at Cannes in 1959. Watching the movie from the balcony he later remarked how lovely the flowers looked at the bottom of the screen.

Thankfully, Truffaut didn't leave Doinel there. In one of the most remarkable film series in all of cinema, Truffaut followed Antoine through first love (*Antoine et Colette*, 1962 – Truffaut's personal favourite in the series), marriage (*Stolen Kisses/Baisers volés*, 1968), marital discord and infidelity (*Bed and Board/Domicile conjugale*, 1970) and the aftermath of divorce (*Love on the Run/L'Amour en fuite*, 1979), with the same actor, Léaud, playing the same part for 21 years. Again the movies borrow liberally from Truffaut's own life: Antoine moves into an apartment to be near a girl, gets imprisoned for deserting the army and goes through the pangs of separation, all things that happened to Truffaut. But Truffaut also leaned on Léaud's life for emotional colour and incident, demolishing the boundaries between fact and fiction, actor and character, performance and personality. *Love on the Run* closes with clips from all the previous Doinel films, ending on a shot

A CLOSE ENCOUNTER

'I needed a man who resembled the soul of a child,' said Steven Spielberg about casting Truffaut in his 1977 science-fiction epic *Close Encounters of the Third Kind*. When Spielberg offered him the role of UFO investigator Claude Lacombe because of his portrayal of the doctor in *The Wild Child*, Truffaut accepted the role primarily to undertake research for a book he was preparing on acting. During the long, complicated shoot, Truffaut struggled with the English dialogue – it was often written out phonetically on cue cards and strapped to other actors' chests – and mused that he could make five films for all the money the Americans were pouring into this one. But, in a sea of special effects, Truffaut shines, his gentle portrayal lending *Close Encounters* a warm, human presence.

M o v i e m a k e r s

from *The Four Hundred Blows* that sees the young
Doinel spinning on a fairground attraction.
Tellingly, the man standing next to him is
Truffaut himself, the director and his alter
ego blurring into one.

UPS AND DOWNS

Away from Doinel, Truffaut still had a few more
masterpieces in hand. His second film, *Shoot
the Piano Player* (*Tirez sur le pianiste*, 1960), turned a
standard detective novel inside out with radical
editing techniques, sight gags and a playful
understanding of thriller staples. He followed
this with *Jules et Jim* (1962), a period ménage à
trois drama starring Oskar Werner, Henri Serre
and a captivating Jeanne Moreau shot through
with a capricious freewheeling spirit.

In 1973 Truffaut delivered what many
considered his best film. *Day for Night* (*La Nuit
américaine*) – named after the moviemaking
term for shooting daylight exteriors with

THE FRENCH NEW WAVE

The critics at *Cahiers du cinéma* – including
François Truffaut, Jean-Luc Godard, Claude
Chabrol, Eric Rohmer and Jacques Rivette
– had become dissatisfied with the stagnant
state of French cinema in the mid 1950s, so
they decided to challenge the old guard. Moving
into filmmaking, the young punks were dubbed
the *nouvelle vague*, or French New Wave, and
made highly personal, improvised and authentic
films; using lightweight cameras, they shot on
the streets of Paris rather than in a studio. They
also paid homage to the American movies they
loved so much – *Breathless*, directed by Godard
and co-written by Truffaut, is a love letter to
American B-movies and is *the* classic *nouvelle
vague* film. Their influence on everything from
Martin Scorsese to pop promos is incalculable.

filters to replicate night – follows the trials and tribulations of a film crew making *Meet Pamela*, a
family drama that is a gentle swipe at his own work. In playing the role of the harried director
himself Truffaut creates a loving tribute to the insanity of moviemaking. With its obvious
appeal to the Hollywood film community, *Day for Night* unsurprisingly carried off the Oscar for
Best Foreign Language Film in 1973.

In between these landmarks Truffaut made some underrated pictures – *Soft Skin* (1964), *The
Wild Child* (1970), *Small Change* (1976) and his swan song, *Confidentially Yours* (1983) – some interesting
misfires – *Fahrenheit 451* (1966), his only English-language film – and some duds, including *The
Bride Wore Black* (1968), *Mississippi Mermaids* (1969) and *The Man Who Loved Women* (1977). As his career
developed he was increasingly criticized, especially by peer Jean-Luc Godard, for moving
away from his *nouvelle vague* roots to a safer, more conventional middle ground. But the fact
remains that few directors can match Truffaut for such coherence of vision: the impossibility of
relationships, the magical qualities of women, the complexities of communication, the pangs
of childhood, an obsession with obsession and the intoxicating transformative power of cinema
were ever present and correct.

At the height of his directorial powers in the mid 1960s Truffaut conducted a series of
interviews with Alfred Hitchcock. It was a unique project – a hotshot director putting his
own career on hold to pay homage to his hero – and it became an indispensable piece of film
criticism. While working on a new edition in 1983 Truffaut collapsed and was hospitalized,
undergoing extensive tests. Just after the book was published, and shortly after the birth of
his third daughter, Truffaut died on 21 October 1984. The filmmaker so concerned with the
continuity of film history had become an essential part of that history himself.

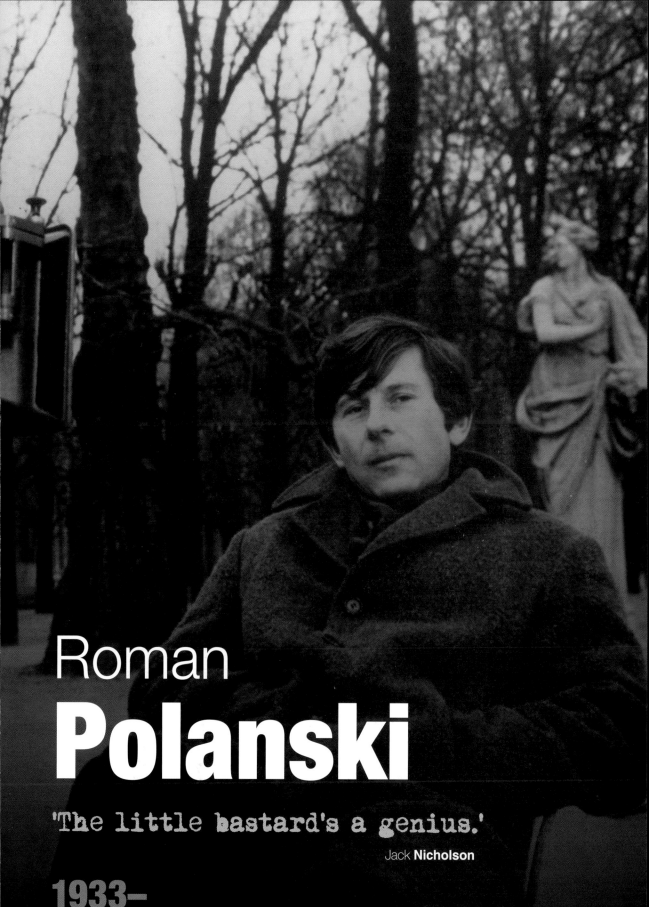

Roman
Polanski

'The little bastard's a genius.'

Jack **Nicholson**

1933–

Roman Polanski has lived a life that few could recover from, which has forged his personal nightmares into art, turning in bleak studies of evil, alienation and warped sexual behaviour leavened with technical virtuosity and pitch-black wit. He is a truly international filmmaker, having worked in Poland, Britain, America and France, but his films traverse national and political boundaries, exploring dark psychological desires that resonate anywhere.

The facts of Polanski's life often outstrip the drama of his fiction. After his family moved from Paris to Poland just before the Second World War his parents were interned in a Nazi concentration camp, and his mother later died at Auschwitz. At the age of eight Polanski escaped from the Kraków ghetto before it was liquidated, and he roamed the Polish countryside looking for Catholic safe-houses. En route he witnessed many horrors, including being forced to take part in a cruel and sadistic game in which German soldiers took shots at him for target practice. It is undeniable that these feelings of fear, dread and violence have informed the tangible atmospheres he conjures up on film.

HOLOCAUST TO HOLLYWOOD

Returning to Kraków after the war he was reunited with his father and started a career as a child actor on Polish radio. He later enrolled in Łódź State Film School and produced imaginative shorts – notably *Two Men and a Wardrobe* (1958) – with limited resources. It proved invaluable training for his first feature, *Knife in the Water* (1962), a tense, taut study of a couple playing mind games with a complete stranger on a boat. The film enraged the communist authorities for showing the country in a negative light but won Polanski an Oscar nomination and prizes at Venice.

Must-see Movies

Knife in the Water (1962)
Repulsion (1965)
Rosemary's Baby (1968)
Chinatown (1974)
The Pianist (2002)

Polanski uprooted to Britain and made two equally disturbing movies. *Repulsion* (1965) is a vivid and horrific portrait of a woman's psychological breakdown in swinging London starring Catherine Deneuve, and *Cul-de-sac* (1966) is a macabre thriller about a couple living in a remote castle whose lives are shattered by the arrival of two gangsters.

Both films make brilliant use of enclosed spaces, a trick that Polanski pulled off again in his Hollywood debut, *Rosemary's Baby* (1968), based on American writer Ira Levin's novel. Polanski twists the story of newlyweds expecting

'My films are the expression of momentary desires.'

Roman **Polanski**

their first child into a nightmare as Rosemary (Mia Farrow) becomes increasingly convinced that Satan has impregnated her. Polanski stirs the witch's brew with heady atmosphere and mordant humour but never lets go of the realism, creating a bona fide modern horror masterpiece.

CHINATOWN

Chinatown, made in 1974, is Polanski's best Hollywood work. Jack Nicholson excels as private eye J.J. Gittes, who digs too deep into a mystery and falls into a mire of deceit, betrayal and corporate politics when a mysterious woman (Faye Dunaway) hires him to investigate her husband. The shoot was a nightmare. Polanski and producer Robert Evans argued constantly over the script, and legend has it that in a fit of pique the director threw a cup of urine in Dunaway's face. Whatever the behind-the-scenes squabbles the result is a masterpiece, a brilliant mix of crime thriller and psychological study. Polanski also makes a memorable cameo as the hood who slits Gittes's nose.

TRAGEDY STRIKES

Polanski earned total creative autonomy after the success of *Rosemary's Baby*, but once again real life conspired against him. He was working away in London on a screenplay when his pregnant wife Sharon Tate and several close friends were brutally murdered by the Manson Family cult. Devastated, Polanski took a break from cinema, returning in 1971 with a naturalistic, gore-filled interpretation of *Macbeth*. Many critics felt that the blood-soaked imagery was a direct response to the Tate tragedy.

Polanski decamped to Europe and became a naturalized French citizen, returning sporadically to Hollywood to work. Following the huge success of *Chinatown* in 1974 Polanski went back to France for *The Tenant* (1976), a bizarre, Kafkaesque tale of a tenant, played by Polanski, who believes his neighbours are driving him to suicide – in some ways this is *Repulsion* from a male perspective, and it effectively revisits the anxieties and dark absurdities of his earlier work.

Back in America in March 1977 his life took another dark turn. After taking pictures of a 13-year-old model at Jack Nicholson's house – ostensibly for *Vogue* – Polanski was arrested by the Los Angeles Police Department and brought to court on charges of drugging and raping a minor. He initially denied the rape charge but eventually entered a plea admitting to partial guilt. When he was freed on bail Polanski skipped the country and was declared by a court to be a fugitive of justice. He has not returned to the USA since.

EXORCIZING THE PAST

Polanski moved on to an adaptation of Thomas Hardy's *Tess of the d'Urbervilles* in 1979, starring Nastassja Kinski as Hardy's heroine caught between two men. He fashioned a sumptuous, visually beautiful period movie that saw him earn an Oscar nomination. *Tess* was followed by swashbuckling flop *Pirates* (1986), Hitchcockian suspense thriller *Frantic* (1988), starring Harrison Ford, lunatic erotic drama *Bitter Moon* (1992), taut hostage character study *Death and the Maiden* (1994) and outlandish horror *The Ninth Gate* (1999) with Johnny Depp.

Polanski's first film of the new millennium has proved to be his most personal. *The Pianist* (2002), adapted from Władysław Szpilman's autobiography, stars Adrien Brody as a Jewish concert pianist who escapes the Warsaw ghetto in 1939 and, while in hiding, witnesses horrors conducted by the SS. It is movingly informed by Polanski's own experiences, and this well-paced, poignant drama won Polanski numerous awards, including Oscars, and perhaps laid some demons to rest. He followed it in 2005 with a well-regarded version of *Oliver Twist* – the parallels of the story charting a young boy's triumph over adversity a clear mirror of his own colourful, controversial life.

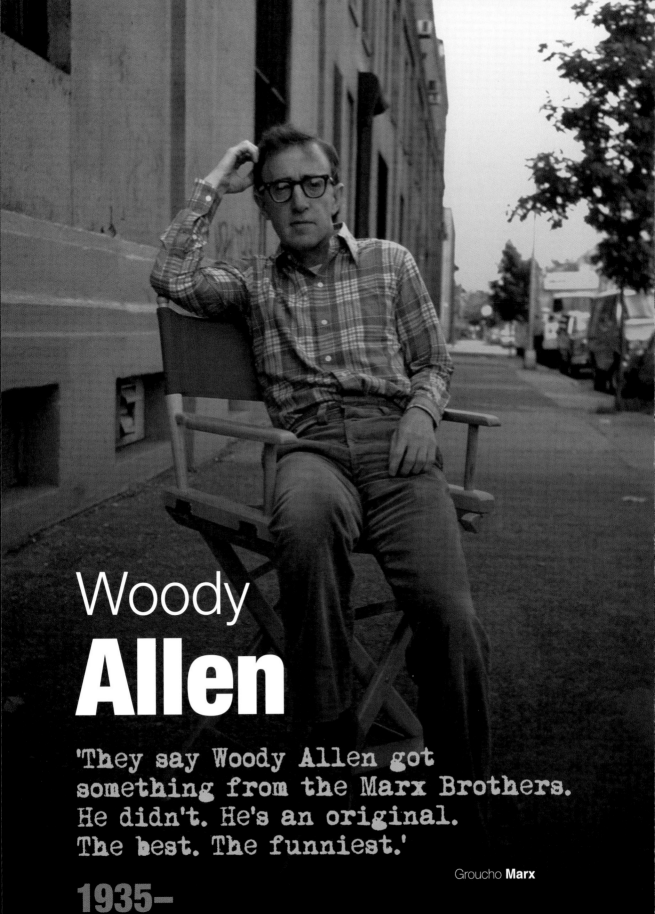

Woody
Allen

'They say Woody Allen got
something from the Marx Brothers.
He didn't. He's an original.
The best. The funniest.'

Groucho **Marx**

1935–

Woody Allen's directorial persona is so well defined that just his name provokes a rapid series of word associations – New York, religion, intellectual, psychoanalysis, relationships, angst – but perhaps what immediately comes to mind is comedy. In a prolific career that has produced nearly a film every year for 40 years he has skewered the pangs and anxieties of modern urban living with a wit and insight that is without peer in American cinema. Allen's work is rooted in a deep understanding that life – and especially love – is unpredictable, uncontrollable and painful, which is what makes his comedy so important. It keeps the whole sorry mess perfectly in perspective.

As a filmmaker Allen has grown in confidence over the years. His early films are, gag for gag, among the funniest ever made, yet as his themes grew more sophisticated so did his directorial style. By staying outside the Hollywood system he has maintained a remarkable control over his work, resulting in a cinema that is highly personal but rarely autobiographical. Or so he claims.

STAND-UP PRODIGY

Woody Allen – born Stewart Allen Konigsberg on 1 December 1935 in New York – started his prolific comedy career early, selling gags to newspapers while still at high school. This talent flourished into a career as a gag writer for Broadway and television, a writer of short stories and literary parodies for magazines and as a hip stand-up comedian. It was as a stand-up that he developed the neurotic, sexually insecure persona, who employed memorable one-liners with cutting understatement. This assumed role would become the basis of his big-screen character.

> ## Must-see Movies
> Sleeper (1973)
> Love and Death (1975)
> Annie Hall (1977)
> Manhattan (1979)
> Hannah and Her Sisters (1986)
> Crimes and Misdemeanors (1989)

After unhappy experiences as actor-writer on *What's New Pussycat* (1965) and James Bond spoof *Casino Royale* (1967), Allen's first directorial effort, *What's Up Tiger Lily* (1966), revoiced Japanese spy thriller *International Secret Police: Key of Keys* in English, with Allen and his cohorts spinning a new comic plot line about the hunt for the world's greatest egg-salad recipe.

His first real directorial outing was *Take the Money and Run* (1969), a fresh and inventive mock crime documentary starring the director as America's most wanted criminal, Virgil Starkwell. The film also starred Allen's wife at the time, actress Louise Lasser, establishing a pattern of Allen co-starring with the women in his private life.

THE EARLY FUNNY ONES

More important in Allen's burgeoning film career than this was his success on Broadway. *Don't Drink the Water* and *Play It Again, Sam* were big Broadway hits and drew Allen substantial offers from Hollywood. But, choosing to work independently, he produced a string of comedies that are

marked out by great sight gags, astonishing verbal dexterity, pointed cultural parodies and a freewheeling, disjointed continuity.

Bananas (1971) uproots the archetypal Allen character from New York and makes him the unlikely hero of a South American revolution. *Everything You Always Wanted to Know About Sex But Were Afraid to Ask* (1972) took the title of a pop psychology book and used it as a springboard for a series of sketches. *Sleeper* (1973), a brilliant melding of science-fiction staples and slapstick comedy, stars Allen again as a New York healthstore owner who goes into hospital for an ulcer operation and wakes up in the year 2173. The film is also notable because it marks the first time that Allen directed Diane Keaton, who would become the best of Allen's female co-stars, her ditzy naïvety the perfect foil to his urban anguish. *Love and Death* (1975), the fullest expression to that point of his love of heavy literature and Bergmanesque mood, located his trademark shtick into the Napoleonic era.

After *Take the Money and Run* each successive film was technically more assured than the last, and *Love and Death*, with its location shooting and large-scale battle scenes, sees a filmmaker bursting with self-belief. It was a confidence that would come to the fore in his next picture.

THE LATER SERIOUS ONES

Allen's next film was originally a modern-day murder mystery entitled *Anhedonia*, a term for the inability to feel pleasure. When he felt the mystery aspect wasn't working he jettisoned it, shot additional footage and fashioned *Annie Hall* (1977), the movie that marks his maturation as a filmmaker. This story of a failed romance between comedian Alvy Singer (Allen) and Annie Hall (Keaton) became Allen's most popular success, winning four Oscars, starting fashion trends, such as women wearing waistcoats, ties and billowing trousers, and firmly establishing the autobiographical nature of his work, with audiences often mistaking his onscreen character and antics with his real life.

Annie Hall was a step forward for Allen in a number of ways. First, he avoided the broad, cartoonish elements of his work, making a film about recognizable human beings that captured real emotional concerns and fragilities. Second, he takes great strides as a filmmaker, staging scenes for more than just their comic effect, using long takes, sophisticated compositions and subtle lighting. It also sees Allen playing with conventional film realism, having characters talk directly to camera, turn into cartoon characters, revisit their younger selves and comment on one another in split screens.

'I don't want to achieve immortality through my work . . . I want to achieve it through not dying.'

Woody **Allen**

Perhaps inevitably, Allen's follow-up, the sombre, serious drama *Interiors* (1978), was a disappointment, but he regained top form with *Manhattan* (1979). He followed this with *Stardust Memories* (1980), in which Allen plays a successful comic filmmaker who doesn't want to be funny any more. The film was misconstrued as a bitter attack on his critics and fans, but it has stood the test of time; it is a thoughtful and funny treatise on creativity, fame and relationships.

Starting a new relationship, both personal and professional, with actress Mia Farrow, Allen's next films were distinctly lighter in tone. These include: the fanciful Bergman parody *A Midsummer Night's Sex Comedy* (1982); the brilliant faux documentary *Zelig* (1983), in which Allen plays a human chameleon, and which is notable for the brilliant way Allen is dropped into old newsreel footage; *Broadway Danny Rose* (1984), a charming romp through the dying world of

MANHATTAN

Manhattan is Woody Allen's masterpiece. Unravelling the tangled love lives of four New Yorkers Allen presents a serious, moving meditation on complex relationships and modern manners but with snappy dialogue – 'I think people should mate for life, like pigeons or Catholics' – and beautiful black-and-white photography that celebrates his hometown, all played out to gorgeous orchestral versions of George Gershwin tunes. What is even more surprising is that once he had completed it Allen hated it, wanted it shelved and offered to make a film for the studio for free. Thankfully, they didn't agree.

variety acts; and *The Purple Rose of Cairo* (1985), which proffers a lovely meditation on the power of cinema as a fictional film character walks off the screen and into the life of a depressed housewife.

Returning to the lives and loves of New Yorkers *Hannah and Her Sisters* (1986) became Allen's most popular film for years, finding a rare, wistful optimism for his bruised romantics. Following *Radio Days* (1987), a nostalgic love letter to the entertainments of his youth, and *September* (1987), a dour Chekhovian drama that he reshot completely from scratch, Allen hit something approaching his best with *Crimes and Misdemeanors* (1989). On the one hand it is a dark drama with Martin Landau as an eye surgeon trying to cover up his infidelity, and on the other a bittersweet comedy featuring Allen as a documentary filmmaker dealing with his art and unhappy marriage. Ambitious and sophisticated, it is a sublime contemplation on guilt and culpability that still manages to be uproariously funny.

KEEPING IT SIMPLE

As Allen moved into the 1990s the events of his private life overtook his fiction (see below) and saw him retreat to simpler forms, producing likable comedies – *Manhattan Murder Mystery*, *Mighty Aphrodite* and *Everyone Says I Love You* (1993, 1995 and 1996 respectively) – and less successful dramas such as *Alice* (1990) and *Shadows and Fog* (1992). His best-received works of the decade are *Bullets Over Broadway* (1994) and the jazz-themed *Sweet and Lowdown* (1999).

In the new millennium Allen has failed to find his footing, his reputation dimming somewhat. Films such as *Small Time Crooks* (2000) and *Melinda and Melinda* (2005) have entertained, whereas *The Curse of the Jade Scorpion* (2001), *Hollywood Endings* (2002) and *Anything Else* (2003) practically disappeared without trace. Uprooting to London, Allen fared better with the impressive *Match Point* (2005), a *Crimes and Misdemeanors*-style drama set among the English upper classes, but his next two films – *Scoop* (2006) and *Cassandra's Dream* (2007) – failed to capitalize on this success.

LIFE MIRRORS ART

In 1992 Allen's romantic relationship with Soon Yi Previn – his then partner Mia Farrow's 21-year-old adopted daughter – was discovered by Farrow and made public. Charges and countercharges followed, all conducted in a cauldron of press scrutiny, resulting in Allen losing custody of his three children. Interestingly, the film prior to these tribulations, *Husbands and Wives*, is a powerful portrait of two disintegrating marriages, including one where Allen is in a relationship with a woman (Juliette Lewis) young enough to be his daughter. With scenes of emotional ferocity enhanced by a ragged handheld camera the film remains one of Allen's most textured, raw and moving works, whatever the context surrounding its release.

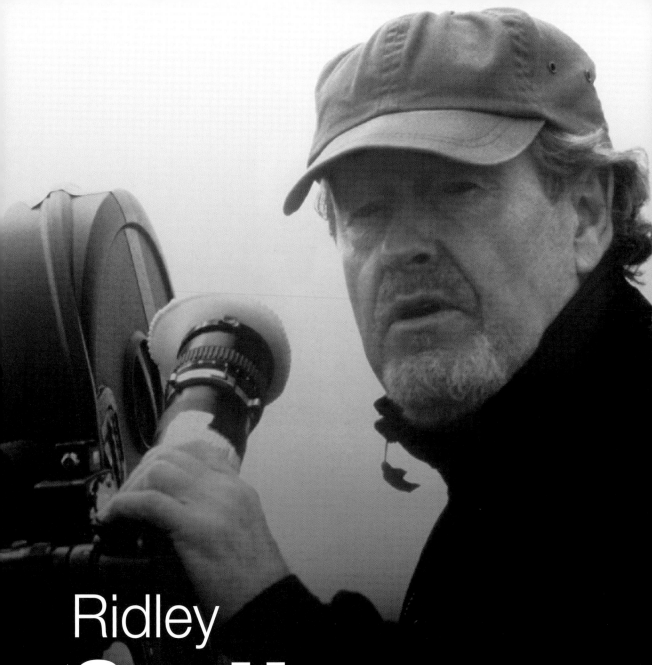

Ridley
Scott

'Ridley Scott is a force of nature.
If I were a woman, I would have made
love with him.'

Gérard **Depardieu**

1937–

Ridley Scott is modern cinema's great stylist.

He started his career in commercials and brought the aesthetics of advertising and applied them to the excitement of genre movies. In his best work he has married his great eye to a sure sense of character, strong narrative drive, a canny understanding of genre and an unsung talent with actors, all skills that have seen him become one of the most respected and sought-after craftsmen in contemporary Hollywood.

This revered position has been achieved even in the face of a hit-and-miss box-office record and a reputation as a prickly, temperamental presence on set. His desire to control every aspect of production has often brought him into conflict with cast, crew and executives. But few directors have such a clear grasp of what they want. Whether it is the futuristic cityscapes of *Blade Runner* or the classical past of *Gladiator*, Scott created the definitive versions.

STUNNING SCI-FI

Ridley Scott grew up in Northumberland, England, surrounded by rainswept locales that must have influenced *Blade Runner*. After art school, the BBC and a glittering career in advertising, Scott was 39 years old before he got the chance to begin his feature-film career with *The Duellists* (1977), the story of two Napoleonic officers (Harvey Keitel and Keith Carradine) engaged in a bitter feud. Scott imbued the tale with haunting visuals and won a Cannes Jury Prize in the process.

Looking for something more mainstream Scott landed *Alien* (1979), a science-fiction–horror hybrid that pitched the crew of a spaceship against an alien predator. Scott's camera prowling down dark, dank industrial corridors created unbearable tension, yet he was equally adept at throwing in shocking surprise – the alien bursting out of John Hurt's chest is one of cinema's great scares. Scott also broke ground with Sigourney Weaver's Ellen Ripley, the kind of gutsy heroine rarely at the lead of an action movie and the first in his gallery of forceful and resilient leading women. *Alien* spawned three sequels and remains one of the most influential science-fiction films ever made.

It was also the film that established Scott's commercial bankability.

'Do what you haven't done is the key, I think.'

Ridley **Scott**

Staying with science fiction Scott next tackled *Blade Runner* (1982), based on a short story by Phillip K. Dick and starring Harrison Ford as a down-and-out detective lured out of retirement to track down a group of renegade androids – 'Replicants' in the film's parlance – in 2019 Los Angeles. Scott caused friction from the outset, forcing his crew to rebuild sets from scratch, clashing with Ford over his character and the studio over the edit. However, the battles seemed irrelevant when the film was a critical and commercial flop. Yet time has been kind to *Blade Runner*, Scott's stunning neo-noir vision of an urban dystopia finding a cult audience and belated critical respect. It is as influential as *Alien*, and it remains Scott's masterpiece.

GALS AND GLADIATORS

Scott tried in vain to find a quick hit. *Legend* (1985), a fairytale replete with elves, goblins and unicorns and starring a young Tom Cruise, *Someone to Watch Over Me* (1987), a routine romantic thriller, and *Black Rain* (1989), a Japan-based cop drama, all saw Scott's visual flair overwhelm slight stories.

Must-see Movies

Alien (1979)
Blade Runner (1982)
Thelma and Louise (1991)
Gladiator (2000)

But in 1991 Scott found his commercial touch in an unlikely place. *Thelma and Louise* follows two small-town women (Geena Davis and Susan Sarandon) who go on the run after killing a rapist. This time Scott's visual flair was allied to narrative drive, brilliantly rendering rainy roadways and desert vistas yet never losing sight of the characters' dilemmas and joie de vivre. An intelligent, freewheeling, post-feminist road movie, *Thelma and Louise* was a big hit, and it earned Scott his first Academy Award nomination.

Scott's three next works – *1492: Conquest of Paradise* (1992), *White Squall* (1996) and *G.I. Jane* (1997) – sent him back to the commercial doldrums. Having launched a production company, Scott Free, with his younger brother Tony, director of *Top Gun*, Scott bounced back with *Gladiator* (2000), a triumphant return to the sword-and-sandal days of the historical epic. In a star-making turn Russell Crowe leads as the Roman general who is forced into slavery and fights his way to freedom as a gladiator. With a spare use of visual effects Scott splendidly realizes the Roman world and mounts spectacular action, but he doesn't stint on the political intrigue, drawing fine performances from Joaquin Phoenix, Richard Harris and Oliver Reed, who died mid production. The film garnered 12 Oscar nominations with Scott earning his second nod and his first Best Picture win.

CRUSADES TO CRIMINALS

Scott followed *Gladiator* with *Hannibal* (2001), a lacklustre but popular addition to the Hannibal Lecter franchise; *Black Hawk Down* (2001), a well-received account of a US helicopter shot down in Somalia; and *Matchstick Men* (2003), a quirky, small-scale and entertaining caper movie that failed to cause ripples. Scott next tackled *Kingdom of Heaven* (2005), a historical epic set during the Second and Third Crusades. Mounted with strong battle sequences, the film suffered from lapses in story logic – issues Scott addressed in a better director's cut – and the film failed to find the resonance of *Gladiator*.

Reuniting with Russell Crowe for poor romantic comedy *A Good Year* (2006), the pair worked together yet again on *American Gangster* (2007), the true story of Harlem drug lord Frank Lucas (Denzel Washington). Despite good performances and strong moments the film failed to transcend crime-thriller conventions and felt somewhat familiar. Still, his restless eye keeps searching, and upcoming projects such as Iraq drama *Body of Lies* (2008) and proposed Robin Hood revamp *Nottingham* (2009) suggest new milieux for Scott to colonize cinematically.

THE BATTLE FOR *BLADE RUNNER*

Perhaps more than any other director Scott has championed the notion of the director's cut, re-editing his films to realize his original vision. In 1982 Warner Bros had forced Scott to release *Blade Runner* with Harrison Ford providing a clichéd 'hardboiled' voiceover and featuring a sunlit happy ending. In 1992 Scott released a shorter version that removed these elements. Instead he added a shot of a unicorn that fans have speculated is a cryptic suggestion that Ford's character Rick Deckard is a Replicant, as it relates to an origami unicorn left outside Deckard's apartment by his cop partner Gaff. In 1997 Scott issued *Blade Runner: The Final Cut*, which cleaned up some shots that niggled him.

Francis Ford
Coppola

'Francis depends on defying
gravity through sheer will. I've
always been in awe of that side
of Francis, and I still am.'

George **Lucas**

1939–

Francis Ford Coppola is cinema's greatest gambler.

He has enjoyed box-office and Oscar triumphs, faced critical brickbats and bankruptcy but always bounced back to defiantly pursue his own sense of cinematic adventure. His reputation would have been assured were it only for the back-to-back masterpieces he made during the 1970s – *The Godfather*, *The Conversation*, *The Godfather Part II*, *Apocalypse Now* – one of the greatest runs by any filmmaker in any period of film history. But equally important has been his desire to push boundaries, both in the advancement of technology and in fostering a more European, personal approach to filmmaking within the Hollywood mainstream.

If his stature has been harmed by periods of purely commercial filmmaking and long stretches of cinematic inactivity – his risk-taking has extended to magazines, real estate and wine production – his influence is wide ranging. Coppola was the first film-school graduate to make it big within the film industry, and his success and chutzpah paved the way for a whole generation of bearded young filmmakers, including George Lucas, Martin Scorsese and Steven Spielberg. He has also helped numerous other moviemakers get difficult projects off the ground. His big personality has added much-needed colour and flamboyance to an increasingly corporate scene – a film world without Francis Ford Coppola would be a much poorer place indeed.

Must-see Movies

The Godfather (1972)
The Godfather Part II (1974)
The Conversation (1974)
Apocalypse Now (1979)

FROM POLIO TO PATTON

Coppola is the son of a musician, who played flute for Toscanini in the NBC Radio Symphony Orchestra, and a former Italian film star. He was a sickly child who escaped the physical limitations caused by polio by playing with home-movie cameras. Consumed by film, in 1960 he enrolled at UCLA cinema department where he became a star pupil. Gaining extra-curricular experience making soft porn with such titles as *Tonight for Sure* (1962), Coppola worked in various capacities for the king of exploitation films, Roger Corman. It was Corman who granted the fledgling director his feature debut with *Dementia 13* (1963), a Gothic horror film so bad that at one point a supposedly scary child corpse actually blinks.

'I probably have genius. But no talent.'

Francis Ford **Coppola**

Coppola subsequently embarked on a successful career as a screenwriter, penning scripts for *Is Paris Burning?* (1966), *Patton* (1970) – for which he won an Oscar – and *The Great Gatsby* (1974). During this period he directed *You're a Big Boy Now* (1966), a fresh, freewheeling rites-of-passage comedy influenced by the *nouvelle vague*. The movie caused shockwaves in the film-school world when Coppola delivered a finished feature for his Masters thesis. It led to him being offered

LIKE FATHER LIKE DAUGHTER

Coppola's filmmaking has always been a family affair. His father Carmine composed music for his early films, his sister Talia Shire appeared in *The Godfather* movies and his nephew Nicolas Cage has found fame in his own right. But perhaps the biggest talent in the Coppola family is his daughter Sofia. After surviving a lambasting from the critics for her role in *The Godfather Part III* she turned to directing, getting attention with *The Virgin Suicides*, the Oscar-winning *Lost in Translation* and *Marie Antoinette*. Her style is more dreamy and lyrical than her father's, but she seems blessed with his ambition and desire to pursue her own path.

Finian's Rainbow (1968), a big-budget musical starring Fred Astaire and Petula Clark that failed to find an audience.

Coppola took his fee from *Finian's Rainbow* and ploughed it into making *The Rain People* (1969), a low-budget movie about a woman (Shirley Knight) who leaves her husband and goes on a journey of self-discovery on the back roads of America. The film, which was made on a shoestring budget by ex-film-school students, including George Lucas, had a loose, improvisatory European feel. Coppola took the equipment and personnel from *The Rain People*, moved to San Francisco and set up American Zoetrope, which was designed to be a creative haven for young filmmakers far away from the meddling Hollywood establishment. It didn't start well. *The Rain People* flopped at the box office and Lucas's feature debut, *THX 1138*, was so esoteric that Warner Bros cancelled the deal. Coppola needed a hit and fast.

AN OFFER HE COULDN'T REFUSE

Given Coppola's poor commercial track record it is difficult to understand why Paramount offered him the chance to work on the movie adaptation of Mario Puzo's popular gangster novel *The Godfather*. From the start Coppola fought running battles with Paramount executives over nearly every issue – the biggest controversy was caused by the casting of Marlon Brando, whom the studio viewed as difficult, as crime lord Vito Corleone – and rumours of his dismissal for being out of his depth were rife.

However, Coppola survived to produce one of the masterpieces of American cinema. Elevating a popular, if trashy, novel, he imbued the gangster trappings with a detailed chronicle of a family whose business happens to be organized crime. Both epic and intimate, Coppola's control over the sprawling story is magnificent – a bravura finale juxtaposes a baptism with brutal murder – but what fascinates is the rituals and rhythms of Italian life, and family dynamics. Proving Coppola completely justified, Brando's casting is a masterstroke, matched by equally brilliant performances from Al Pacino, James Caan, Robert Duvall and Diane Keaton. Ushering in a new era of blockbuster filmmaking as well as securing Coppola's financial status and enhancing his reputation, *The Godfather* is that rare thing: a film that is over three hours long but still leaves you hungry for more.

Following the somewhat less epic *The Conversation* (1974) Coppola returned to the Corleones with *The Godfather Part II*. Rather than merely retreading the glories of the first film he created an audacious structure that counterpoints the rise to power of the young Vito Corleone (Robert De Niro) with the ascendancy of Pacino's Michael as the head of the family business 30 years later. It is a deeper, more ambitious film than its predecessor, and it garnered six Academy Awards, including three for Coppola as producer, writer and director. In 1990 he made *The Godfather Part III* for purely financial reasons, with a much older Michael now trying to renounce his life of crime. This film fails to reach the heights of the previous two, but it is better than originally judged – melancholy, autumnal and full of strong moments.

THE DEATH OF A DREAM

After the success of *The Godfather Part II* Coppola used his newfound power to mount his most expensive and ambitious project. *Apocalypse Now*, based loosely on Joseph Conrad's novella *Heart of Darkness*, charts the journey of a CIA operative (Martin Sheen) upriver in Cambodia to 'terminate with extreme prejudice' the command of Colonel Kurtz, a decorated American soldier who has formed a renegade army in the jungle. After the rigours of jungle shooting – star Martin Sheen suffered a heart attack, the production was beset by typhoons and schedule overruns – and a protracted editing process, *Apocalypse Now* was unveiled to great acclaim as a work in progress at an emotional premiere at the 1979 Cannes Film Festival, winning the Palme d'Or. Full of hallucinatory images, intellectual philosophizing and memorable vignettes from the theatre of war, *Apocalypse Now* is ambitious, technically astonishing, breathtaking cinema – uneven, certainly, but frequently blessed with the buzz of brilliance.

Following the eventual success of *Apocalypse Now* Coppola pursued his dream of turning Zoetrope into a full-scale working studio, but the notion turned sour with *One from the Heart* (1982), a visually stunning but painfully thin story of love lost then regained. The film's budget ballooned from US$2 million to US$25 million but was a financial misfire, leaving Coppola to assume huge debts. He was declared bankrupt in 1990.

ART VERSUS COMMERCE

Since *One from the Heart*, Coppola's career has been a reaction to the failure of Zoetrope, mixing small personal projects – *The Outsiders*, *Rumblefish* (both 1983), *Gardens of Stone* (1987), *Tucker: The Man and His Dream* (1987) – with broader, more commercial affairs. Of these *The Cotton Club* (1984) was an uneven attempt to revisit the gangster glories of *The Godfather*; *Peggy Sue Got Married* (1985) was a melancholy time-travel fable; and the less said about risible Robin Williams comedy vehicle *Jack* (1996) the better. The most interesting of the commercial ventures was *Bram Stoker's Dracula* (1992), starring Gary Oldman as the count, which has a strikingly theatrical feel.

After *The Rainmaker* (1997), a colourless John Grisham adaptation, Coppola spent nearly a decade trying to get epic science-fiction project *Megalopolis* off the ground, but the film – about idealism in a futuristic New York – was overtaken by history with the Twin Towers tragedy. Out of the collapse of this project Coppola decided to go small again with *Youth Without Youth* (2007), a heady exploration of philosophical themes on ageing, identity and communication based on the writings of Romanian author Mircea Eliade. The result was critically savaged, but at least it felt like a Coppola film: visually sumptuous, ambitious and challenging. One of American cinema's distinctive talents has started to find his voice again.

THE CONVERSATION

In between the first two *Godfather* movies Coppola made *The Conversation*, a resonant post-Watergate paranoia thriller based on his own screenplay and inspired by Michelangelo Antonioni's *Blow-Up*. The story follows lonely surveillance man Harry Caul (Gene Hackman) who gets involved with the couple on whom he has been hired to eavesdrop. A fascinating portrait of a guarded, inward-looking man – brilliantly played by Hackman – the film is also remarkable in its use of sound, a key weapon in Coppola's arsenal. Working with legendary sound designer Walter Murch, Coppola fashioned a film that is as much to be listened to as it is to be viewed. It is a complex collage of dialogue, sound effects, music and aural washes that put the work of sound designers on the map.

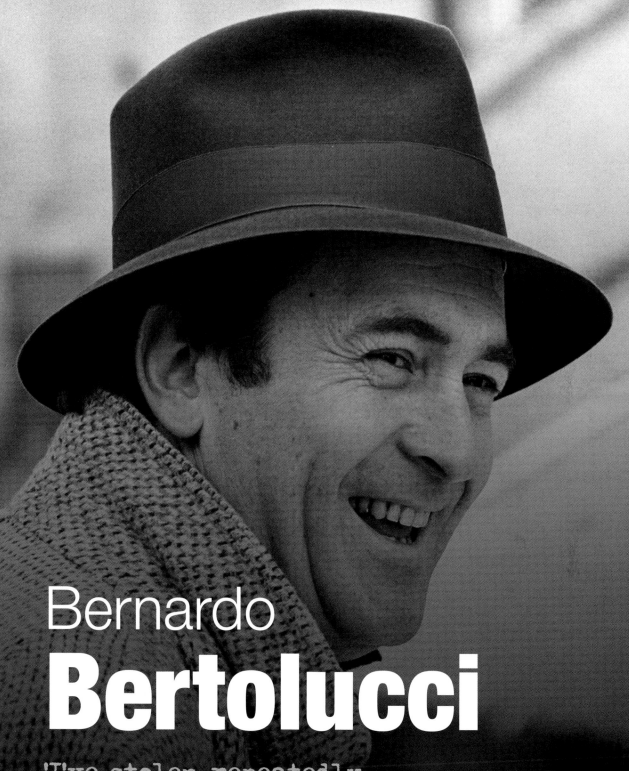

Bernardo
Bertolucci

'I've stolen repeatedly
from Bertolucci.'

Paul **Schrader**

1940–

Politics, sex, psychoanalysis, cinema: these are

the touchstones that have captivated Bernardo Bertolucci for over 30 years. The pursuit of these concerns has landed him in the hot water of controversy and his work remains divisive, but at their best his films are challenging, intoxicating experiences that are often marked by the push and pull of freedom and conformity.

Bertolucci's early work owed a huge debt to the intimacy of the *nouvelle vague*, being full of novelty, invention and dedicated to the exploration of ideas. But as his career has progressed his creativity has sought increasingly epic scales, with varying degrees of success. Yet having moved through this phase Bertolucci now seems happiest back in the small-scale forms that made him one of the leading lights in Italian cinema.

SEX AND POLITICS

Bernardo Bertolucci's life was filled with culture from an early age. Raised in Parma, he is the son of a poet and film critic, and he developed an early passion for film by attending screenings with his father. He started making amateur 16-mm movies aged 15, and in 1961 dropped out of university in Rome where he was studying literature to become an assistant on Pier Paolo Pasolini's *Accattone*. The following year Bertolucci made his filmmaking debut, *The Grim Reaper*, about the murder of a prostitute. It caused few ripples.

It took Bertolucci's second film to establish his name. *Before the Revolution* (1964) tells the story of a middle-class youth who is forced to choose between his Marxist political ideals and an alluring marriage into the bourgeoisie. The film is an intense, believable portrait of turbulent youth that established the director's filmmaking style. In making such audacious work at a very young age comparisons were drawn with Orson Welles, but the film failed at the box office, forcing Bertolucci to retreat into directing television films and screenwriting – including supplying the story for Sergio Leone's *Once upon a Time in the West*.

Bertolucci resumed his cinema career with *The Spider's Stratagem* (1970), the story of a son's search for his father that is told in an increasingly surreal narrative. The film is important because it introduced the director to Vittorio Storaro, the genius cinematographer who has defined the look and feel of Bertolucci's work. With his next film Bertolucci created his masterpiece. A luscious adaptation of Alberto Moravia's novel, *The Conformist* (1970), makes links between sexual repression and Italian fascism, as the lead character Marcello

> 'I don't film messages. I let the post office take care of those.'
>
> Bernardo **Bertolucci**

(Jean-Louis Trintignant) joins the fascists in an attempt to suppress his homosexuality. A poetic, elegant, intricate experience, its feel is perhaps best encapsulated in a memorable set piece in which two women dance a deeply erotic tango – a metaphor that would inform his next great work.

DANCE WITH DANGER

Eschewing his fascination with politics – but not sex – Bertolucci's next film caused a huge stir. *Last Tango in Paris* (1972) is one of cinema's great portraits of an obsessive relationship, charting the

Must-see Movies

Before the Revolution (1964)
The Conformist (1970)
Last Tango in Paris (1972)

sexual couplings between an ageing widower (Marlon Brando) and a younger woman (Maria Schneider) who is about to marry. It was hugely controversial at the time, but the film beautifully creates the lovers' hermetically sealed world in natural tones.

The success of *Last Tango* enabled Bertolucci to raise the finances for his long-gestating Marxist history, *1900* (1976), the first film to reveal his predilection for the epic. With an all-star cast led by Robert De Niro, Burt Lancaster, Gérard Depardieu and Donald Sutherland the film covers 45 years of social and political history in northern Italy. The original cut unveiled at Cannes was five hours long, but, following a heated argument with producer Alberto Grimaldi, Bertolucci released a three-hour version for the American and UK markets. Whatever the version, the film displays moments of genius but somehow falls short of masterpiece status.

EPIC AND INTIMATE

Following small-scale efforts *La Luna* (1979) and *Tragedy of a Ridiculous Man* (1982) Bertolucci went big with *The Last Emperor* (1987), the story of Pu-Yi, the man who started his life as the last emperor of China and finished it as a gardener in post-revolutionary Beijing. Here Bertolucci continues to explore his core theme of how individuals are shaped by political forces, but it lacks the depth and complexities of *The Conformist*. Still, the film was a stunning visual experience – famously Bertolucci was the first Western filmmaker to shoot in Beijing's Forbidden City – and this sumptuous pictorialism turned it into an Academy Award winner, earning nine Oscars, including Best Picture and Best Director. He completed his so-called 'Eastern trilogy' with an adaptation of Paul Bowles's cult novel *The Sheltering Sky* (1990) and *Little Buddha* (1994), which follows the life of the Buddha – played, in a curious piece of casting, by Keanu Reeves.

While Bertolucci created huge, beautiful canvases, there is something missing from this epic period that might account for his next move. *Stealing Beauty* (1996) is a small character study of an American girl (Liv Tyler) who explores her sexuality while on holiday in Tuscany. Beautifully shot, the film is a lighter reworking of the director's favourite conceits: the search for father figures, shifting generations and the allure of sexuality. After the even smaller *Besieged* (1996), *The Dreamers* (2004) depicted a ménage à trois between three cineastes in the politically charged arena of Paris in 1968. Perhaps revitalized by revisiting the years of his own politicization Bertolucci delivered his most engaged, coherent and affecting film for years.

THE TROUBLE WITH TANGO

The sexually explicit nature of *Last Tango in Paris* caused one of the film world's biggest controversies. In Italy the film was banned in Bologna for two months, copies were confiscated and burned, Bertolucci had his civil rights revoked for five years and he was given a four-month suspended prison sentence and a 30,000 lire fine. Elsewhere, the film was placed on the US Catholic Conferences list of condemned films, while in Britain it was passed by the censors but brought to trial under the Obscene Publications Act and was not allowed to be shown on British television until the early 1990s.

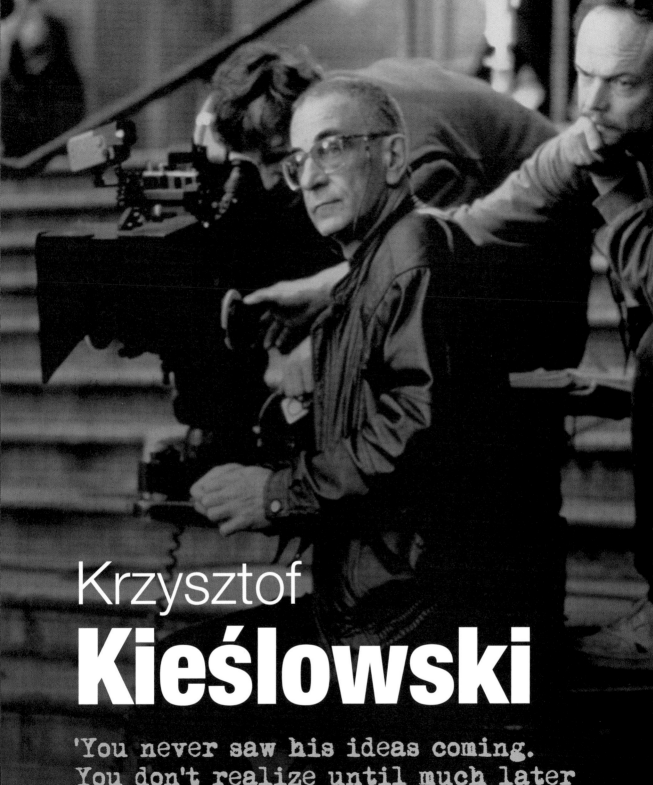

Krzysztof
Kieślowski

'You never saw his ideas coming.
You don't realize until much later
how profoundly they have reached
your heart.'

Stanley **Kubrick**

1941–96

Krzysztof Kieślowski was perhaps the last

of the great heavyweight European directors. In an age when the idea of the truly serious filmmaker was completely out of fashion and the lighter likes of Pedro Almodóvar held sway, Kieślowski represented a return to arthouse ambition, exploring big themes with high style. Like Bergman he was consumed by the random mysteries of the universe, and he attempted to impose order on chaos through his fascination with paradoxes, chance encounters and unlikely connections as well as with his incredible control of colour, camera and sound.

Kieślowski's career falls into two distinct phases. The early period consists of politically charged analyses of contemporary Polish lives, done in a harsh, stripped-down style that reflected the toughness of everyday existence. Yet he did more than create angry polemics, as Kieślowski was always alive to the human implications of his narratives. His interest in the personal outstripped his passion for the political, however, and his later work grapples with the ambiguities of existence, in particular the destructive potential of relationships, the possibilities of cosmic coincidences and the alienated female psyche. That he did it with a kind of poetry – both visual and musical – unmatched in modern cinema makes his early passing all the more tragic.

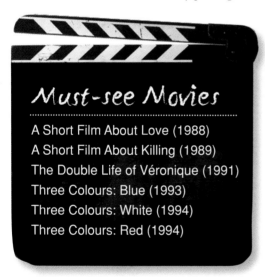

Must-see Movies

A Short Film About Love (1988)
A Short Film About Killing (1989)
The Double Life of Véronique (1991)
Three Colours: Blue (1993)
Three Colours: White (1994)
Three Colours: Red (1994)

POLAND AND POLITICS

Kieślowski's first career plan was to be fireman, but he dropped out after three months of intensive training. He later applied to the Łódź Film School, the renowned Polish academy where Roman Polanski had studied, and after three applications he was finally accepted. He graduated in 1968 and started to make documentaries – chiefly about the social conditions shaping everyday Polish lives – and made his first theatrical film, *The Scar*, in 1976.

He first gained attention with *Camera Buff* (1979), a sly, humorous satire on censorship. With his next film, the impressive *Blind Chance* (1981), Kieślowski became a victim of censorship himself. The movie posits three different political outcomes for Poland – a fourth in which Poland rejects the Communist Party, was not included. The film was still banned in Poland until 1987.

No End (1984) concerned the political trials that took place in Poland under martial law, and again the film was attacked by the government. It was also important for bringing Kieślowski together with two key collaborators, writer Krzysztof Piesiewicz and composer Zbigniew Preisner. It was Kieślowski's next work that really established him on the international scene, however. *Decalogue* (1988), made for Polish television, was a powerful series of films based on the Ten Commandments and set in a Warsaw housing project. For all its awareness of Poland's socioeconomic plight *Decalogue* is a delicately funny, compassionate drama.

METAPHYSICAL MASTERPIECES

As Kieślowski moved from purely Polish financing to co-productions funded by France, so his interests broadened. *The Double Life of Véronique* (1991) is the baffling tale of a Polish choir singer and a French choir teacher (both played by Irène Jacob) who look exactly the same but live separate but strangely linked lives, suggesting that they share the same soul. Beautiful and mesmerizing, *Véronique* is a visual and musical treat, and it received a rapturous reception at Cannes. It is one of those rare films that can be termed 'inexplicable' – in a positive way.

Véronique was a popular arthouse hit, and it paved the way financially, thematically and visually for a much more ambitious and profound project. *Three Colours: Blue* (1993) was the first part of a trilogy based on the values embodied in the blue, white and red of the French tricolour: liberty, equality and brotherhood. *Blue* remains the best of the troika. Juliette Binoche stars as a woman whose composer husband and child are killed in a car crash, and the story follows her attempts to liberate herself from her anguish. Visually ravishing, the film is a minutely observed portrait of the processes of grief built around a subtle performance by the brilliant Binoche as a woman struggling to rediscover her humanity.

> 'There are mysteries, secret zones in each individual.'
>
> Krzysztof **Kieślowski**

Three Colours: White (1994), generally considered the weakest of the three, follows the comic adventures of a divorced husband (Zbigniew Zamachowski) as he tries to get even with his ruthless wife (Julie Delpy) while maintaining his dignity. Between the heavyweight bookends of *Blue* and *Red* it does feel slight, but Kieślowski in lighter mode is still compelling. *Three Colours: Red* (1994) explores the unlikely but touching friendship between a retired judge (Jean-Louis Trintignant) and a model (Jacob again). It is not only, like *Véronique*, a compelling exploration of ties that bind but also a stunning piece of filmmaking, and Kieślowski, in a masterful display of his palette, turns in one of the most sumptuous films of the 1990s.

RETIREMENT

After the *Three Colours* trilogy won a host of prestigious awards at major film festivals around the globe Kieślowski shocked the film world by announcing his retirement and his intention to sit at home and smoke cigarettes. After suffering a coronary Kieślowski died during open-heart surgery on 13 March 1996. At the time of his passing he was working on a new trilogy inspired by Dante's *Divine Comedy* to be called *Heaven, Hell and Purgatory*. *Heaven* was the only completed screenplay, and it was made into a film by *Run, Lola, Run* director Tom Tykwer in 2002.

TWO SHORT FILMS

Kieślowski took episodes five and six of *Decalogue* and expanded them into feature films. *A Short Film About Killing* focuses on a youth who kills a cab driver and must face the consequences. The director delivers a powerful, visually pared-down and harrowing exploration of murder that won him the Jury Prize at the Cannes Film Festival. A companion piece, *A Short Film About Love*, is a grim portrait of a teenage voyeur that is less about scopophilia and more about the impossibility of love – hence the ironic title – and the difficulty of communication in modern society.

Werner
Herzog

'Werner makes movies like he's
wrestling them to the ground.'

Christian **Bale**

1942–

Werner Herzog is the mad visionary of German

cinema, one of the most startlingly original European filmmakers to emerge in the 1970s and a man who doesn't know the meaning of the word compromise. He is a truly international director, and his restless appetite has seen him make films all over the world, often pushing himself and his crews to the edge of mental and physical endurance. Whether making them or watching them, his films are not for the faint hearted.

Although he does not have a distinctive visual style, Herzog's work is unified by epic ambition, an intense lyricism and an overriding mood of despair. He loves to render the ugly and horrible sublime and yet he ignores or destroys the beautiful and explores this triumph of the grotesque both in the casting, through an expressionistic acting style, and big uncomfortable close-ups.

Herzog is also one of modern cinema's greatest characters, a never-ending fount of astounding stories, some of them complete fiction – he was never a rodeo rider or a gun smuggler – and others absolute fact. While conducting an interview for the BBC he was shot and wounded by a sniper, and he completed the interview without batting an eyelid.

BONDING WITH OUTSIDERS

Werner Herzog (born Stipetić) was raised in abject poverty in Munich – where his family for a time shared a boarding house with actor Klaus Kinski – and in Austria. He developed a strong passion for movies and was already pitching script ideas to local producers aged 14. Rather than attend the renowned Munich Film School Herzog worked nights as a welder and ploughed all his earnings into short films, making three in quick succession. Following a brief spell studying and working in America Herzog completed his filmmaking apprenticeship with *The Unprecedented Defence of Fortress Deutschkreuz* (1966), a scathing anti-war satire. He returned to themes of conflict for his debut feature, *Signs of Life* (1967), which told the story of three bored soldiers assigned to guard a munitions dump in Greece. The film established many of the themes that Herzog has returned to throughout his career: man's relationship with the natural world, the corrupting power of loneliness and alienation and a sympathy with the outsider.

Herzog revisited these concerns in his second feature, *Even Dwarfs Started Small* (1970). This bizarre allegorical story of an uprising in a penal colony for dwarfs was a dark condemnation of institutionalism and crumbling bourgeois values. The film also produced the first anecdote about Herzog's famously crazy behaviour. During the shoot he felt so bad when a dwarf cast member was run over by a car that he stripped completely naked and jumped headlong on to a cactus. He followed up in a similar vein with *Fata Morgana* (1971), the study of a bunch of eccentrics living in the desert, and the documentary *Land of Silence and Darkness* (1971), a sensitive documentary about a deaf and blind woman on the verge of embarking on her first aircraft flight. The film features a band of fellow sufferers that once again revealed Herzog's affinity with the damaged souls of humanity.

'Film should be looked at straight on. It is not the art of scholars but of illiterates.'

Werner **Herzog**

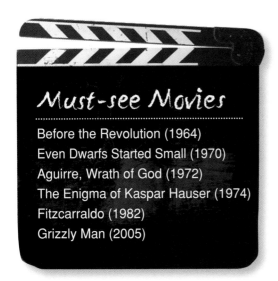

Must-see Movies

Before the Revolution (1964)
Even Dwarfs Started Small (1970)
Aguirre, Wrath of God (1972)
The Enigma of Kaspar Hauser (1974)
Fitzcarraldo (1982)
Grizzly Man (2005)

PARTNERS IN MADNESS

It took *Aguirre, Wrath of God* (1972) to catapult Herzog into the forefront of a new wave of German film directors known collectively as New German Cinema. *Aguirre* is the fable of a Spanish conquistador who is driven mad by his ambition to find the legendary city of El Dorado. From the opening image of men as ant-like figures toiling up a mountain Herzog conjures up a continuous stream of haunting, arresting images, concluding with the camera circling around Aguirre's raft as it heads down the Amazon, trapping the character in his fate.

The film was acclaimed and became a hit all over the world, but perhaps its real significance lies in its casting, as *Aguirre* brought Herzog together again with Klaus Kinski, spawning arguably the most tempestuous director–actor relationship in film history. For example, when Kinski threatened to abandon the film mid shoot Herzog said that if Kinski attempted to leave he would kill the actor and then turn the gun on himself. Some reports even suggested that Herzog wielded a pistol to make his point. Whatever the tensions, Herzog pulled an astonishing and committed performance from Kinski, and he remains the only director to bring the best out of the actor's unhinged and eccentric talent.

Herzog picked an equally difficult leading man for his next feature. *The Enigma of Kaspar Hauser* (1974) tackles the true story of a 16-year-old boy, found in a Nuremberg town square in the 1820s unable to walk or talk, having been confined in a cellar since birth. Herzog cast Bruno S., a former psychiatric patient, in the lead role of Hauser, and he gives an astonishingly expressive, captivating performance as the man-child reacting excitedly to a world of polite society that treats him with suspicion. Herzog delivers a lyrical film about a non-lyrical man, tellingly using nature and landscapes to embody Kaspar's new reality.

Herzog's remaining films of the 1970s never quite reached such heights. *Hearts of Glass* (1976), which depicts a backwater community wandering around in a trance-like state, is notable for the fact that Herzog put the entire cast bar one under hypnosis to direct them. *Stroszek* (1977) follows a trio of misfits into the wilds of Wisconsin and *Nosferatu the Vampyre* (1979), a remake of the silent German horror classic starring Klaus Kinski as a vampire, allowed Herzog the full rein of his expressionist and obsessive tendencies. After finishing the shoot Herzog shipped 10,000 rats into the small town he had used as a location, dyed them white and left them there as a leaving present for the locals.

THE NEW GERMAN CINEMA

During the 1960s and 1970s a movement similar to the French *nouvelle vague* swept through German cinema as a response to the stale aesthetic and social and financial status of the dominant home-grown industry. Initiated by the Oberhausen Manifesto, a document signed by 26 young filmmakers, the movies produced by this group were diverse in theme and content but linked by a harsh tone, extreme techniques, a fatalistic viewpoint and critiques of affluent bourgeois life. Apart from Herzog, leading lights in the movement included Wim Wenders (*The American Friend, Paris Texas*), Rainer Werner Fassbinder (*The Marriage of Maria Braun*), Edgar Reitz (*Heimat*) and Volker Schlöndorff (*The Tin Drum*).

AN OBSESSION WITH OBSESSION

After filming *Woyzeck* (1979), again with Kinski, Herzog embarked on his most ambitious project. *Fitzcarraldo* (1982) charts the epic efforts of a mad opera enthusiast (Kinski once again) to drag his steamship up and over a mountain to achieve his dream of bringing opera to the Amazon jungle. The making of the film is the stuff of legend, but the movie, like *2001* and *Apocalypse Now*, is an astonishing visual experience and a brave, courageous film made all the more impressive by the fact that Herzog did everything for real. It is also impossible not to read the film as self-portrait: the similarities between Fitzcarraldo, in his desperate attempts to bend nature to his will, and Herzog are difficult to ignore.

Perhaps laid low by the grand scale of *Fitzcarraldo* Herzog has spent most of the past 25 years making documentaries. Among his most interesting non-fiction works are *Lessons of Darkness* (1999), about the environmental cost of the Gulf War in Kuwait, and *My Best Friend* (1999), a portrait of his tortured relationship with Kinski. But his best and most accessible is 2005's *Grizzly Man*, a typical tussle with nature that Herzog assembled from 70 hours of footage of Timothy Treadwell, a man who lived with bears in the wild before he was eaten by a rogue grizzly in 2003. Complex and probing, it is arguably Herzog's most entertaining work.

Continuing to dabble with drama – *Cobra Verde*, *Scream of Stone* and *Invincible* (1987, 1991 and 2001), for example – Herzog made a powerful return to form with *Rescue Dawn* (2007), a film based on his 1997 documentary *Little Dieter Needs to Fly*. Christian Bale stars as a pilot held captive in Laos during the Vietnam War, who leads an escape attempt. It could have been a routine action adventure, but in Herzog's hands it is yet another harrowing demonstration of the director's eternal battle – between the natural world, human nature and himself.

THE MAKING OF *FITZCARRALDO*

The shooting of *Fitzcarraldo* is a catalogue of natural and manmade disasters, the likes of which few other moviemakers have ever had to cope with. When he arrived on location Herzog found himself in the middle of a border dispute between Peru and Ecuador and was forced to shift location. His original star, Jack Nicholson, pulled out before filming commenced, and Jason Robards, who replaced him, was forced to leave because he was suffering from amoebic dysentery, so causing a delay that forced co-star Mick Jagger to depart for a Rolling Stones tour. In the end Klaus Kinski came in to save the day. The sorry mess is brilliantly covered in Les Blank's must-see 1982 documentary *Burden of Dreams*.

Martin
Scorsese

'Martin Scorsese has the best
director's vocabulary in this
country. He also has the intensity
of passion.'

Elia **Kazan**

1942–

'America's greatest living director' is a tag that has
followed Martin Scorsese for the best part of 30 years. Bold, versatile,
challenging, uncompromising, intelligent and provocative, Scorsese's
decision to switch his calling from the priesthood to movies has resulted
in electrifying, dangerous, highly personal cinema. His films explore
notions of machismo, religious guilt, disenfranchised mindsets and the
glamour and allure of crime, all with a profane passion and unflinching
honesty that make his films uncomfortable but essential viewing.

Stylistically Scorsese deploys a restless moving camera, bravura editing strategies and a protean
use of music – from rock to opera – to explore violent, edgy, male-dominated milieux, typically the
Italian-American neighbourhoods of New York where he grew up. Being a passionate supporter
of film preservation he peppers his films with cinematic allusions, often half-remembered scenes
from his movie-soaked childhood, yet he has always managed to reflect raw reality rather than
empty pastiche. His creativity might have been shaped by Hollywood fictions, but Scorsese can't
do anything other than tell the truth.

ITALIAN-AMERICAN LIFE

Martin Scorsese was raised in a tenement block
in New York's Little Italy, the son of Sicilian
immigrants. Beset by asthma as a child he
took refuge in the cinema, devouring films on
television and drawing out movies in comic strips
bearing the logo MarSco Productions. He entered
a seminary with the intention of becoming a
priest, but he dropped out and went to study
film at New York University, turning out award-
winning shorts and staying on as an instructor.
During this time he directed his first feature, the
autobiographical *Who's That Knocking at My Door?*
(1969), a lively portrait of Italian-American youths that stars a fresh-faced Harvey Keitel.

Must-see Movies

Mean Streets (1973)
Taxi Driver (1976)
Raging Bull (1980)
Goodfellas (1990)

After working on documentaries in New York – Scorsese has continued to make non-fiction
films throughout his whole career – his desire to direct his own work led him to Los Angeles
where he hooked up with exploitation maestro Roger Corman. Corman offered Scorsese the
chance to direct *Boxcar Bertha* (1972), a spiritual sequel to his own *Bloody Mama (1970)*. Scorsese
accepted and delivered a well-crafted Depression-era gangster flick.

Independent filmmaker John Cassavetes saw *Boxcar Bertha* and urged Scorsese to get back
to making more personal films in the vein of *Who's That Knocking*. His response to this was *Mean
Streets* (1973), an autobiographical tale of a young hood (Keitel again) coming to terms with his
wayward cousin (Robert De Niro), religious guilt and a life of crime in Little Italy. Characterized
by raw energy, authentic street talk, unexpected violence, a constantly moving camera and a
groundbreaking rock-music soundtrack, *Mean Streets* became Scorsese's first masterpiece: an
unforgettable, plotless study of male friendship and Italian-American rituals.

PET PROJECT

In 1987 Scorsese finally got to make *The Last Temptation of Christ*. Starring Willem Dafoe as Christ, Scorsese's film generated controversy for its depiction of the human side of the Messiah, including a coda that shows him married, having sex and raising children. The film was condemned sight unseen in sermons across America and was subsequently picketed by protest groups – in a Parisian cinema incendiaries were thrown at the screen, injuring 13 people. Amid all the controversy the film itself was forgotten, but it is a brilliantly made, serious, deeply reverential treatise on the difficulties of maintaining religious ideals in the face of human desires.

Using *Mean Streets* as a calling card Scorsese went back to Hollywood, where he diversified from being solely a purveyor of urban, male-dominated movies by directing *Alice Doesn't Live Here Anymore* (1974), a feminist drama that earned star Ellen Burstyn an Oscar and became a popular hit. Scorsese now used his newfound commercial clout to get a much more challenging project off the ground.

ARE YOU TALKIN' TO ME?

Taxi Driver was a labour of love for Scorsese, star De Niro and screenwriter Paul Schrader. Charting a slow descent into madness, it is a character study of De Niro's Vietnam veteran Travis Bickle who takes a job driving cabs at night and is torn between dating a blonde angel (Cybill Shepherd) and rescuing a child prostitute (an astonishing Jodie Foster). Anchored by a wired, committed performance from De Niro, Scorsese mixes realism and expressionism to create the ultimate vision of New York as hell – he puts you inside the head of a madman and never lets you leave. Riveting, unnerving and surprisingly funny, it's a film that stays with you forever.

Just as *Taxi Driver* updated elements of film noir, so Scorsese's next film, *New York, New York* (1977), injected realism into the musical. In this love letter to a moribund genre Scorsese flits between great musical numbers – the film gave Sinatra his signature song – and a telling portrait of how creative neurosis affects relationships. It was a flop on release, and the film's poor reception sent Scorsese into depression and cocaine addiction, but *New York, New York* remains his unsung masterpiece.

However, in 1980 he bounced back with his greatest film, *Raging Bull*, a biopic of heavyweight boxing champion Jake LaMotta. Shot in striking black and white it is unlike any other sports movie ever made. It features only 12 minutes of boxing, although these are the most brutal, compelling, imaginative fight scenes ever shot. It is even more impressive away from the ring, charting LaMotta's abusive relationship with his wife and brother and his fall from grace, all of which is handled in a way that brilliantly exposes a teetering, self-destructive machismo. The film received mixed reviews, winning only two Oscars – De Niro and editing – but is now rightfully seen as a classic.

Scorsese reined in the emotional and filmmaking fireworks for *The King of Comedy* (1982), featuring De Niro buttoned down and blackly funny as an aspiring comedian who kidnaps a talk-show host. That same year Scorsese started work on his pet project, an adaptation of Greek author Nikos Kazantzakis's reinterpretation of Christ's story, *The Last Temptation of Christ*, but the project was dropped because of pressure on Paramount from religious groups. Just to keep his hand in, Scorsese made sprightly black comedy *After Hours* (1985) and *The Color of Money* (1986), a sequel to *The Hustler*, which won star Paul Newman an Oscar.

MOB RULES

After the heat of controversy surrounding the eventual production of *The Last Temptation of Christ* in 1987 Scorsese went back to his roots with his first film of the 1990s. *Goodfellas* (1990), starring De Niro, Ray Liotta and an Oscar-winning Joe Pesci, is a vividly realized depiction of Italian mob

life, full of virtuoso direction, sharp suits, lovingly observed rituals, non-linear storytelling, bone-crunching violence and never-ending profanity – the film averages an F-word every 28 seconds. *Goodfellas* represents a high point in Scorsese's technical mastery but perhaps lacks the emotional dimensions of his best work. Staying with the crime genre Scorsese and De Niro delivered a bravura remake of 1962 thriller *Cape Fear* (1991) and *Casino* (1995), the latter a compelling mixture of the documentary and the operatic that depicts how the mob was involved in the birth of Las Vegas.

In between these crime movies Scorsese explored very different areas of concern. *The Age of Innocence* (1993), based on Edith Wharton's novel of a failed romance in late-19th-century high society, raised eyebrows about the director's suitability for the task. Yet Scorsese found familiar ground in the material – tightly wound men, codes of behaviour, New York – and delivered a masterwork of nuance and understatement, full of a quiet emotional violence that is just as shocking as anything in *Goodfellas*. *Kundun* (1997), an account of the early life

> 'My whole life has been movies and religion. That's it. Nothing else.'
>
> Martin **Scorsese**

of the Dalai Lama, is an interesting companion piece to *The Last Temptation*, with Scorsese again exploring the difficulty of maintaining spirituality in the everyday world.

OSCAR CURSE

As he entered the new millennium much of the critical attention and writing about Scorsese centred on the fact that despite such a great body of work he had never been rewarded with an Oscar after five nominations. *Gangs of New York* (2002), a long-cherished Scorsese project about New York gang warfare in the 1880s, lost out to Roman Polanski and *The Pianist*; *The Aviator* (2004), a biopic of aviator-filmmaker-recluse Howard Hughes (Leonardo DiCaprio), lost out to Clint Eastwood and *Million Dollar Baby*. His time, it seemed, had passed.

Perhaps frustrated by his lack of Academy success Scorsese went back to the crime thriller with *The Departed* (2006), an all-star remake of 2002 Hong Kong police drama *Infernal Affairs*. Scorsese turned in a slick, supremely entertaining thriller that was well received but didn't feel substantial enough to be Oscar worthy – except, on 25 February 2007 Martin Scorsese was presented with the Oscar for Best Director by friends Francis Ford Coppola, Steven Spielberg and George Lucas. It was overdue validation, but Scorsese's daring vision doesn't need a gold statuette to prove its worth.

ALTER EGO

Martin Scorsese first met Robert De Niro at a mutual friend's Christmas dinner in the late 1960s. Starting with De Niro's explosive performance in *Mean Streets*, what followed was one of the great actor–director partnerships, with Scorsese giving De Niro full rein to experiment and De Niro going to extraordinary lengths to realize Scorsese's vision. For *Taxi Driver* the actor spent nights driving a New York cab; for *New York, New York* he learned to play the saxophone; and, most famously, for *Raging Bull* he not only recreated Jake LaMotta's boxing style, he gained 60 pounds (27 kg) in weight to portray the older incarnation. The result is one of cinema's outstanding performances.

George
Lucas

'George smashed open the possibilities
of what film could actually do.'

Peter **Jackson**

1944–

The George Lucas story is riddled with fascinating anomalies. It is about an experimental film student who became the most commercially successful director in the world; it is about an intellectual who regularly dedicates his intelligence to children's entertainment; it is also the story of a filmmaker who fought hard to secure his creative independence yet, once earned, decided to give up directing for 20 years. There is so much more going on here than just lightsabers and Darth Vader pyjamas.

Must-see Movies

THX 1138 (1971)
American Graffiti (1973)
Star Wars: Episode IV – A New
 Hope (1977)

Lucas is a notoriously quiet figure on set. A lot of his direction takes place before the cameras roll, planning out the movie with computerized storyboarding. Once filming has finished, his skilful use of cutting-edge visual effects with imaginative editing and sound design add another level of manipulation. With only six films as a director to his name, his influence on cinema and popular culture is arguably more important than the films themselves.

HOT RODS TO COLD FISH

George Walton Lucas Jr was born on 14 May 1944 in the small Californian town of Modesto. His first passion was cars and drag racing, but his ambitions were extinguished by a life-threatening car crash. A chance encounter with cinematographer Haskell Wexler encouraged Lucas to explore filmmaking, and he enrolled in the Cinema School at the University of Southern California.

While many students in the 1960s got high on drugs, Lucas got high on film, winning awards for his animation, documentaries and dramas. Straight out of USC he was taken under the wing of Francis Ford Coppola, who was setting up American Zoetrope, a haven for young independent-minded filmmakers. *THX 1138* (1971), expanded from Lucas's award-winning short, became his and Zoetrope's first film. It is a chilling vision of a totalitarian future with THX (Robert Duvall) trying to escape the confines of his subterranean, state-controlled existence. If the film's Orwellian themes were familiar, Lucas's directorial vision – full of extreme close-ups, stark sets and a dense, abstract soundtrack – makes it seem less a film about the future and more like a film *from* the future. *THX* was admired for its daring technique, but its lack of human warmth left audiences and critics cold. If Lucas was to continue in the film industry he was going to have to get emotional.

BUSTING THE BLOCKS

Lucas's response to this cold-fish image was *American Graffiti*. Shot for just US$780,000 in just 28 days, the film is a nostalgic elegy to growing up in the late 1950s and early 1960s as four friends spend their last night together before college and adulthood beckon. Written with Lucas's old 45s in the background and infused with his love of automobiles, *Graffiti* is warm, witty and true, shot through with a lovely golden hue as it captures a specific point in history – the shift from the innocence of the early 1960s to the turbulence later in the decade.

The huge success of *Graffiti* gave Lucas the chance to pick his next project. In the early 1970s he had toyed with writing a space-adventure movie like the serials he had loved as a child. After failing to acquire the rights to *Flash Gordon* he spent two years writing and researching *The Star Wars*, as it was then called. The script was turned down by practically every studio in Hollywood, including Universal which had released *Graffiti*, until Alan Ladd Jr, a huge *Graffiti* admirer, at 20th Century Fox

> '**A special effect without a story is a pretty boring thing.**'
>
> George **Lucas**

invested in the movie but allowed the sequel and merchandising rights to remain with Lucas. It was a decision Fox would come to rue. *Star Wars*, released in 1977, became the most profitable film of all time, both at the box office and on the toy shelves; the first film to truly capitalize on its merchandising potential. It is a vintage adventure with a hip, high-tech spin, and Lucas assembled an adroit compendium of film genres and styles, a perfectly poised mixture of moral certainty, comic-book corn and mythical overtones. It changed the movie industry overnight, influencing everything from the return of orchestral musical scores to state-of-the-art special effects, and the cannibalizing of film history. It also changed Lucas's life, making him extraordinarily wealthy. But, at the height of his powers and popularity as a director, he made an unexpected move. He retired.

THE FORCE RETURNS

Lucas's decision to withdraw from directing didn't stop him making movies. He provided stories for, and supervised, the equally successful *Star Wars* sequels, *The Empire Strikes Back* (1980) and *Return of the Jedi* (1983). He also presided over a diverse range of productions, from the commercial *Indiana Jones* trilogy to the arthouse *Mishima* and the derided *Howard the Duck*.

In 1997 Lucas released special editions of the *Star Wars* trilogy, enhancing the 20-year-old films with digital special effects. It heralded his return both to *Star Wars* and directing. Surrounded by rabid fan anticipation and unparalleled media hype *Star Wars: Episode I – The Phantom Menace* (1999) took huge amounts at the box office, but, despite sumptuous visual elements and some great moments, it failed to provide a story and characters as iconic as the original trilogy. Lucas continued with *Attack of the Clones* (2002) and *Revenge of the Sith* (2005), which both improved on *The Phantom Menace*.

In 2008, with Lucas back producing his other franchise – *Indiana Jones and the Kingdom of the Crystal Skull* – it is unknown whether he will direct again, although he has spoken of his desire to return to the personal and esoteric films of his student days. The Jedi master, apparently, still has things to explore and learn.

CHANGING THE FACE OF FILM

During his time out from directing Lucas's behind-the-scenes work changed the face of film production. His Skywalker Ranch was set up as a think-tank for San Francisco filmmakers. Housed at the ranch, Skywalker Sound is the world's leading sound-design company – its THX sound system is named after Lucas's debut movie. Lucas has also pushed his Industrial Light and Magic outfit into the forefront of digital effects, breaking new ground in computer techniques with *The Abyss, Terminator 2* and *Jurassic Park*. Lucasfilm's computer department evolved into Pixar, the computer-animation company behind the *Toy Story* films and *Finding Nemo*.

David
Lynch

'He's Jimmy Stewart from Mars.'
Mel **Brooks**

1946–

As an art-school student David Lynch was known to burn the skin off a mouse just to study its innards. In retrospect, the act is a great metaphor for Lynch's art – probing through the surface of normality by shocking, often sick, methods to discover a festering world underneath. He is that rare artist who has brought avant-garde sensibilities into the mainstream, be it period drama, science fiction or murder mystery. He finds the sinister in wholesome locales and the comedy in perverted human relationships, challenging and antagonizing audiences to peer into his dark world.

Although a cult figure he has been allowed to cross over into other disciplines, but it is as a filmmaker that he has remained most potent, delivering his vision through painterly yet offbeat compositions accompanied by disturbing, disorientating soundtracks and kitsch pop music. The result, a kind of Hieronymus Bosch meets Frank Capra, is like nothing else in modern American cinema.

INDUSTRIAL NIGHTMARES

David Lynch was born on 20 January 1946 in Missouri, Montana. His upbringing was normal if disjointed; his father was a research scientist for the Department of Agriculture and so the family moved around, with Lynch growing up in the kinds of picturesque small towns that would later feature in his movies. After art school he was commissioned to create an art installation, a four-minute clip called *The Alphabet* (1968), that led to him winning a US$5,000

Must-see Movies

Eraserhead (1976)
Blue Velvet (1986)
Mulholland Drive (2001)

grant from the American Film Institute. He used the money to make *The Grandmother* (1970), the bizarre tale of a young boy who, abused by his parents, grows a living grandmother from a seed. The film won numerous festival awards and foreshadowed many Lynchian hallmarks: disturbing surrealistic images, unsettling sound – courtesy of sound designer Alan Splet – and a freeform exploration of unconscious desires at the expense of narrative.

'It's better not to know so much about what things mean.'

David **Lynch**

Lynch crystallized these ideas in *Eraserhead* (1976), his debut feature. Using US$10,000 from the AFI, Lynch started shooting the film in 1972 but did not have the funds to finish the production, so he borrowed money from friends, family and industry professionals – and even took a paper round – to complete it. The film that emerged is unlike any other in film history. Set in a nightmarish wasteland, *Eraserhead* is about a quiet man (Jack Nance) whose girlfriend gives birth to a constantly crying mutant and then leaves him holding the baby. Around the nightmarish premise Lynch delivers urban alienation, frightened sexuality and relationship fears within astounding expressionist sets, an

oppressive industrial soundtrack and images that are half horror film, half surrealist fever-dream. It is a classic of sorts but not one you are likely to watch more than once.

INTO THE MAINSTREAM

Eraserhead proved a huge cult hit that played America's midnight-movie circuit for years. It also brought Lynch to the attention of the mainstream. Mel Brooks hired him to direct *The Elephant Man* (1980), a biopic of the horrifically disfigured John Merrick who gained notoriety during the Victorian era. Lynch might have seemed an odd choice, but he brought *Eraserhead*'s steamy industrial imagery and affinity with the outsider and turned it into its polar opposite: a period biopic. Lynch draws an affecting and poignant performance from John Hurt, who manages to be touching under a pile of prosthetic makeup. The film received eight Academy Award nominations and put Lynch in the unlikely position of being bankable.

George Lucas offered Lynch the chance to direct *Revenge of the Jedi* – before it was retitled *Return of the Jedi* – yet Lynch refused, feeling the film would be more Lucas's vision than his own. Still, Lynch stayed with science fiction for his next project, a US$45-million adaptation of Frank Herbert's sprawling science-fiction saga *Dune* (1984). The film – the story of a battle for control of a mind-altering drug – has touches of Lynch's genius in its visual design and set pieces, but the experience as a whole is inconsistent and incoherent. The film was re-edited and extended for television, but Lynch disowned the version, taking his name off the credits.

IN DREAMS

Part of his deal for *Dune* ensured that Lynch would be able to make a project of his own choosing with complete creative control, and the film he produced is his masterpiece. Part detective story, part teen romance, part film noir, part kitsch musical, *Blue Velvet* (1986) sees a clean-cut college student (Kyle MacLachlan, often a Lynch alter ego) find a severed ear on a lawn, a discovery that leads him to uncover a dark, twisted world set in the heart of an all-American small town. Controversial on its release because of its depiction of an abusive relationship between a tormented lounge singer (Isabella Rossellini) and a psychopathic killer (a terrifying Dennis Hopper), it is also a brilliant piece of filmmaking. Lynch's deployment of colour and inspired use of vintage songs, including Roy Orbison's 'In Dreams' and Bobby Vinton's 'Blue Velvet', conspire to create a disturbing, unsettling experience which this time is allied to an engaging plot.

Lynch stayed in the dark heart of small-town America for his next project, the television series *Twin Peaks* (1990–1). Yet, with typical perversity, he produced a theatrical prequel, *Twin Peaks: Fire Walk With Me* (1992), about the last seven days in the life of Laura Palmer, the character whose murder is central to the plot of the television show. It is full of hypnotic sequences that went

SURREAL SIDELINES

Lynch is a modern renaissance man, showcasing his skewed world view in art installations, furniture design, music projects and a website as well as his movies. Some of his more unusual sidelines include: 'The Angriest Dog in the World', a weekly comic strip for the *Village Voice*, that has unchanging panels of an angry dog chained up in a yard accompanied by various cod-philosophical phrases; *Blue Bob*, a rock album on which Lynch plays a guitar upside down and backwards; and David Lynch Signature Cup, his own brand of organic coffee that bears the motto 'It's all in the beans . . . and I'm just full of beans'.

TWIN PEAKS

Lynch's landmark television series *Twin Peaks* was, notionally, about an investigation led by FBI Agent Cooper (Kyle MacLachlan) into the death of popular high-school student Laura Palmer (Sheryl Lee), but it spun off into illogical storylines with a whole gallery of freakish sideshow characters. When launched on the ABC network the show became a cult favourite, spinning off numerous catchphrases – 'Damn fine coffee' – and entering the culture with references in *The Simpsons* and a *Time* magazine cover. During its second season Lynch clashed with network bosses over their insistence on revealing the identity of Palmer's killer, and the show was cancelled in 1991.

further than the small-screen incarnation, but it failed to capitalize on the success of the series and flopped at the box office.

Sandwiched between the *Twin Peaks* television series and the film, Lynch made *Wild at Heart* (1990), a lurid, hyperkinetic road movie. It is a thin story of lovers Sailor Ripley and Lula Fortune (Nicolas Cage and Laura Dern) being chased across America by Lula's crazed mother (Diane Ladd, Dern's real-life mother). Lynch pumps the movie full of excessive violence, Elvis tributes, crazy sex, *Wizard of Oz* allusions and nods to his own work – Willem Dafoe's psycho is a dead ringer for *Blue Velvet*'s Frank Booth – but it can't match the coherent vision and compelling intensity of his best work. It was a failure in America but won the Palme d'Or at the Cannes Film Festival.

WEIRDER AND WEIRDER

After returning to television with *On the Air* and *Hotel Room* (1992 and 1993) Lynch's next feature film reverted to the non-linear abstract approach of his earlier films. *Lost Highway* (1997), starring Bill Pullman and Patricia Arquette, is an impenetrable retooling of film-noir staples, but this ambiguity makes it one of Lynch's most provocative works, open to endless interpretation and debate.

Seemingly a reaction to *Lost Highway*'s Chinese puzzle-like plot Lynch's next film could not be simpler. *The Straight Story* (1999) follows the journey of an ageing Iowa farmer who travels across country on a lawnmower to visit his dying brother. Whimsical, heartwarming and accessible, the film remains the most un-Lynch-like film of his career – if he had stuck closer to these concerns we would have a very different image of him today.

The same year he returned to make a two-hour pilot for ABC entitled *Mulholland Drive*, which is an exploration of the darker side of Hollywood. When the project was cancelled Lynch completed it using French financing and delivered his best film for years. Tracing the relationship between an amnesiac movie star and the fledgling young actress who helps her recover her memory and identity, Lynch explores the hinterland between the Hollywood dream and the dark reality, embroidering the tale with multiple layers of stunning visuals, teasing enigmas and emotional intensity.

Lynch's most recent film, *INLAND EMPIRE* (Lynch insists the title be in capitals), made in 2006, shares similarities with *Mulholland Drive* as he once again explores the fractured inner psyche of a movie star. The movie starts conventionally enough with an actress (Laura Dern) preparing for her biggest role yet, but half an hour into its three-hour running time it goes on a flight into weirdness that takes in a sitcom with giant rabbits, prostitutes singing 'The Locomotion' and scenes that shift from Łódz to Hollywood Boulevard. Yet perhaps even stranger were Lynch's marketing strategies. He made public appearances with a cow and a placard bearing the motto 'Without cheese there would be no *INLAND EMPIRE*'. It doesn't come more Lynch than that.

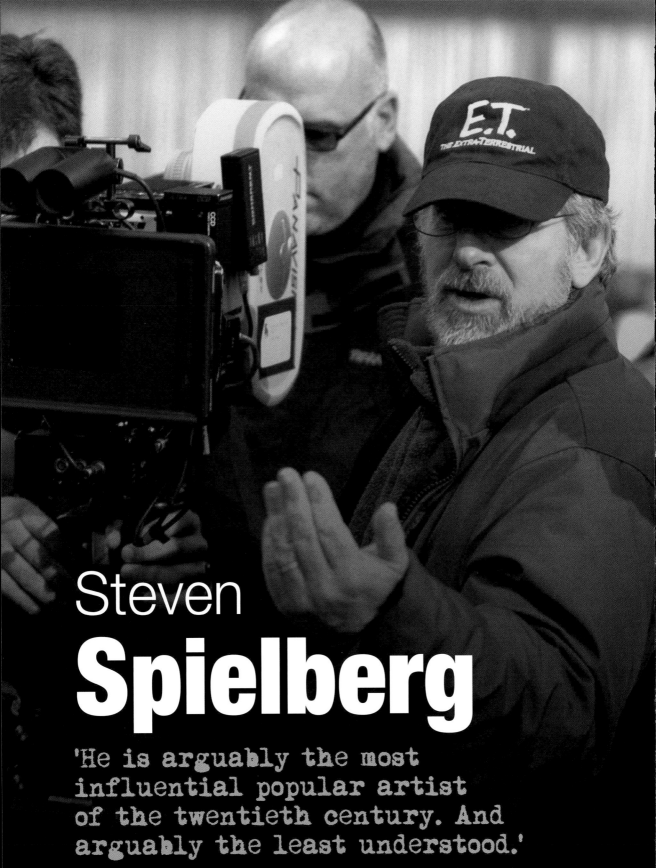

Steven
Spielberg

'He is arguably the most
influential popular artist
of the twentieth century. And
arguably the least understood.'

Michael **Crichton**

1946–

Steven Spielberg is the world's most famous living filmmaker. Like DeMille and Hitchcock before him he encapsulates for the general public what a film director is, even setting the directorial dress code – jeans, sneakers, baseball cap – for anyone wishing to make movies. He is also the world's most commercially successful filmmaker with three of the highest-grossing films of all time bearing his imprint. As a popular artist doing the most interesting creative work at the heart of the mainstream he stands comparison with the Beatles as one of the most important popular-cultural figures of the past 100 years.

Spielberg has been criticized for being overly manipulative and sentimental, but few filmmakers can match the dexterity with which he switches between blockbuster movies and powerful yet personal films. He combines a breathless mastery of modern moviemaking and old-fashioned storytelling values, all in the service of devastating emotional directness, infusing tension, wonder, comedy and melodrama into perfectly formed confections. That he does this with such regularity is proof positive he is among the most naturally gifted cinematic entertainers in the history of the medium.

Must-see Movies

Duel (1971)

Jaws (1975)

Close Encounters of the
 Third Kind (1977)

Raiders of the Lost Ark (1981)

E.T. The Extra-Terrestrial (1982)

Schindler's List (1993)

BOY WONDER

Steven Allan Spielberg was born on 18 December 1946 in Cincinnati, Ohio, and he grew up in the kind of suburban environments he has often put at the heart of his cinema. Despite being a keen amateur filmmaker Spielberg's C-grade average was not good enough to get him into film school. Instead, he enrolled at California State nominally to study English but actually devoting his life to movies. He gained an internship at Universal Studios, where he made a 24-minute, 35-mm short called *Amblin'* (1968) about a couple of hitchhikers. Astonishingly confident and technically assured for such a young filmmaker, the award-winning movie was enough to win Spielberg a contract with the studio as their youngest television director. He was barely 22 years old.

Spielberg's first assignment was on science-fiction show *Night Gallery*, where he showed enough confidence to direct the legendary Joan Crawford. This led to him working on *Columbo*, *The Name of the Game* and *Marcus Welby, MD*, but he didn't really catch the eye until he made a television movie based on a short story he had read in *Playboy*. *Duel* (1971) starred Dennis Weaver as a mild-mannered businessman who plays a cat-and-mouse game with a malevolent monster truck on the highway. Marked by economical character sketching, black humour and virtuoso directorial touches, the film was so cinematic it garnered a movie-house release in Europe and made Spielberg a name to watch.

After two more television movies – the underrated 1972 horror *Something Evil* and average thriller *Savage* the following year – Spielberg moved up to theatrical features. *The Sugarland Express* (1974) tapped into the same ability for staging spectacular action that he had displayed in *Duel* but added a skilful touch with character as a couple hijack a police car to regain custody of their baby. The film, while precociously confident, failed to find an audience and could have been the end of Spielberg's career.

THE SHARK TO THE ARK

Luckily for Spielberg he had another project to go on to. *Jaws*, based on a best-selling book by Peter Benchley, had echoes of *Duel* in its story of everyman heroes battling a killing machine, this time a great white shark that is terrorizing a small resort reliant on summer dollars. The shoot was nightmarish – the mechanical shark routinely failed to work – but Spielberg turned adversity into triumph, creating astonishing tension by delaying the first sight of the shark through a brilliant mixture of suspense and surprise. But he also created sharply defined, memorable characters that make you forgive the fake-looking shark when it does actually arrive.

'I always like to think of the audience when I am directing. Because I am the audience.'

Steven **Spielberg**

Jaws was released in June 1975. Earning US$470 million, it became the highest-grossing film of all time and ushered in a whole new era of summer blockbusters. It also gave Spielberg the clout to pick and choose his next project. *Close Encounters of the Third Kind* (1977), which was written by Spielberg, reunited the director with Richard Dreyfuss, who had appeared in *Jaws*, in a tale of UFO obsession and government cover-up. It remains astonishingly important in Spielberg's career, establishing many of the themes and motifs that have become most identified as his: a collision between the otherworldly and the suburban, a skill at directing children, a benign sense of wonder and optimism. It was another huge success, and it firmly ensconced Spielberg at the top of the Hollywood heap.

It was a golden touch that eluded him on his next project. *1941* (1979), a hugely expensive Second World War comedy, was brilliantly assembled but was overindulgent and unfunny, becoming a notorious flop. To get back on track Spielberg took up an offer from his old friend George Lucas – the pair had met in 1967 at a student film festival – to direct *Raiders of the Lost Ark* (1981), a throwback to the no-budget, cliffhanger serials of the 1930s. Spielberg conjured up a brilliant cavalcade of stupendous stunts, great comedy, exotic adventures and supernatural scares. It was a trick that he pulled off again with the dark, kinetic *Indiana Jones and the Temple of Doom* (1984) and the lighter, more emotional *Indiana Jones and the Last Crusade* (1989). Spielberg returned to the character to mixed notices in 2008 with *Indiana Jones and the Kingdom of the Crystal Skull*.

PHONE HOME

After the breakneck pace and scale of *Raiders* Spielberg's next project could not have been more different. Based partly on his memories of growing up lonely in a broken home – Spielberg's parents eventually separated when he was 17 – *E.T. The Extra-Terrestrial*, the touching tale of a young boy who befriends an alien stranded on earth, is perhaps his perfect movie. Unlike the shark in *Jaws* Spielberg's mechanical *E.T.* performed beautifully, and he elicited a clutch of great child performances from Henry Thomas, Robert MacNaughton and Drew Barrymore.

E.T. is one of American cinema's most tender, delicate emotional experiences, and it changed Spielberg's image into one of a spinner of fairytales. Its astonishing financial success paved the way for him to become a brand name in American entertainment, attaining a celebrity status rare among film directors.

As if making a conscious attempt to tackle more mature material Spielberg spent the mid 1980s taking on acclaimed novels with grown-up themes. In 1985 eyebrows were raised when he adapted *The Color Purple*, author Alice Walker's Pulitzer Prize-winning novel about an African-American woman's journey of self-discovery in Depression-era America. Full of beautiful craft, Spielberg never fully commits to exploring the frankness of some of the material, toning down some of the explicit lesbian scenes found in the book. Two years later he directed an absorbing adaptation of *Empire of the Sun*, J.G. Ballard's autobiographical novel of growing up in Shanghai during the Japanese occupation. Casting a young Christian Bale as the young Ballard, Spielberg mounts a moving elegy to the death of childhood surrounded by brilliant set pieces of large-scale action.

Perhaps hurt by the mixed reactions to these films, Spielberg returned to more familiar territory. After *Last Crusade* he made lightweight supernatural romance *Always* (1989), then *Hook* (1990), a reworking of J.M. Barrie's *Peter Pan* story with Robin Williams as a grown-up Peter Pan, which should have been perfect for Spielberg, but in the end it descends into an ersatz, childish, rather than childlike, pantomime.

It took *Jurassic Park* (1993) to put Spielberg back on top again. Based on Michael Crichton's novel of genetically engineered dinosaurs running amok in a theme park, it was the third Spielberg work to become the highest-grossing film of all time. The movie was marked out by Spielberg's bold decision to jettison traditional animation effects and recreate the prehistoric creatures through cutting-edge computer imagery, so paving the way for a whole new era of digital special effects. Although supremely entertaining it is not the director working at full tilt – probably because his mind was already on his next project.

JOHN WILLIAMS

The most consistent and fruitful creative relationship of Spielberg's career has been with composer John Williams. For *Jaws* he talked Spielberg out of using a melodic theme for the shark, replacing it with the now infamous two-note piece. For *Close Encounters* he worked through hundreds of combinations of five-note tones to get the perfect musical greeting between aliens and humans. By the time of *E.T.* Spielberg re-edited his pictures to match the operatic score – a true testament to how much the director values the emotional power of Williams's soundtracks.

HISTORY LESSONS

Astonishingly, in the same year that he made the blockbusting *Jurassic Park* he also turned in the darkest, most ambitious film of his career, *Schindler's List*. In order to imbue with power the story of Oskar Schindler – the ethnic-German Moravian industrialist who saved 1,300 Jews from Nazi death camps by putting them to work in his factories in Poland and Czechoslovakia – Spielberg adopted a black-and-white, handheld approach to document the chilling remembrances. Whether it is the broad sweep of history, such as the liquidation of the Jews in the Kraków ghetto, or such evocative details as children hiding from their pursuers by submerging themselves in excrement, Spielberg's eye, heart and mind have never been so forcefully engaged, filling every frame with rich texture, biting intelligence and simmering anger. Earning almost across-the-board ecstatic reviews, the film also ended Spielberg's Oscar curse, winning the Best Director and Best Picture awards.

Following the 1997 *Jurassic Park* sequel *The Lost World* Spielberg returned to the darker recesses of history with *Amistad* (1997), the true story of a slave rebellion on a Cuban ship in 1839 and the subsequent trial in the USA, and Second World War drama *Saving Private Ryan* (1998). The latter was an instant classic, following an American unit behind enemy lines in France charged with bringing home a private (Matt Damon) whose three brothers have been killed in battle. Bookended by two of the most ferocious battle scenes ever committed to film – the opening Omaha Beach assault is one of cinema's greatest recreations of the confusion, violence and terror of war – the film builds up an emotional portrait of the bravery and fortitude of an entire generation. Spielberg won his second Oscar for directing, although the film inexplicably lost out to *Shakespeare in Love* in the Best Picture category.

HEART OF DARKNESS

The success of *Schindler's List*, and to a lesser extent *Saving Private Ryan*, seemingly freed up Spielberg's willingness to take risks, and his films of the new millennium explore diverse, often dark material. In 2001 he picked up *A.I. Artificial Intelligence* following the death of his idol Stanley Kubrick, who had been working on the film for some years. The result is a science-fiction fable about a child android who yearns to be human that delivers an absorbing hybrid of Spielberg sentiment and Kubrick pessimism. Spielberg continued on the darker science-fiction track with *Minority Report* (2002), an exciting, visually bleached-out noir thriller based on a work by Phillip K. Dick, and a big-budget version of H.G. Wells's *War of the Worlds* (2005) that drew 9/11 resonances from the story of a horrific alien invasion of the eastern seaboard of the USA.

Spielberg's non-science-fiction projects of recent years include *Catch Me If You Can* (2002), a breezy 1960s-set caper movie with Leonardo DiCaprio and Tom Hanks, and romantic comedy *The Terminal* (2004). But Spielberg's most impressive – not to mention controversial – film of the post-*Saving Private Ryan* period is *Munich* (2005), a chronicle of the Mossad response to the massacre of Israeli athletes during the 1972 Munich Olympics. Spielberg presents a balanced view of the political and psychological complexities raised by the story but charges the thriller aspects with searing, almost documentary-style filmmaking.

Now in his 60s Spielberg shows no sign of slowing down, and his slate is full of ambitious, diverse projects – an adaptation of the Tintin books with Peter Jackson, an Abraham Lincoln biopic, science-fiction project *Interstellar* – which astonishingly, given his body of work, could mean that the best is yet come.

CHILDHOOD MOGUL

Spielberg took over the role of shooting the family home movies after his father proved inept, and he made films in every genre from westerns to horror, war films to comedy. In 1961 he produced *Fighter Squadron*, which spliced together shots of kids in cockpits with actual Second World War dogfight footage to create a thrilling aerial-combat movie, and *Escape to Nowhere*, which recreated the campaign in Africa during the Second World War. But his most ambitious project was *Firelight* (1964), a two-and-a-half-hour science-fiction epic that now looks like a dry run for *Close Encounters.* With typical Spielberg showmanship *Firelight*'s premiere earned US$500, giving the director his first box-office success by turning a US$100 profit.

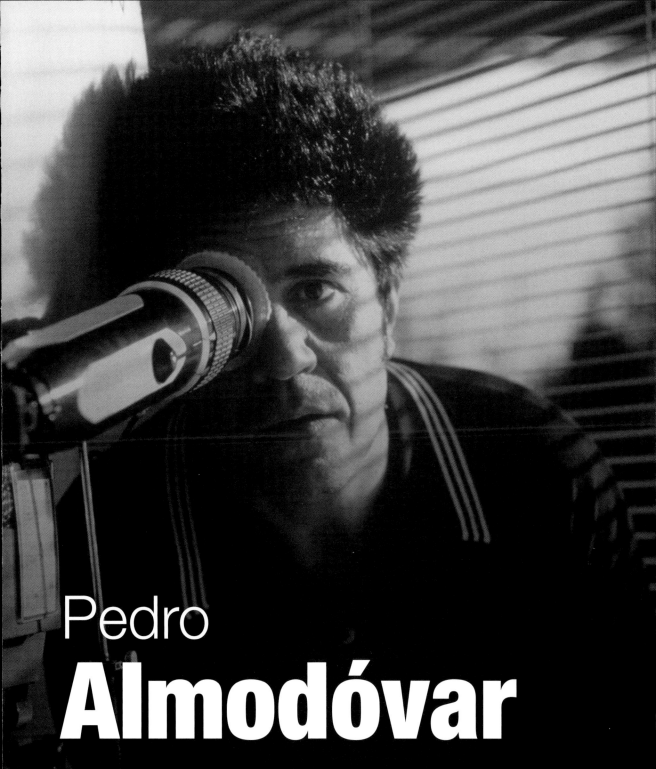

Pedro
Almodóvar

'He connects with people everywhere,
of any age, of either sex and of any
culture.'

Penélope **Cruz**

1949–

Pedro Almodóvar is the most important

filmmaking talent to emerge from Spain since Luis Buñuel, and like Buñuel, Almodóvar's cinema often breaks taboos. His early films were cult, camp and kitsch melodramas, but the comedy and outrageousness often masked multilayered analyses of a country in turmoil. He was at the forefront of *La movida madrileña* (the 'Madrid Scene'), the cultural rebirth that followed the death of Franco, and his films have an affinity for the dreams and desires of the post-Franco generation – colourful, caustic screwball melodramas fuelled by hedonism, passion and the joy of sexual and political liberation.

Yet Almodóvar's cinema is not static. While he has retained his mesmerizing style he has tapped into deeper emotions and more serious tones in a run of later award-winning films that launched him on to the international stage. He is a brilliant director of women, and his work is fused with the power of female solidarity, confusions of identity and the unpredictability of passion.

KING OF KITSCH

Pedro Almodóvar was born on 24 September 1949 in Calzada de Calatrava, Spain. Moving to Madrid aged 17 he worked for Spain's national telephone company but used his time to pursue his own artistic passions. He started dabbling in Super 8 short films in the mid 1970s before graduating to 16 mm with his feature-film debut *Pepi, Luci, Bom and Other Girls on the Heap* (1980). Charting the adventures of three women living on the fringes of society, the film, with its camp tone, explicit sex, outrageous comedy and a prevailing sense of freedom and hedonism, set Almodóvar's stall out from the beginning. He further explored these obsessions in films such as *Dark Habits* (1982), *What Have I Done to Deserve This?* (1984), *Matador* (1986) and *Laws of Desire* (1987), the last three all starring Carmen Maura.

Maura, a key player in Almodóvar's work, also took a central role in Almodóvar's next film, *Women on the Verge of a Nervous Breakdown* (1988), which charts 48 hours in the lives of madcap women in Madrid. The film calms the director's outrageous excesses down for a frenzied farce involving Islamic terrorists and drug-laced gazpacho. Stylish but without his usual edge, it is a witty throwback to the high comedy of 1950s Hollywood. It became Spain's most commercially successful film and broke Almodóvar internationally, winning 50 prizes including an Academy Award nomination.

> 'If I lived like my characters, I would have been dead before I made sixteen films.'
>
> Pedro **Almodóvar**

As if to prove he had not lost his ability to provoke and shock, Almodóvar's next film, *Tie Me Up, Tie Me Down* (1990), charts the dark relationship of an actress (Victoria Abril) who falls in love with her kidnapper (Antonio Banderas). On one level the film is a twisted romantic comedy and Almodóvar's most straightforward love story, but feminist groups condemned the film, arguing – incorrectly – that it condoned rape. In America the film earned an X rating because of one protracted love scene that concentrated on the sexual fulfilment of Abril's character.

Must-see Movies

Women on the Verge of a Nervous
Breakdown (1988)
All About My Mother (1999)
Volver (2006)

Almodóvar followed this with mother–daughter melodrama *High Heels* (1991) and *Kika* (1993), a film that again caused a huge controversy in the US for a lengthy comedy rape scene. Again shifting gears he delivered his most mature film to date, *The Flower of My Secret* (1995), a character study of a romance writer whose life is falling apart. The movie is filled with telling moments, strong dialogue and anchored by a great performance by Marisa Paredes, and it is a bridge in Almodóvar's style to a more restrained, mature approach.

THE ENFANT TERRIBLE GROWS UP

Almodóvar's first film in this new career phase, *Live Flesh* (1997), was his first non-original screenplay, being based on a novel by crime writer Ruth Rendell. Almodóvar spins his story around a bullet fired in a bungled police investigation and follows how it ricochets into the lives of different characters, using the tale to reflect on love, loss, destiny and death with a seriousness new to his work. Being set during the Franco years, *Live Flesh* is also the first Almodóvar film to directly address and criticize the fascist dictatorship in Spain.

He followed this with *All About My Mother* (1999), which brought him Oscar glory. He received another Oscar nomination, this time for Best Screenplay, for *Talk to Her* (2002), which uses shifting timeframes and striking set pieces to tell the story of two men who bond over caring for two comatose women. Almodóvar's next film, *Bad Education* (2004), recalls the high style and outrageousness of his earlier work. It is a baroque, complex tale of child sexual abuse, transgenderism and drug use that borrows elements from film noir and is unusual in the director's canon in that it is exclusively about men. The film divided critical opinion.

Volver (2006), Almodóvar's most recent film to date, was a return to greatness. It is a haunting celebration of motherhood and a touching delineation of how the dead can influence the living, all lensed in beautifully subdued tones. The film earns its power from Almodóvar's ability to slip between the potent and the poignant, the real and the surreal, drawing stunning performances from two actresses returning to his directorial fold, Penelope Cruz and Carmen Maura. Almodóvar has remarked that *Volver* marks the end of his explorations of female unity. If the next phase of his career is just as rewarding, then we have much to look forward to.

ALL ABOUT MY MOTHER

All About My Mother returned Almodóvar to his fascination with female solidarity, as a hospital worker, mourning the death of her son, finds solace in a group of women that includes an HIV-positive nun, a transvestite prostitute and a grande dame of the theatre. Dedicated to a trio of great actresses – Bette Davis, Romy Schneider and Gena Rowlands – the film is theatrical in theme and tone but also manages to be flamboyant yet true, moving without being sentimental. It became the most highly decorated Spanish film in history, winning an Oscar, a Golden Globe and Best Director at Cannes. Coming full circle, it has also spawned a successful stage version.

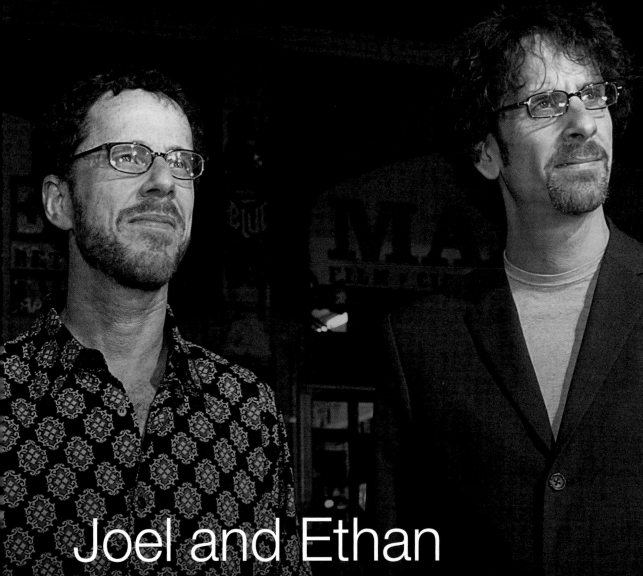

Joel and Ethan
Coen

'They're like one guy with two heads, but they have an understanding of their own sensibilities that allows them to do what they do.'
Josh **Brolin**

1954– (Joel) / 1957– (Ethan)

The most famous fraternal filmmaking

partnership of the modern era, Joel and Ethan Coen have bent the conventions of genre – especially crime thrillers and screwball comedies – turning them inside out with hyperreal sensibilities, unexpected plot twists, black comedy and sophisticated film geekery run amok. They have been derided as slick, empty stylists, but later films such as *Fargo* and *No Country for Old Men* have managed to transcend these criticisms to factor in deeper dimensions. Every one of their films has moments that sing with the thrill of unforgettable cinema – a skill that the Hollywood mainstream looks upon with envy and respect.

Must-see Movies

Blood Simple (1984)

Miller's Crossing (1990)

Barton Fink (1991)

Fargo (1996)

The Big Lebowski (1998)

No Country for Old Men (2007)

The Coens have never enjoyed huge audiences, but their fanatical fanbase love to spot the recurring motifs – vomiting, fat men screaming, extreme hairstyles – and regular collaborators, including John Goodman, John Turturro, Steve Buscemi, Frances McDormand and George Clooney, as well as trying to sift through the elaborate in-jokes. For as much as the Coens are master filmmakers they are also masters of misdirection, deliberately misleading critics and viewers for their own merriment: the opening titles of *Fargo* tell us it is based on a true story, which it is not; *O Brother, Where Art Thou?* is purportedly based on Homer's *Odyssey*, but the brothers claim never to have read it. It may seem smug, but it prevents their fascinating, brilliant, rewarding cinema from being taken too seriously.

INDEPENDENT DAYS

The sons of an economics-professor father and art-historian mother, Joel and Ethan Coen were raised in St Louis Park, Minnesota, a suburb of Minneapolis. Obsessed with movies and television Joel bought a Super 8 camera with money earned from mowing lawns, and the brothers started remaking their favourite films, including *Lassie Come Home* and *The Naked Prey*, which featured Ethan as a spear-wielding African tribesman.

After these joint efforts in nascent moviemaking the brothers pursued individual studies, Joel studying film at New York University and Ethan reading philosophy at Princeton. Following graduation Joel started to work as a production assistant on industrial films and pop promos. His big break came when he landed a job as an assistant editor on *The Evil Dead*, a low-budget but immensely successful horror film directed by Sam Raimi. Inspired by Raimi's guerrilla funding tactics, where cash was found independently of the major studios, Joel and Ethan raised US$750,000 from private financiers to make *Blood Simple* (1984), a brilliant, brooding film-noir pastiche inspired by such hardboiled writers as Dashiell Hammett and James M. Cain. The film

immediately established their style: assured storytelling marked by unexpected twists and dramatic ironies, quirky three-dimensional characters, a self-conscious stylization of visuals and sound, and a skill with compelling, violent spectacle.

Blood Simple was a huge critical success, and it became an instant cult classic, winning awards at the Sundance and Independent Spirit film festivals. Significantly, it also introduced Joel to his wife, actress Frances McDormand, who would become a significant player in the brothers' later work.

GENRE HOPPING

The brothers' next directorial effort, *Raising Arizona* (1987), was a throwback to the screwball

CULT CLASSIC

If any one of the Coens' films has attained cult status it is *The Big Lebowski*. Spinning a crazy yarn about an ageing hippie, the Dude (Jeff Bridges), who gets embroiled in a fake kidnapping plot, the Coens factor in memorable characters – a gun-toting Zionist (John Goodman), a creepy bowling champion (John Turturro) and a trio of German nihilists – a Busby Berkeley musical fantasy, kooky plot twists and quotable dialogue: 'The Dude abides'. The film didn't fare well at the box office but has become a cult favourite, even spawning the annual Lebowski Fest where fans dress up as characters, trade dialogue and party.

comedies of the 1930s with Nicolas Cage and Holly Hunter superb as a childless couple who kidnap one of a set of quintuplets in the hope of raising him as their own. More accessible than their first effort, *Raising Arizona* flies by on great visual gags, outlandish camera moves, memorable supporting characters, yodelling music, quotable dialogue and a heartfelt, homespun belief in what's right. By turns slapstick, surreal and sentimental, it is the Coens at their most flamboyant – not to mention fun.

Miller's Crossing (1990), which returns to the crime milieu of *Blood Simple*, strips away the twisted glee. Set during Prohibition and starring Gabriel Byrne, Albert Finney and Marcia Gay Harden, the film, which has its own vernacular compiled from the whole history of crime fiction, is a complex, compelling tale of mob warfare, shot in dark and sombre hues and filled with dazzling operatic set pieces – a shootout to the strains of 'Danny Boy' is astonishing.

While working on the intricate, dense plotting of *Miller's Crossing*, the brothers suffered an acute case of writer's block, and as a distraction the pair took time off to write a comedy. *Barton Fink* (1991), written in just three weeks, stars John Turturro as a left-wing playwright summoned to Hollywood to write a wrestling picture in 1940s Hollywood. Beset by a creative impasse, Fink is drawn into a bizarre relationship with the travelling salesman (John Goodman) holed up in the hotel room next door. After the

> ## 'We do pander to the audience. But the audience we think about are us.'
>
> Joel **Coen**

ambitiousness of *Miller's Crossing*, with *Barton Fink* the Coens turned in an atmospheric chamber piece, full of telling detail and subtle filmmaking, especially the soundtrack – the buzzing of a mosquito, a noisy bed and a whirring fan are all deployed to etch brilliantly Fink's state of mind.

Nominated for three Academy Awards and winning the Palme d'Or at the Cannes Film Festival, the brothers used their rising stock to make a big-budget movie from a script they had written back in the earliest days. *The Hudsucker Proxy* (1994) stars Tim Robbins as the Capraesque hero Norville Barnes, a mailroom worker who is ushered to the top of a huge corporation with the idea that the naïve and inexperienced pawn will bring it all crashing down. On release

Hudsucker became the first of their films to receive lukewarm reviews, but with hindsight it is one of their most interesting works – visually spectacular, brilliantly funny and with plenty of sly points to make about corporate America in the 1990s.

Perhaps stung by the rejection of *The Hudsucker Proxy*, the Coens literally retreated to familiar territory for their next film. Set in their home state of Minnesota *Fargo* (1996) is a low-budget crime thriller, but unlike *Blood Simple* and *Miller's Crossing* it is less about exploring crime conventions and more a character study of local sheriff and homemaker Marge Gunderson, played in an Oscar-winning performance by Frances McDormand. The film also looks and feels different from their previous works, as the snowy landscapes seem to rein in their visual excesses. More importantly, however, it is the sunny disposition of Marge in the face of horrific events that gives *Fargo* something new in the Coens' canon – optimism without irony.

HOMER AND HOMBRES

Continuing the critical success of *Fargo* and *The Big Lebowski* (1998) the Coens' next, *O Brother, Where Art Thou?* (2000), was another twist on the screwball comedy. It is the story of three dim 1930s criminals (George Clooney, John Turturro and Tim Blake Nelson) who break away from a chain gang and set off to recover the loot from an old bank job. The film plays fast and loose both with motifs from the *Odyssey* – a Cyclops and sirens – and convicts-on-the-run movies. Using digital technology to create a unique sepia look and a nicely self-mocking performance by Clooney – currently the Coens' favoured comedy actor – the film is perhaps best known for its bluegrass soundtrack, which helped kick-start a resurgence of interest in American folk music.

The next three films – low-key noir thriller *The Man Who Wasn't There*, legal comedy *Intolerable Cruelty* and remake of Ealing classic *The Ladykillers* (2001, 2003 and 2004 respectively) – all represent minor works in the Coens' canon. The latter is important as the first film for which the brothers received a joint directing credit; previously only Joel had been down as director, but changes in the rules of the Directors Guild of America allowed the recognition that truly reflected their unique partnership.

In November 2007 the brothers came roaring back to their best with *No Country for Old Men*. Although based on the acclaimed novel by Cormac McCarthy the cat-and-mouse story of a drug deal gone wrong on the Texas–Mexican border feels pure Coen brothers. Yet the film represents a break from their typical house style, eschewing many of their regular supporting actors and stripping away the irony, especially with Javier Bardem's sinister assassin, a chilling personification of evil and bad hair. The film won four Academy Awards, including Best Picture and Best Director, the first time since 1961 – when Jerome Robbins and Robert Wise won with *West Side Story* – that two directors have picked up the award.

RODERICK JAYNES

Check the credits of the Coen brothers' movies and you will see that 9 of the 11 features have been edited by Roderick Jaynes. Jaynes, an old-time Hollywood film editor, has twice won Academy Awards for his work on Coen brothers pictures, for *Fargo* and *No Country for Old Men*. The only thing is that Roderick Jaynes doesn't really exist; he is the pseudonym under which Joel and Ethan edit. Playfully, the pair created a whole history for him, writing essays and book introductions in his name and even using a photo of a Dust Bowl-era farmer to represent him.

Spike
Lee

'Spike is a bold, controversial filmmaker. He is not afraid to stir things up.'

Denzel **Washington**

1957–

Since emerging in the mid 1980s Spike Lee

has raised anger and admiration in just about equal proportions. His cinema is incendiary in its ability to provoke, and typically it explores controversial aspects of the African-American experience with bundles of filmmaking energy and flair.

He eschews positive role models from all races, concentrating instead on three-dimensional characters and a confrontational attitude to the realities of race in modern America. It is a head-on approach that opens him up for criticism but is impossible to ignore.

Must-see Movies

She's Gotta Have It (1986)
Do the Right Thing (1989)
Malcolm X (1992)
He Got Game (1998)
Inside Man (2006)

TWO-WEEK WONDER

Shelton Jackson Lee – Spike is a nickname from childhood – was born in Atlanta, Georgia, to middle-class parents. He first became interested in film while majoring in communication at Morehouse College and subsequently studied at New York University's film school where Martin Scorsese was one of his tutors. He gained attention with controversial short *The Answer* (1980), in which a screenwriter struggles to retell *Birth of a Nation* from an African-American perspective, and *Joe's Bed-Stuy Barbershop: We Cut Heads* (1983), which won a student Academy Award.

When his first feature, *The Messenger*, fell through Lee wrote, directed, edited and co-starred in *She's Gotta Have It* (1986), making the film for US$175,000 in just two weeks. It stars Tracy Camilla Johns as an independent young woman trying to decide between three very different men and is a smart, sassy, sophisticated look at African-American female sexuality shot through with bravura freewheeling filmmaking reminiscent of the *nouvelle vague*. It also bears the title A Spike Lee Joint, a credit that has remained on all his feature films.

He was now a hot property, and Columbia snapped up his next film, *School Daze* (1989), a riotous musical comedy building on his experiences at Morehouse, which dealt with racism based on the shade of skin colour in the African-American student community. It was a critical disappointment but was important for Lee, becoming the first African-American director to have complete artistic control over a studio film. It was an autonomy he put to stunning use in his next work.

COURTING CONTROVERSY

In 1989 Lee directed *Do the Right Thing*, which is still considered his masterpiece. Set on a long hot summer's day in a Brooklyn neighbourhood, it explores the friction between the African-American and Italian-American communities and the inevitable eruption into violence. Lee's filmmaking style is crisp and imaginative, using tight close-ups, moving cameras, extreme angles and distorting lenses to underline both the comedy and the tension. Yet, more potently, the racial differences are drawn sympathetically but unsentimentally – in one scene racial epithets and slurs are hurled directly to the camera from all communities – and the film remains one of the most controversial of the past 20 years.

SPIKE LEE, DOCUMENTARIAN

Lee's best work in recent years has often been in the arena of documentaries. *4 Little Girls* (1997) explores the infamous racially motivated bombing of an African-American church at the height of the Civil Rights Movement. *When the Levees Broke: A Requiem in Four Acts* (2006) details the Hurricane Katrina tragedy and in particular the US government's lack of response to endangered – predominantly African-American – lives. Fuelled by the fury and intelligence that marks Lee's best fiction, these are powerful works that suggest he has lost none of the fire in his belly.

If not as incendiary as *Do the Right Thing*, Lee's next films still caused debate. *Mo' Better Blues* (1990), a celebration of jazz and its artists, was attacked for its thin female characters and charges of anti-Semitism for his depiction of a pair of Jewish nightclub owners. *Jungle Fever* (1991) raised further hackles with its mixed-race relationship between a married African-American professional (Wesley Snipes) and his Italian-American secretary (Annabella Sciorra), with Lee highlighting the cultural differences rather than adopting a platitudinous, liberal, love-is-blind angle. Both films had moments of real imagination but failed to match the achievement of *Do the Right Thing*.

Perhaps the pinnacle of Lee's career as an agitator came with *Malcolm X* (1992), a biopic of the charismatic Nation of Islam leader played by an Oscar-nominated Denzel Washington. With the project originally in the hands of white director Norman Jewison the entertainment press had a field day relating tales of Lee badgering Jewison to hand over the reins, arguing that only an African-American director could do the material justice. Once in charge Lee took the project over budget and schedule, and turned to African-American entertainment legends such as Bill Cosby, Oprah Winfrey, Janet Jackson and Michael Jordan for finances. The resulting three-and-a-half-hour epic is a mixed affair, full of dance numbers, gangster set pieces and sprightly directorial touches yet also strangely cautious and conservative. It may be his most important film, but it is not his best.

> **'I ain't Martin Luther King. I don't need a dream. I have a plan.'**
> Spike **Lee**

COMMERCIAL WITH CLASS

Since *Malcolm X* Lee has explored idiosyncratic personal projects such as *Crooklyn* (1994), *Girl 6* (1996), *Bamboozled* (2000), and *She Hate Me* (2004) that have mostly failed to deliver the disciplined power of his early work. The best of these is 1998's *He Got Game*, a father–son reconciliation story that sings with Lee's love of basketball. He has fared better in documentaries and his more overtly commercial outings, including *Clockers* (1995), a gritty crime drama; *Summer of Sam* (1999), a compelling portrait of New York at the height of the Son of Sam serial murders; and *25th Hour* (2002), a film that is both a character study of the dilemmas of a drug dealer (Edward Norton) and the choices facing America post 9/11.

His most recent film, *Inside Man* (2006), is a thoughtful and exciting heist thriller that also manages to be a searing portrait of New York's multicultural melting pot. It could be instructive about Lee's future career. As a dramatist he is far more effective these days sneaking his points into the subtext of mainstream genres than when he goes for the jugular. The angry young man has grown up.

Tim
Burton

'I would do anything Tim wanted
me to do. You know — have sex with
an aardvark . . . I would do it.'

Johnny **Depp**

1959–

Tim Burton is Hollywood's current crown

prince of darkness. Hijacking the mainstream machine to suit his own twisted visions Burton mixes small personal films – *Edward Scissorhands*, *Ed Wood* and *Big Fish* – with big personal films such as *Beetlejuice*, *Batman*, *Batman Returns* and *Sweeney Todd: The Demon Barber of Fleet Street*. By allowing audiences to make journeys to the dark side – albeit with a safety net of Burton's playful sense of the quirky and emotional sensibility – he has proved that the macabre can be both popular and profitable.

Must-see Movies

Beetlejuice (1988)
Edward Scissorhands (1990)
Batman Returns (1992)
Ed Wood (1994)
Sweeney Todd: The Demon Barber
of Fleet Street (2007)

Burton's work is marked by a series of interests that are as confessional as they are coherent. His heroes, who often display an artistic bent, are outcasts from regular society, a society that Burton likes to reveal as being weird and often pernicious beneath the gloss. His films may be Hollywood blockbusters, but they are self-portraits as revealing as those of any *nouvelle vague* artist.

THE OUTSIDER

Like many of his central characters Tim Burton grew up a loner. Raised in Burbank, California, he withdrew from family life into a world dominated by horror movies – Vincent Price was his hero – and drawing cartoons. This artistic talent won him a Disney Scholarship to study animation at the California Institute of the Arts. After graduating he became an apprentice animator, working on Disney features *The Fox and the Hound* and *The Black Cauldron*, though his talent was constricted by the studio's house style.

Two imaginative short films, *Vincent* (1982) and *Frankenweenie* (1984), acted as calling cards for Burton's feature debut. *Pee-wee's Big Adventure* (1985) told the simple story of the titular man-child (Paul Reubens) searching for his missing bicycle, yet Burton invests the yarn with striking primary colours and a live-action cartoon feel. It was a sensibility he took to even further extremes in *Beetlejuice* (1988), in which an obnoxious spirit guide (Michael Keaton) is enlisted by a dead couple to scare away the new inhabitants of their old house. Full of inventive set pieces, outlandish special effects, zany comedy and a sense of the afterlife as an extension of earthly existence, the film catapulted Burton into the big time.

BLACK BLOCKBUSTERS

Burton's entry into the top flight came with *Batman* (1989). Eschewing the campness of the 1960s television series, Burton reimagined the caped crusader (Keaton again) as an obsessed vigilante and paid equal attention to Jack Nicholson's Joker. He also brought out the Gothic elements inherent in the story, recreating Gotham City with long shadows and

THE WORLD'S WORST FILM DIRECTOR

In a book celebrating cinema's greatest moviemakers it seems appropriate to consider briefly the man who is generally considered the world's worst: Edward D. Wood Jr. Where most directors would film one scene per day, Wood could shoot up to 30, rarely doing more than one take. His best-known films, *Glen or Glenda* (1953) – a film about transvestism that showcases Wood's fetish for angora – and science-fiction horror *Plan 9 from Outer Space* (1959), are truly terrible, and it reveals much about Burton's generous sensibility that he can treat these works with such loving respect.

distorted angles. It was a huge success, and Burton revisited the character with *Batman Returns* (1992). Full of melancholy and sadomasochistic imagery – Michelle Pfeiffer's Catwoman – it is one of the most daring, unconventional blockbusters ever made.

In between his *Batman* brace Burton released the film that best sums up his concerns and interests. *Edward Scissorhands* (1990) is the story of a manmade boy (Johnny Depp) who has scissors instead of hands and whose freakishness stirs up the lynch-mob mentality of the suburban community in which he lives. In this adult fairytale Burton pointedly satirizes the plastic population of suburbia while expressing strong sympathy for Edward as a talented outsider. *Scissorhands* also marked his first collaboration with Johnny Depp, an actor who has introduced a whole new emotional level to Burton's vision.

After the ghoulishly imaginative animated musical *The Nightmare Before Christmas* (1993) Burton teamed up once again with Depp for *Ed Wood* (1994), an affectionate black-and-white tribute to the 'worst film director in the world', Edward Wood Jr. It was Burton's first film to be set in a recognizably real world but still feels part of his universe. It is filled with love for the joy of creativity, with Depp fully committing to Wood's delusional conviction that he was making great work.

Burton followed *Ed Wood* with one of his least satisfying films, *Mars Attacks!* (1996), a thin parody of 1950s alien-invasion movies. He came back strongly in 1999 with *Sleepy Hollow*, based on Washington Irving's tale of a discredited police officer (Depp) investigating mysterious beheadings at the hands of the headless horseman in a small Dutch community. Employing a look partly inspired by British Hammer Horror movies, Burton syringed the tale with malevolent mood and sly humour.

EMOTION PICTURES

After a disastrous remake of *Planet of the Apes* (2001), starring Mark Wahlberg, Burton rebounded with *Big Fish* (2003), the story of a father–son reconciliation, the familial rift caused partly by the father's insistence on telling tall tales. On sure ground here, Burton brilliantly recreates these imaginative stories but also handles the fractured relationships sensitively, perhaps drawing on his difficult relationship with his own family.

'Movies are like an expensive form of therapy for me.'

Tim **Burton**

After this intimate story Burton successfully returned to a big canvas with *Charlie and the Chocolate Factory* (2005), sticking closer to the darkness of Roald Dahl's original novel than previous adaptations. Burton's most recent film, *Sweeney Todd: The Demon Barber of Fleet Street* (2007), is a passionate adaptation of Stephen Sondheim's acclaimed musical. Depp is terrific as the barber who slits the throats of those who have wronged him, and Burton informs the musical with a toughness in its gore and a tenderness in its emotion. The film received the best reviews of the director's career and, a rarity for Burton, award recognition. Yet, however feted he becomes, let's hope Burton remains the eternal outsider. That's just the way we like him.

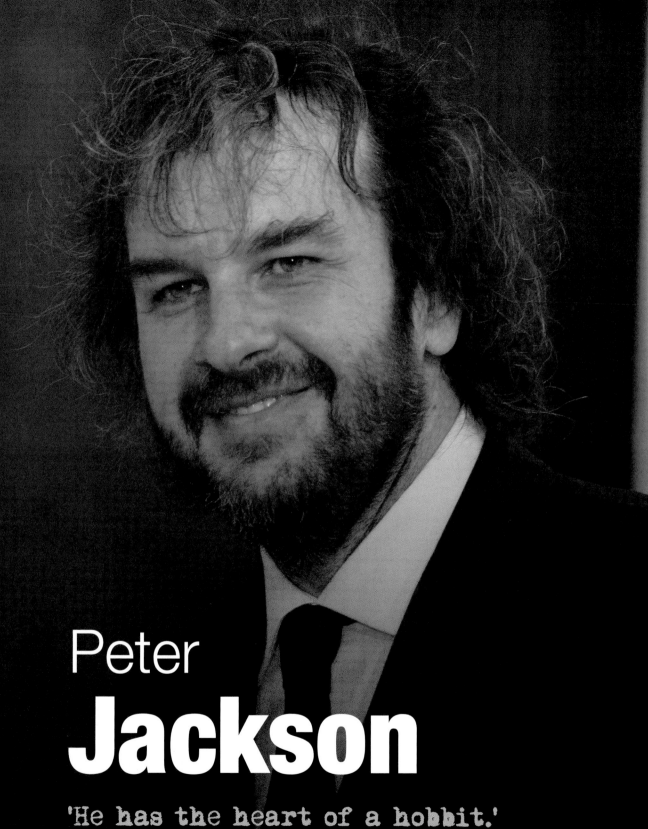

Peter
Jackson

'He has the heart of a hobbit.'

Sean **Astin**

1961–

As a child Peter Jackson used to commandeer

his mother's kitchen to cook up gore and viscera for his homemade 8-mm movies, and in his eight features he has never lost this childlike glee in the sheer joy of making movies. He started his career making outrageous no-budget horror films, but *The Lord of the Rings* trilogy put him at the top of the Hollywood filmmaking fraternity and able to initiate any project he chooses. A canny operator, he has, remarkably, achieved this autonomy without moving from his native New Zealand – Hollywood bends to his every whim without him having to stir from his own backyard.

But whether he is working on cheap, independent horror flicks or studio-approved blockbusters, his approach and aesthetic remain the same: he has a penchant for the grotesque, a reliance on blunt, crude humour, a delight in subverting genre expectations and a manic desire to make his films work for his audience.

HOMEMADE GORE

Peter Jackson was born in Pukerua Bay, New Zealand, in 1961 and became obsessed with movies at an early age. He began experimenting with his parents' Super 8 camera, and his early filmography includes a Second World War piece entitled *The Dwarf Patrol*, a James Bond spoof, *Coldfinger* – with Jackson himself playing 007 – and *Revenge of the Gravewalker*, a widescreen zombie epic.

However, all this Super 8 experience was not enough to land him a job at the National Film Unit, the government body that produced newsreels as well as tourist films promoting New Zealand. Undeterred, Jackson started making his most ambitious project yet, a ten-minute horror film called *Roast of the Day*, financing the shoot himself from a day job as a photo-engraver at *The Evening Post* newspaper in Wellington. The project was beset with production and financial difficulties, but Jackson persevered for over four years, and the project expanded from a short to a 90-minute feature. Fate was on Jackson's side, as the NZ Film Commission got wind of his project and provided additional funds.

The film, when it eventually emerged in 1987, was now called *Bad Taste*. The story is simple: an alien fast-food manufacturer looking for new delicacies lands in the small New Zealand town of Kaihoro. The government dispatches the Astro Investigation and Defence Service (AIDS) team to investigate. Influenced by horror maestro Sam Raimi and Monty Python, *Bad Taste* lives up to its billing, thriving on homespun gore, adolescent humour and gross-out excesses. It was a huge hit at the Cannes

Must-see Movies

Bad Taste (1987)
Heavenly Creatures (1994)
The Lord of the Rings: The
 Fellowship of the Ring (2001)
The Lord of the Rings: The Two
 Towers (2002)
The Lord of the Rings: The Return
 of the King (2003)

Film Festival and was sold to 30 countries, putting Jackson on the film-industry ladder. It also brought him together with his wife and future screenwriting partner, Fran Walsh, whom he met during postproduction.

PUPPETS AND ZOMBIES

Jackson's next film was meant to be *Braindead*, an ambitious zombie movie, but the project proved too costly. He needed a smaller-scale project, and his solution was to use no actors. *Meet the Feebles* (1989) is a vicious satire on *The Muppet Show*, injecting the backstage antics with all forms of sleaze and filth – such as a frog haunted by Vietnam flashbacks and a musical number extolling the virtues of sodomy – that really has to be seen to be believed.

HEAVENLY CREATURES

Based on the notorious Parker–Hulme murder case in 1950s New Zealand, *Heavenly Creatures* charts the slow descent of two 15-year-old girls, Pauline Parker and Juliet Hulme, into an obsessive relationship that results in the murder of Parker's mother. Jackson vividly creates the fantasy landscapes of Borovnia, the modelling-clay fairytale kingdom that the girls inhabit. But it is the compassion and insight which Jackson brings to the intense adolescent feelings that gives the film its power, drawing brilliant performances from Melanie Lynskey and a then unknown Kate Winslet as the central duo.

The success of *Meet the Feebles* meant *Braindead* (1992) was back on. Jackson subverts the whole zombie sub-genre when a Sumatran rat monkey bites a domineering mother, and her son (Timothy Balme) has to keep his now flesh-eating mother from infecting the rest of the town. Fuelled by high-octane action and nutty invention – look out for the kung fu priest and the zombie baby – Jackson flits between toilet humour and sharp satire as he piles up the half-eaten craniums and dismembered limbs in the Grandest of Guignols.

After Jackson proved with *Heavenly Creatures* (1994) that he could do more than just gore he returned to the horror-fantasy arena. The difference this time, however, was that *Heavenly Creatures* had attracted the attention of Universal and Jackson was now working with a sizeable budget. *The Frighteners* (1996) is a battle of wits between a psychic private eye (Michael J. Fox) and creatures from the hereafter. It is a fun showcase both for Jackson's imagination and the new computer-generated effects, but lacking the anarchy of his so-called 'splatstick' era or the sensitivity of *Heavenly Creatures*, it remains the forgotten film of Jackson's career.

THE RINGS CYCLE

Following *The Frighteners* Jackson was slated to remake *King Kong*, a favourite film from his childhood. When Universal Studios shelved the project Jackson turned to another cherished ambition. His first contact with J.R.R. Tolkein's trilogy *The Lord of the Rings* came when he saw the 1978 animated version and then read the original texts. Determined to bring it to the screen properly Jackson originally worked with Miramax to adapt the three parts into two films, but when Miramax boss Harvey Weinstein insisted the film be reduced to a single movie Jackson baulked and moved the production to New Line, now as a trilogy.

This boldness and reluctance to compromise flows through the entire production of *The Lord of the Rings*. This is no slavish reproduction of a classic novel. Jackson and co-writers Walsh and Philippa Boyens excised key scenes and characters while building up others. Equally courageous, Jackson opted to shoot all three films concurrently over 274 days in 150 locations the length and breadth of New Zealand. The shoot produced over 6 million feet of film (approximately 1,140 miles or 1,830 km), ultimately whittled down, if you take all three movies together, to 11 hours and 23 minutes.

'What I don't like are pompous, pretentious movies.'

Peter **Jackson**

The result is thrilling, epic cinema. Jackson takes the potentially hokey story of four hobbits travelling across the fantastical land of Middle Earth to dispose of an all-powerful ring and imbues it with unforgettable spectacle – but through careful direction and great casting he never loses sight of the characters, be they elves, dwarves or walking trees. He also creates a believable, almost tangible, world in which the characters exist through a brilliant fusion of organic, beautiful New Zealand landscape and state-of-the-art visual effects.

With a budget of US$280 million the trilogy was a huge gamble, but it paid off handsomely. The movies are, respectively, the 14th-, 7th- and 2nd-highest-grossing films of all time, the whole series earning in excess of US$2 billion. The trilogy won 17 out of its 30 Academy Award nominations, with the third part, *The Return of the King*, taking 11 out of 11, the joint biggest haul in Oscar history. But perhaps more important than all the number crunching, these are movies that audiences have embraced as classics for all time.

THE RETURN OF KING KONG

The success of *The Lord of the Rings* put Jackson on the very top of the heap. Yet, admirably, he decided to stay in New Zealand, returning to his cherished remake of *King Kong*. As you would expect from a director reworking his favourite film, the adaptation is reverential to the 1933 original, using modern technology to brilliantly reimagine the film's famous moments, including the giant ape's battle with dinosaurs and the duel with biplanes atop the Empire State Building. But there is something missing in Jackson's retelling – some of the storytelling bravery that marked out *The Lord of the Rings*, perhaps.

Jackson has gone small for his next project, an adaptation of Alice Sebold's *The Lovely Bones*, which shares elements with *Heavenly Creatures* in its mingling of teenage girls, fantasy and death. Not that he is forsaking large-canvas movies for ever – he is also planning to co-direct with Steven Spielberg an animated version of comic-book favourite *Tintin* for release in 2009. It all seems a long way from his mother's kitchen – but then again, maybe not.

THE WIZARDS OF NZ

Named after a New Zealand beetle, WETA is the special-effects workshop that Jackson set up with childhood friend Richard Taylor, and it was essential to the success of *The Lord of the Rings*. Key effects developed for the film include very large miniature models nicknamed 'bigatures', a computer program called MASSIVE, which digitally created thousands of realistic extras, and the motion-capture animation techniques used to create Gollum. Actor Andy Serkis performed as Gollum wearing a suit that stored the movements as digital data, which was then used by animators to create flawless character movement. This process – again using Serkis – was later refined to bring Kong to life.

Quentin
Tarantino

'If Quentin hadn't made it in the film business, it's very likely he would have ended up a serial killer.'

Roger **Avary**

1963–

Quentin Tarantino is the geek who inherited

the earth. The video-shop worker who became cinema's boy wonder, Tarantino grabbed headlines and plaudits for his ability to turn the flotsam and jetsam of popular culture into compelling, almost arthouse fare.

In a mere five films he has created a unique style with fractured, achronological narratives, idiosyncratic and memorable dialogue – often about nothing to do with the plot – violence played for comedy as much as shock value and a telling use of forgotten actors and little-known pop songs. And let's not forget his foot fetish – close-ups of female feet abound in his work! Unlike the previous generation of filmmakers Quentin Tarantino didn't receive his training at film school; he served his apprenticeship watching films. Weaned on movies, television, comic books and rockabilly music, at the age of 22 Tarantino took a job at Californian movie-rental store Video Archives. As well as firing his imagination and providing an opportunity to make the short film *My Best Friend's Birthday* (1987), working in a video store also brought Tarantino into contact with various film-industry professionals who were struck by his knowledge and livewire energy. One such person was producer John Langley, a regular customer, who introduced Tarantino to fledgling producer Lawrence Bender. Their first project together would send a rocket through the film world.

Must-see Movies

Reservoir Dogs (1992)
Pulp Fiction (1994)
Jackie Brown (1997)
Kill Bill Vol. 1 (2003)
Kill Bill Vol. 2 (2004)

LET'S GO TO WORK

Tarantino originally conceived *Reservoir Dogs*, the script for which he developed at a Sundance workshop, as a 16-mm low-budget (US$35,000) heist movie. But when actor Harvey Keitel read the script and agreed to act as executive producer the film immediately gained kudos and credibility, leaping to a budget of US$1.3 million and attracting a hot group of young actors, including Tim Roth, Steve Buscemi and Michael Madsen. The finished film, the story of the aftermath of a bloody jewel theft, was a shot in the arm for the entire film industry, with Tarantino playing fast and loose with all kinds of conventions: it is a heist movie where you never actually see the heist; it is a film noir set in the blinding Californian sunshine; and it is a genre movie where the characters forget about the plot to discuss the hidden meaning in Madonna's lyrics, the ethics of tipping and 1970s cop shows.

Dogs also became notorious for its violence, especially the scene in which violent psychopath Mr White (Madsen) tortures a kidnapped cop, resulting in an ear being sliced off with a cut-throat razor to the soundtrack of Stealers Wheel's 'Stuck in the Middle With You'. The film subsequently had a huge cultural impact, changing the face of the American independent film scene, spawning floods of imitators and adding phrases and images to the cultural lexicon.

Moviemakers

THE PRINCE OF PULP

On the back of *Reservoir Dogs* Hollywood began to snap up his back catalogue of screenplays, including *True Romance* (1993), directed by Tony Scott, and *Natural Born Killers* (1994), directed by Oliver Stone. Both films feature couples on the run and plenty of violence.

It was during an extended stay in Europe promoting *Reservoir Dogs* that Tarantino landed on the idea for his next project. An anthology of crime stories inspired by the lurid tales in dime-store magazines and hardboiled detective novels, *Pulp Fiction* (1994) once again breathed new life into stock genre situations – the gangster taking out the mobster's wife, the boxer who has to take a fall, the assassin taking care of a hit. This he does by adding reality checks – famously a discussion about the European names of McDonald's products – criss-crossing the stories in a non-linear fashion and building up suspense, surprise, irony and tension.

> 'If I've made it a little easier for artists to work in violence, great! I've accomplished something.'
>
> Quentin **Tarantino**

Once again the film's violence caused controversy: at a showing at the New York Film Festival an audience member fainted during the scene where a hypodermic needle is plunged into Uma Thurman's chest. The film was also heavily criticized for its foul language, in particular the constant use of racial slurs. But it remains a rich, funny, thrilling tapestry of the LA underworld, fuelled by a dazzling array of quotations from other films as well as scenes that have subsequently been parodied in their own right – John Travolta and Uma Thurman's twist, for example. *Pulp Fiction* also revealed another string to Tarantino's bow, that of his skill in casting out-of-favour actors – Travolta and Bruce Willis both received career revivals on the back of it.

Tarantino won both the Palme d'Or at Cannes and an Oscar for Best Screenplay, and the movie earned US$200 million at the box office. He became an ever-present figure on the film scene, acting in cameos, co-directing anthology film *Four Rooms* (1995) and setting up a production and distribution company. For his long-awaited follow-up to *Pulp Fiction* he directed his first adaptation, *Jackie Brown* (1997), based on the Elmore Leonard crime novel *Rum Punch*. Those expecting a repeat of the fireworks of *Pulp Fiction* were disappointed. More subdued in both its gore and filmmaking style, *Jackie Brown* is a slow-moving, absorbing

SMALL-SCREEN TARANTINO

For a high-profile movie director Tarantino has never been afraid to revel in his love of television by making episodes of his favourite shows. He has directed episodes of *ER* and *CSI: Crime Scene Investigation*, which included a live interment reminiscent of *Kill Bill Vol. 2*. He was slated to direct an episode of *The X-Files*, but not being a member of the Directors Guild of America he was prevented from doing so. However, the episode had been written with Tarantino in mind so has little in common with the tone and style of the rest of the series. As a performer he has appeared in *Alias*, hosted *Saturday Night Live* and was a judge on *American Idol*.

character study, and it once again showcased Tarantino's deftness with forgotten talents by casting Pam Grier and Robert Forster.

EXPLOITATION KING

Apart from the occasional foray into – poorly received – acting Tarantino took a break from both filmmaking and public life, firing rumours of writer's block. He returned with *Kill Bill*, a bloody valentine to the kung fu films he had wallowed in at Video Archives. The story, written with Uma Thurman in mind after the two had met up at the 2000 Academy Awards, follows a bride left for dead on her wedding day who swears violent revenge on her attackers. After the film grew in ambition and budget, production studio Miramax took the unusual decision to release the film in two parts – *Vol. 1* (2003) and *Vol. 2* (2004) – a move that generated mountains of hype and column inches. *Vol. 1* is a riot of Tarantino chutzpah and brilliantly choreographed violence – the final bloodbath was turned black and white by the censors to tone down the impact – whereas *Vol. 2* slows the action down for more considered character moments.

For his most recent film, *Grindhouse* (2007), a double-bill feature directed by Tarantino and friend Robert Rodriguez, Tarantino continued to pay homage to Z-grade entertainments. Tarantino's talk-driven episode, 'Death Proof', stars Kurt Russell as Stuntman Mike, a crazed killer who gets his kicks by mowing women down in a black Chevrolet Nova. The experiment failed to communicate with audiences, however, with many patrons leaving after Rodriguez's 'Planet Terror' section. Tarantino's effort was subsequently released in its own right, but its commercial failure highlights an interesting crossroads in his career: if audiences have tired of his glorious revivals of film history, where does he go next?

TARANTINO'S UNIVERSE

Tarantino often litters his films with characters, events, companies and brand names that work across his entire fictional universe. Michael Madsen's character in *Reservoir Dogs*, Vic Vega, is the brother of *Pulp Fiction*'s Vincent Vega, played by John Travolta. Alabama, the heroine of *True Romance*, is name-checked in *Reservoir Dogs*. Cigarette brand Red Apple, fast-food joint Big Kahuna Burger and Fruit Brute – a real discontinued cereal – crop up in numerous Tarantino films.

INDEX OF MUST-SEE MOVIES